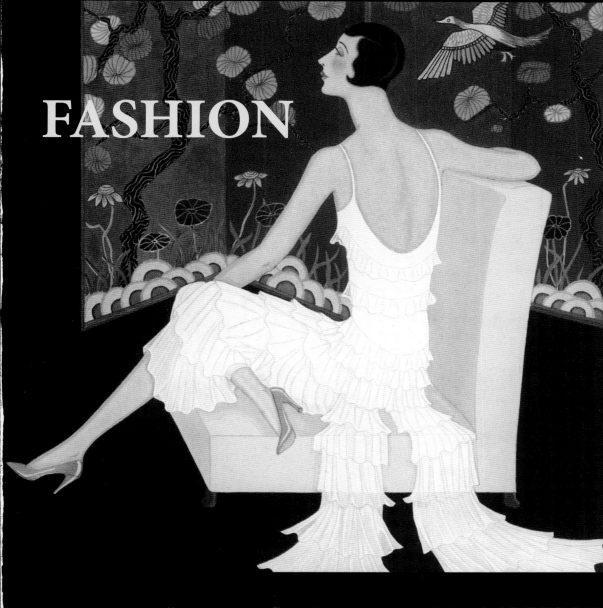

FASHION

FASHION
The Evolution of Style

Lucinda Gosling
in association with the Mary Evans Picture Library, London

NEW
HOLLAND

This edition published in 2016
First published in 2015 by
New Holland Publishers Pty Ltd
London • Sydney • Auckland

The Chandlery Unit 009 50 Westminster Bridge Road London SE1 7QY United Kingdom
1/66 Gibbes Street Chatswood NSW 2067 Australia
5/39 Woodside Ave Northcote, Auckland 0627 New Zealand

www.newhollandpublishers.com

A record of this book is held at the British Library and the National Library of Australia.

ISBN 9781742579085

Managing Director: Fiona Schultz
Publisher: Alan Whiticker
Designer: Lorena Susak
Proofreader: Jessica McNamara
Production Director: Olga Dementiev
Printer: Toppan Leefung Printing Limited

10 9 8 7 6 5 4 3 2 1

Keep up with New Holland Publishers on Facebook
www.facebook.com/NewHollandPublishers

PAGE 2-3: Gabrielle 'Coco' Chanel (1883-1971), remains one of the most influential designers of the past century. She pioneered a chic, easy-to-wear look for the modern woman and wore her own designs all her life. Pictured here in the 1950s in a classic jacket with her trademark 'costume' strings of pearls. Chanel herself once said, 'Fashion fades, only style remains the same.'

CONTENTS

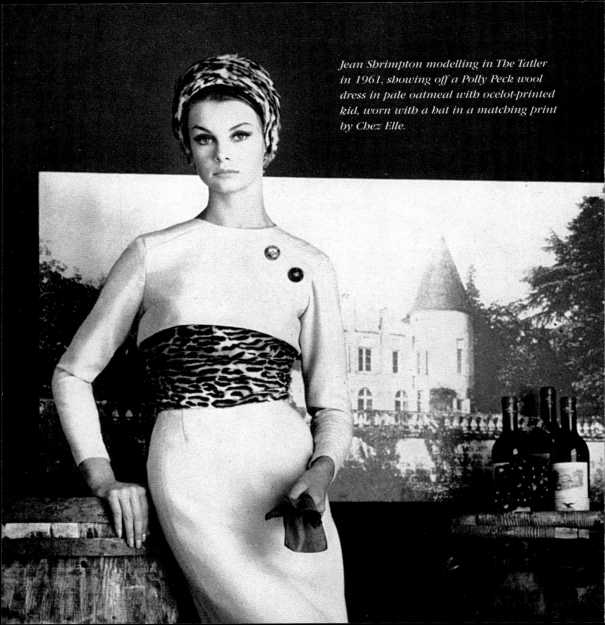

Jean Shrimpton modelling in The Tatler in 1961, showing off a Polly Peck wool dress in pale oatmeal with ocelot-printed kid, worn with a hat in a matching print by Chez Elle.

INTRODUCTION

Vintage fashion is having a moment. From festivals celebrating the style, attitude and music of the past, to Hollywood stars in vintage couture. These days, second hand definitely does not mean second best. There are published guides to hunting down the best vintage finds, dedicated magazines, blogs galore, and in 2014, the BBC screened a series titled 'This Old Thing' in which reluctant shoppers were encouraged to try out vintage clothes as an alternative to the high street. Retro dressing has gone mainstream, a development that is frustrating for any dyed-in-the-wool vintage fan. Bargains are becoming harder to find, charity shops have become savvy in their pricing and eBay has opened up the world of retro dressing to anyone with the time and inclination to click through the hundreds of vintage sellers.

I have my own memories of shopping for vintage clothes as a teenager in the 1980s. Rummaging through a small, second-hand clothes shop in the back streets of a town near where I lived in North East England, yielded a haul of treasures – a 1950s swimsuit, a 1940s tea dress, an Edwardian blouse and a tiny man's dinner jacket (1930s perhaps). All of it was procured for the price of a modest round of drinks today. The highlight of a sixth form trip to Paris was not the Notre Dame or the Musée D'Orsay, but the pair of genuine ripped Levis 501 jeans I bought at a market. During another holiday, in London at the age of sixteen, my best friend and I each bought 1950s handbags at Camden Market for a couple of pounds each, and spent the rest of our time in the city walking around the capital with our bags hanging off our wrists like the Queen. I realise now, with a certain feeling of unease, that the wooden cross I picked up in Oxfam and wore to several school discos probably once belonged to a nun. I lacked both the means and the commitment to wear old clothes prescriptively. I mixed them up with high street t-shirts and shoes. 1980s vintage lovers favoured the sharp tailoring of the 1940s, and the 'rockabilly meets school prom romance' of the 1950s (this, after all, was the era of the American high school movie). The 1970s were still too close, an embarrassment relegated to fancy dress parties. All of that has changed. The children of the 1970s are now in their forties and their children are teenagers.

Recently I visited a local vintage sale in London and there was a tightly buttoned, voluminous sleeved, green Ossie Clarke dress from the early 1970s. Its price tag read £400.

Ossie Clarke's sexy, dreamy, bohemian vibe was of course a sublime version of 1970s fashion and his covetable designs have reached cult status. But in general, we need to be removed from an era by at least two decades to be able to take the retrospective long view. Styles that were, for a while, considered passé need time to resurface, and often they are resuscitated by a new generation hungry for new ideas, even though their parents may have seen it all before.

Because in fashion, nothing is truly new, at least, not any more. Fashion borrows from history constantly,

and is relentlessly cyclical. Anyone with a big enough wardrobe can keep discarded clothes safe in the knowledge that sooner, or later, most of them will come back into fashion. At the time of writing, flared jeans, dungarees and suede A-line skirts strongly reminiscent of the 1970s are a big story for the forthcoming season. It is an unsurprising development. Many of today's fashion designers, journalists and buyers were born in the 1970s and remember their own mothers' personal style with a fond nostalgia. Jess Cartner-Morley, writing in *The Guardian* concluded of this season's shows, 'the catwalk muse is the 70s mum'. She added, 'If you can picture yourself learning to ride a Chopper bike or watching Happy Days on TV, then the mum you can picture in the background is the woman you want to be this season.' A feature in the New York Times on the trend asks, 'who can help but plunder fashion's past … clearly (it) retains an emotional pull. In retrospect, the decade that spawned the DVF wrap dress, maxi-coats worn over hot pants, and Ladies of the Canyon in battered jeans seems a garden of earthly delights.'

Seven or eight years ago as the vintage wave began to swell, 1940s tea dresses were all the rage, a trend that dovetailed with the expansion of vintage 'shabby chic' purveyor, Cath Kidston, now a global brand. Skip back to the 1970s itself and one particular designer, Laura Ashley, was looking further into the past, building a business on her romantic, high-collared maxi dresses in sprig prints inspired by original Victorian textiles. The rational, aesthetic dress movement of the 19th century favoured their own version of a loose, flowing maiden's dress in a medieval or Renaissance style. Women's clothes leading up to the First World War had a touch of the Napoleonic era about them, known as the 'Directoire' style, and Teddy Boys of the 1950s mimicked the tailored dress coats of the Edwardian dandy. Even the wasp waists and expansive skirts of the so-called 'New Look' – unveiled by Christian Dior in 1947 – was a modernised version of the crinoline. Cecil Beaton, that arch observer of passing modes thought that an Yves St. Laurent show he went to in 1970 referenced 'Callot Soeurs' (an early 20th century Parisian fashion house run by the Callot sisters). He also identified traces of 1918 and 'some absolutely hideous travesties of the 1945 fashions with velvet turbans, square shoulders, short skirts and heavy clogged feet.' Beaton could sniff out derivations a mile away, and he treated any mishandling or clumsy interpretations with derision. Some of us might like the sound of 1945's square shoulders and velvet turbans, which just goes to show how subjective fashion can be, and how tastes and trends vacillate with the passing of time.

The elegant 1930s may seem the apogee of good dressing to many of us today, but the perspective of journalist Sarah Drummond, writing her fashion column in *London Life* magazine in 1966 reminds us that being too close to an era can easily quash any admiration. And that mothers' clothes were once the very opposite of cool. That year, the movie 'The Group' was released, based on the novel by Mary McCarthy about a group of women during the 1930s. The late 1960s and early 1970s witnessed a rash of period films

inspire new 'old' trends. Drummond seriously doubted 'The Group' was going to influence fashion, writing, 'to me the thirties are one of the ugliest eras in the history of fashion. Photographs of my mother in those ludicrous hats, drooping shoulders, amazingly unflattering hairstyles and dreary skirt lengths are laughable and pathetic, whereas photographs of my grandmother in her heyday (the Edwardian period presumably) are wizard.'

Victoriana and Edwardiana was the pervading look in the mid to late sixties, a vintage mood picked up by London boutiques. *London Life* assured readers, 'No need to hunt through Granny's trunk or the antique markets for the memory of a yesterday. For the old-fashioned girl the search is over – with manufacturers finally rising to meet the demand and offering the blouse of yesterday today.' As the decade progressed, eclecticism ruled. Vintage and boutique buys, borrowing from a cross-section of historical eras made the 1960s one of the most playful and creative periods for dressing up with as much choice on offer for men as women. Historical twists were wide ranging. One shop in Portobello Road specialising in old Guards uniforms and antique military costume gloried in the name, I Was Lord Kitchener's Valet. Another legendary London boutique was Granny Takes a Trip on the Kings Road in Chelsea. Inspired by Art Nouveau style (a pervasive trend during this period, due in part to an Aubrey Beardsley exhibition staged at the V&A in 1966), GTAT was the original home of flamboyant, psychedelic clothes, selling an eclectic mix of globally sourced antique pieces. They also designed a clothing range, including their famous tailored jackets in William Morris fabrics, worn by the most hip and happening of the day from the Beatles to Jimi Hendrix. Granny Takes a Trip's unforgettable name plainly referenced the drug culture of the sixties but also seduced shoppers with the promise of sartorial time travel. Biba too, arguably the biggest and most successful fashion boutique in London during the 1960s, mixed art deco with Edwardian decadence. Peacock feathers and other such symbols of these vanished eras provided Biba's set dressing – it was all part of the concept. Anthony Little, the man responsible for designing the interiors at places such as Biba and Hung on You considered the late sixties gravitation towards this florid, bohemian maximalism to be a reaction to the clinically clean Swedish style of design.

He too was quoted in *London Life* magazine, a publication that despite lasting a painfully short fifteen months from October 1965 to the end of 1966, reigned supreme as a cool chronicle of the capital city which had been dubbed by *Time* magazine during that period as, 'swinging London.' *London Life* launched with an editorial dream team of David Puttman and writer and cartoonist, Mark Boxer. It filled its pages with photographs by Donovan and Duffy, cartoons by Gerald Scarfe and picture features on clubs, nightlife, movers and shakers and, of course, clothes. Not just on models, but on real people. Every week, the regular 'What People Are Wearing' page featured a parade of creative types, boutique sales assistants, hair salon

managers, society girls, ad agency secretaries, actors and artists. All of them were photographed in the latest gear from shops that were part of the London boutique explosion – Bazaar, Biba and Quorum, as well as Maxine Leighton, Hildebrand, Annacat, Mexicana and Carrot on Wheels. Anna Gahin, a secretary at the Kasmin art gallery in 1966 was just the right type of girl to make the 'What People Are Wearing' page. She was pictured with a friend, Rosemary Flegg and both were wearing dresses with ric rac trim (designed by the latter). Speaking fifty years later, Anna remembers, 'my absolute favourite designer was Gerald McCann. I had one Mary Quant dress (early on), of course used to make the Saturday morning pilgrimage to Biba's (before she moved into that big department store), though I remember when she was in a much smaller shop before the Ken High Street one. But my top favourite dress was a really simple navy one that I had stitched a wide band of emerald green around midriff. For my wedding party I had a wonderful Ossie Clark navy trouser suit – palazzo pants and loose jacket.' Anna's Ossie Clarke suit, along with a flock trouser suit from Granny Takes a Trip met a tragic end when she lent them to her daughter who put them in a washing machine on a hot cycle. I asked Anna if she had ever visited Clobber, a boutique opened by designer Jeff Banks in Blackheath village in south-east London in 1964. She remembered it but never visited saying that, 'Blackheath seemed far away.' But Clobber was hugely successful. It opened with a fanfare of publicity in 1964, mounted police called in to control the crowd of over a thousand that had descended on the village in order to catch a glimpse of the specially invited guests including John Lennon. Celebrity endorsement came in the form of singer Sandie Shaw, who became the face of Clobber as well as Banks's wife.

In the same year Clobber launched, another, very different, business began in Blackheath, albeit more quietly. Banks sold Clobber after just a few years – the building now houses an Age Exchange centre and café – but fifty years on, Mary Evans Picture Library remains a Blackheath institution and a successful business. From its quirky office, based in a converted parish hall on the edge of the heath, it has been supplying pictures of the past to a range of publishing and design clients for half a century. The library was borne out of Mary, and her husband Hilary's love of pictures, books and collecting. Beginning at the time it did, with tastes for the Victorian look in vogue, the bedrock of the collection is formed from an archive of 19th century material, whether weekly news periodicals, music sheets, scraps or fashion plates. In a way, as incongruous as it may seem, Mary Evans Picture Library also successfully tapped into a trend.

Fast forward to the present day and the library can offer pictures of all periods and genres of history through a mix of photographs, prints, illustrations, advertisements and ephemera. It is from this unique and extraordinary collection that we have drawn together pictures that tell a story of 20th century fashion. From the 1900s up until the dawn of the 1980s this book presents a blend of material that ranges from elegant 1950s fashion shoots to art deco lipstick advertisements, comic postcards to magazine covers. The

library's strength is in its depth as well as breadth of material allowing us to show fashion from all angles, working down from iconic couture designs and fashion's trendsetters down to family snapshots and vintage knitting patterns. It is a scrapbook of styles through the ages, cherry picking the classic moments of history alongside the more unexpected. We might anticipate the inclusion of Audrey Hepburn and Jackie Kennedy as fashion influencers, but there is also the dancer Irene Castle, who in her heyday during the First World War was declared an, 'absolute arbiter of style'. Or there is a photograph of a moody looking Biruta Stewart-Ure, whose nickname of Biba was the inspiration behind her sister Barbara's legendary store. We know about the trend for outlandish, Oxford bags, but the library's small collection of *Man and his Clothes* magazine 1929–1931 also reveals the popularity of towelling 'Verandah suits' among Oxford students, a forerunner of the modern day onesie perhaps? French tennis star Suzanne Lenglen was as renowned for her on court style as her ballet-like tennis, and a page from the 1933 Illustrated Sporting and Dramatic News reports on a range of tennis dresses she designed for Selfridges. Fashion illustration is given equal billing with photography. There are the exquisite, colour saturated pochoir prints from precious volumes of *Gazette du Bon Ton* and *Art, Goût, Beauté* alongside magazine sketches that sum up the sophistication of 1950s evening wear in a few sparse, simple lines or jolly illustrations celebrating the flirty flapper fashions of the 1920s. The aforementioned London Life is another treasure held at the library, one of ten publications making up the Illustrated London News archive. Browsing through the four volumes representing the title's brief existence is to gain entry to a world just beyond reach, and to get a real sense, of how fashion was part of a bigger, cultural shift.

The history of people is also a history of their clothes. The pictures in this book not only record the touchstones in fashion's story and the people who set trends, but it also tries to show how those ideas filtered down and were adopted by ordinary people. Shimmering 1930s brides, bowler hatted city Gents, schoolboys in shorts, vulpine packs of Teddy Boys, sirens in swimsuits, cool Mods, exquisitely attired actresses, 1960s 'dolly birds' and women in Utility dresses are just some of the characters making up the cast of this book.

Vintage aficionados of today can choose who they wish be, which style they want to emulate from the perpetually revolving wheel of fashion. There is something undeniably elegant about the clothes worn by a previous generation, with a few notable exceptions of course. But dressing in vintage isn't just about looking good. It's about recreating a lifestyle and a code of conduct from a time when manners mattered, and life was a little more innocent and moderately paced. It is about nostalgia for what has gone before and making a connection with what is just out of our reach. This book offers a window into our fascinating, fashionable past.

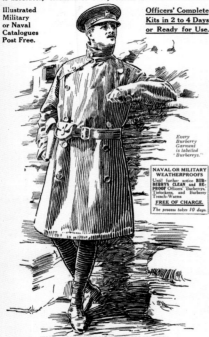
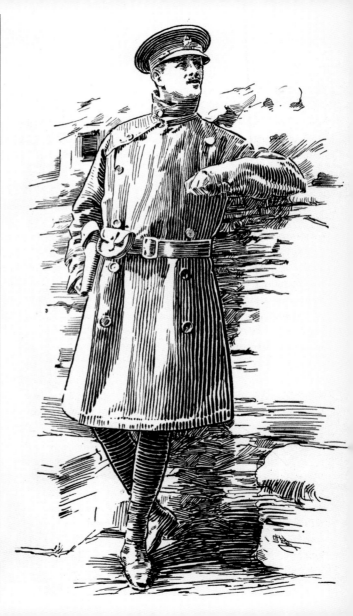

CLASSICS

In 1856, a twenty-one year old draper's assistant from Basingstoke, Thomas Burberry, set up a business that was to evolve into one of the world's most famous and distinctive fashion brands. Burberry's original ambitions were simple and straightforward. As he catered to a largely rural community, he experimented with waterproof fabrics that would provide comfortable protection from the elements. In 1884 he invented gabardine, a close-woven fabric, proofed before and after weaving without the use of rubber to ensure it was lightweight and breathable. The business moved to London in 1891 and quickly established itself as a leading purveyor of quality outerwear to the discerning gentleman. With a canny sense for promotion and marketing, Burberry ensured his products received celebrity endorsement from some of the most heroic action-men of the day. Lord Baden-Powell and Lord Kitchener made use of their Burberrys while on campaign in South Africa leading to orders from the British Army in 1906, and Shackleton, Scott and Amundsen were all equipped for their South Pole expeditions by Burberry. By the First World War, the Burberry 'Tielocken' would be the prototype for several versions of overcoats, including the 'trench warm,' purchased by officers to wear on the Western Front. One of the multitudinous Burberry advertisements appearing in magazines of the time sternly advised readers:

'The greatest danger, that the soldier has to face on active service is not the poison gas and liquid fire of the enemy, but bad weather the insidious foe that undermines both health and efficiency. As an economical insurance against the risk the Burberry trench-warm is absolutely essential to every officer at home or abroad.'

Burberry cannot take sole credit for this classic. Aquascutum, another British company with roots that go even further back (1850 to be precise), was also marketing a similar style, as were numerous gentlemen's outfitters and military tailors from Wilkinson's and Moss Bros to department stores such as Harrods and Gamages. But regardless of its origins, the First World War gave birth to a classic wardrobe staple – a coat that was distinctive in style and yet a neutral foil to anything worn beneath. Chic and practical, it could be a breezy style statement, or a coat that whispered of shady dealings and moral ambiguity, a quality that owed more to its association with film noir in the 1930s and 40s than with its dashing, mud-spattered military

OPPOSITE:'The greatest danger', that the soldier has to face on active service is not the poison, gas and liquid free of the enemy, but bad weather, the insidious foe that undermines both health and efficiency.' Advertisement for Burberry, The Tatler 26 April 1916.

origins. Marlene Dietrich wore one in the film 'Manpower', artfully knotting, instead of buckling the belt and Humphrey Bogart's image is indelibly associated with the trench coat he wore in Casablanca. In 2012, Bogart's estate launched a legal action against Burberry when the latter used an image to promote their brand. As Bogart's son Stephen claimed, 'It is well-known my father was a loyal Aquascutum customer in his personal life.'

People who buy a Burberry or Aquascutum trench coat don't just buy a well-made, practical garment; they buy into that garment's heritage and tradition. They invest in a brand that quietly announces a person with taste, confidence and discernment and in so doing, are making the ultimate, understated style statement. The same could be said of a bespoke suit, an investment that should give the wearer a polished, effortless elegance. As Hardy Amies famously said, 'A man should look as if he's bought his clothes with intelligence, put them on with care and then forgotten all about them.'

For women, a cashmere jumper from a brand such as Pringle of Scotland (established in 1815), or a simple string of pearls projects a similar refinement. Pair the two together and the result is the classic twin set and pearls look that defined the cool, feminine aesthetic of the 1950s star Grace Kelly. Kelly lent her name to one of the most desirable accessories of the 20th century. The Hermès Kelly bag, originally called the 'sac haut a courroies' (translated quite literally as 'the tall bag with straps') had been in production since 1930, but when Kelly was spotted carrying the bag at the height of her fame (ostensibly to hide her first pregnancy from the paparazzi), it was renamed in her honour. Each Kelly bag is handmade by a single craftsperson whose name is embossed inside the bag. Hand-stitched with over 2600 individual stitches in a technique unique to Hermès it is not only an example of exquisite workmanship but also a symbol of pure, timeless luxury.

Classic fashion need not necessarily scale the luxurious and purse-squeezing heights of a statement bag, a Rolex watch or full set of Louis Vuitton luggage. The defining feature of classic clothes is often their hardy longevity, practicality and quality. Harris Tweed has been woven in the Outer Hebrides for centuries, and in the Victorian age became a popular cloth for sporting and hunting among the upper classes. It was adopted by 20th century designers for women's tailored suits who valued its quality and traditional heritage, and was later subverted into modern sixties dresses. In the 1990s, it was taken up again by Vivienne Westwood, a designer who adores to playfully blend tradition with historic style references and a touch of the avante garde.

Nothing declares a clothing company's classic credentials more eloquently than a royal warrant. Queen Elizabeth II, a monarch who has lived through seven decades of changing fashions, has forged her own individual style with only a slight regal nod towards current trends. Within her wardrobe are classic brands

she has loyally stuck to through the years – Launer handbags and shoes by Rayne, and later, Anello and Davide. The headscarf, once widely worn by women in the 1950s, in a triangular fashion with the ends tied under the chin, remains a staple of the Queen's off-duty look today, at Badminton Horse trials, or driving around Windsor Great Park. Whether it is a look that is outdated is of no consequence to the octogenarian Queen. The Queen dresses like the Queen, whether in public or private, transcending rather than following fashion.

As a young girl however, she was something of a trendsetter. The arrival of Princess Elizabeth of York, as she was then known, aroused interest among the public who were keen for details of the royal arrival. Her nursery décor was reported to be primrose yellow and patterns were published allowing knitters to recreate her clothes. Seen on outings with her parents wearing a tailored, double-breasted coat, her sister Margaret Rose dressed identically, the style was soon widely known as the 'Princess coat'. It was worn by thousands of little girls for the next three decades, often complemented by a smart pair of Start-rite shoes.

The royal family also made popular the sailor suit after the future King Edward VII was portrayed by the painter Winterhalter in 1846 dressed charmingly as a miniature Jack Tar. Thereafter, for more than half a century, the sailor suit became *de rigeur* for little boys, and their sisters (who would wear a feminized version). *The Queen* Magazine in January 1879 carried a feature on 'Man of War' suits, enjoying a renewed popularity, due to the adoption of the naval uniform by the Prince of Wales' sons, who, 'of the ripe age of twenty-two months', were being measured for suits that would be worn by the boys until Eton or Harrow suits were required. The royal family's love of the highlands is well known and they often dress traditionally when holidaying at Balmoral. But while they favour traditional highland dress, tartan is a perennial favourite among designers, adopted for everything from mini-kilts to skintight punk trousers over the years. That temptation to tap into tradition and give it a modern twist is a recurring theme throughout fashion history.

Traditional sailor suits and tartan kilts may no longer be everyday wear, but classic garments that have stood the test of time, along with brands that boast a long and noble heritage, form the bedrock of many a style-seeker's wardrobe. Fashion may be fleeting, but a sense of style is forever and investment in a classic is unlikely to be regretted. One Burberry advertisement from 1940 advises potential customers of the, 'lasting wear, continuous satisfaction and complete efficiency' guaranteed with the purchase of their overcoats and weatherproofs. Another earlier advert from 1913 promises, 'luxurious comfort in severe conditions.' For Burberry aficionados of today, their investment is less about the garment's performance but more about the brand's heritage, cachet and the thrill of wearing a coat that has over 150 years of history sewn into every stitch.

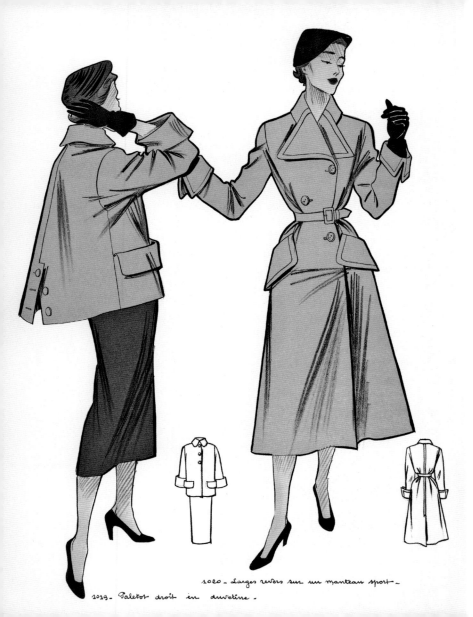

A variation on the trench coat for women; French fashion sketch, 1950s.

1020 - Larges revers sur un manteau sport -

1019 - Paletot droit en duvetine -

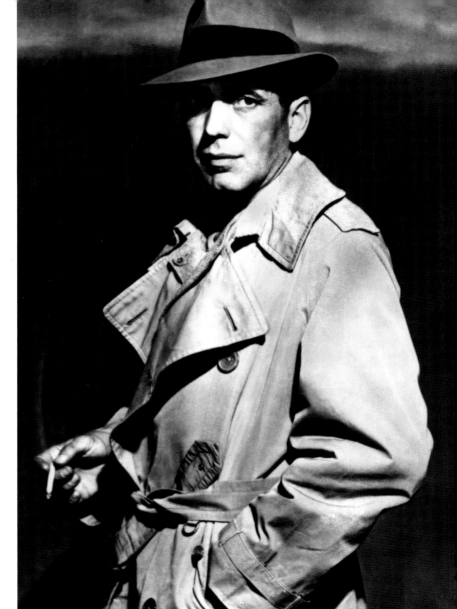

Actor Humphrey Bogart (1899–1957) whose quietly confident on-screen persona was matched by his casual but classic style.

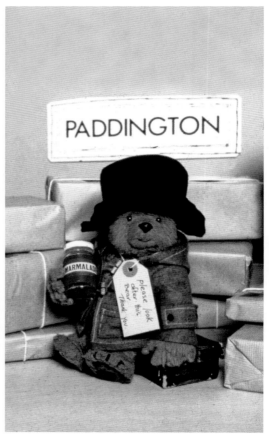

ABOVE LEFT AND RIGHT: The popularity of the duffle coat, which takes its name from a town in Belgium, stems from its use by the Royal Navy during the First World War. Worn by well-known figures including Field Marshal Montgomery, the former Labour party leader Michael Foot and of course, Paddington Bear, its defining features include a tartan lining, toggle fastenings, a bucket hood and large external patch pockets.

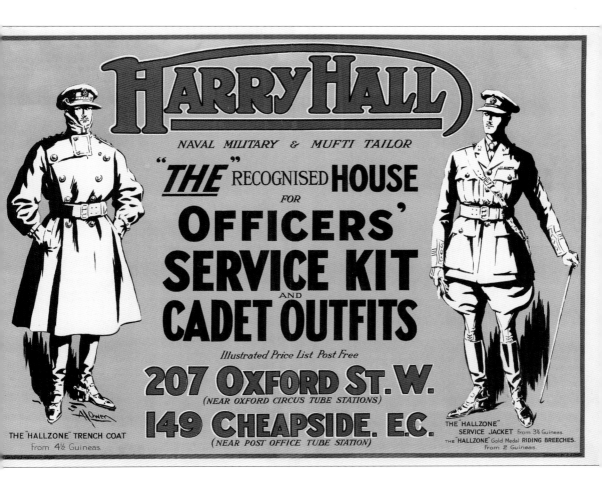

*ABOVE: Advertisements for Harry Hall, illustrating their
'Hallzone' trench coat during the First World War.*

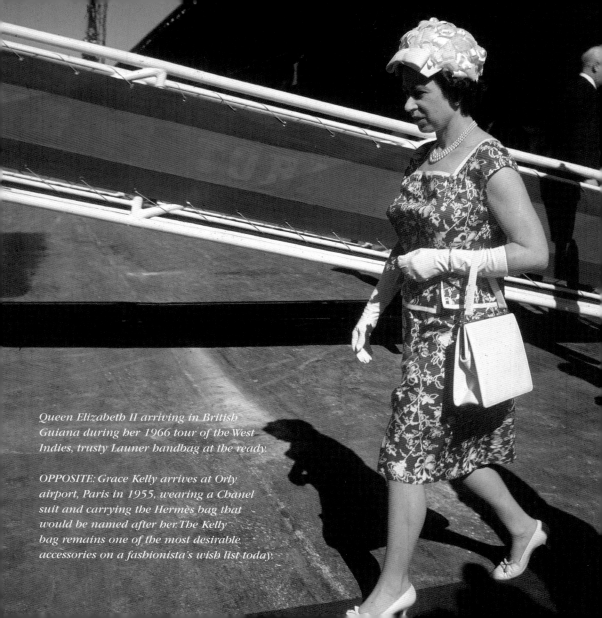

Queen Elizabeth II arriving in British Guiana during her 1966 tour of the West Indies, trusty Launer handbag at the ready.

OPPOSITE: Grace Kelly arrives at Orly airport, Paris in 1955, wearing a Chanel suit and carrying the Hermès bag that would be named after her. The Kelly bag remains one of the most desirable accessories on a fashionista's wish list today.

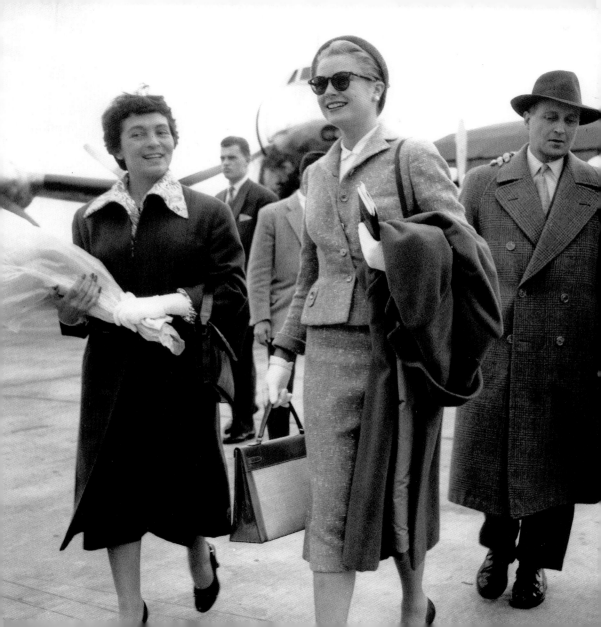

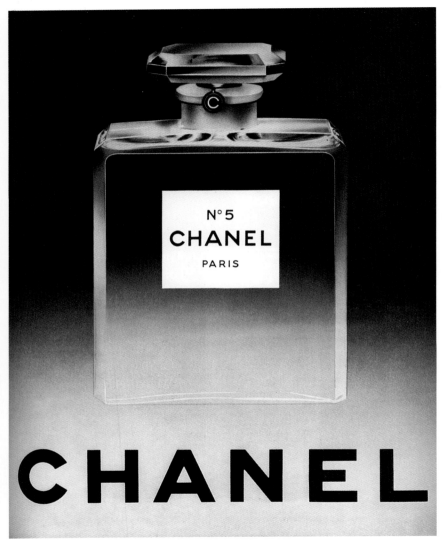

Generally agreed to be the world's most iconic fragrance, No. 5 was Coco Chanel's first perfume, launched in 1921. Created as a sophisticated but feminine floral aldehyde Chanel specifically requested a complex fragrance of its creator Ernest Beaux that 'smells like woman.' From its timeless numeric name to its classic rectangular glass bottle, Chanel No. 5 remains a paragon of the perfume world today. Marilyn Monroe claimed it was all she wore in bed.

A selection of hand bags by the firm Asprey in 1928. Founded in 1781, Asprey received its first Royal Warrant in 1862. Its advertising promised, 'articles of exclusive design and high quality, whether for personal adornment or personal accompaniment and to endow with richness and beauty the table and homes of people of refinement and discernment'.

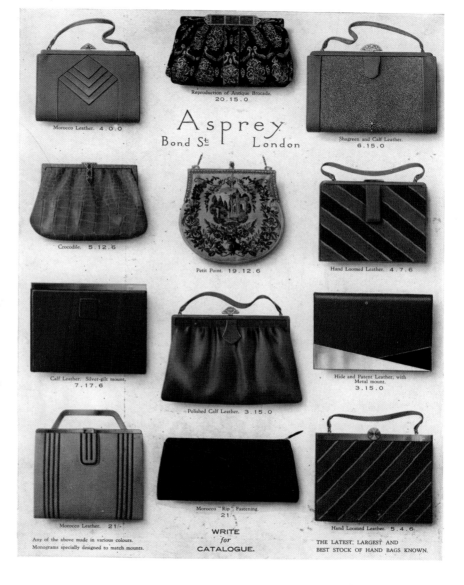

Reproduction of Antique Brocade.
20.15.0

Asprey
Bond St. London

Morocco Leather. 4.0.0

Shagreen and Calf Leather.
6.15.0

Crocodile. 5.12.6

Petit Point. 19.12.6

Hand Loomed Leather. 4.7.6

Calf Leather. Silver-gilt mount.
7.17.6

Polished Calf Leather. 3.15.0

Hide and Patent Leather, with Metal mount.
3.15.0

Morocco Leather. 21/-

Morocco "Rip" Fastening.
21/-

Hand Loomed Leather. 5.4.6

Any of the above made in various colours.
Monograms specially designed to match mounts.

WRITE
for
CATALOGUE.

THE LATEST, LARGEST AND
BEST STOCK OF HAND BAGS KNOWN.

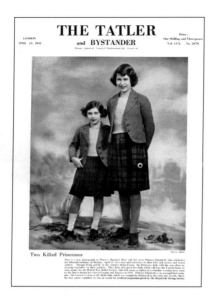

THE TATLER
and BYSTANDER

LONDON
APRIL 23, 1941

Price:
One Shilling and Threepence

Vol. CLX. No. 2078

Two Kilted Princesses

ABOVE: Princesses Elizabeth and Margaret, sporting matching kilts and tweed jackets, photographed around the time of the future Queen's 15th birthday in April 1941.

RIGHT: A smart tailored suit for ladies with a tartan kilted skirt and cheviot coat from Scott Adie's, of Regent Street, London in December 1915, finished with a tam o'shanter in white. Tartan enjoyed huge popularity during the First World War, inspired by the dashing uniforms of the highland regiments. This outfit from December 1915 shows how rapidly skirt hems widened during the war to reflect women's active role in the war effort.

HIGHLAND DRESS

for GIRLS

"The Atholl" outfit as illustrated is as serviceable as it is attractive and comprises Tweed Jacket (which may be supplied in any shade to tone with kilt), Tartan Kilt, Jersey/Blouse, Tie, Stockings, Brogue Shoes and Kilt Pin

The Kilt still retains its charm and usefulness and has an appeal unachieved by any other Juvenile Dress.

Catalogue and self measurement forms on application.

Paisleys LTD.

JAMAICA STREET
GLASGOW, C.1

LEFT: 1956 advertisement for the Atholl outfit – 'as serviceable as it is attractive' comprising a Tweed jacket, tartan kilt, jersey blouse, tie, stockings, brogue shoes and kilt pin. Available from Paisleys Ltd of Glasgow.

BELOW: A little boy dressed in a tartan kilt and velvet jacket rides on a rocking horse. His very smart outfit is completed by an Eton collar, a stiff white collar such as that worn by students at the public school. It was widely worn by young boys during the Edwardian period.

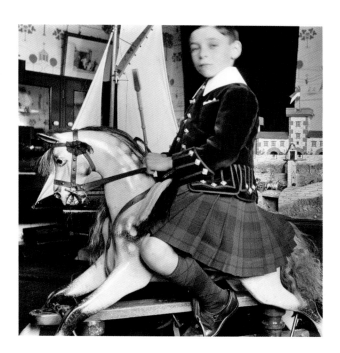

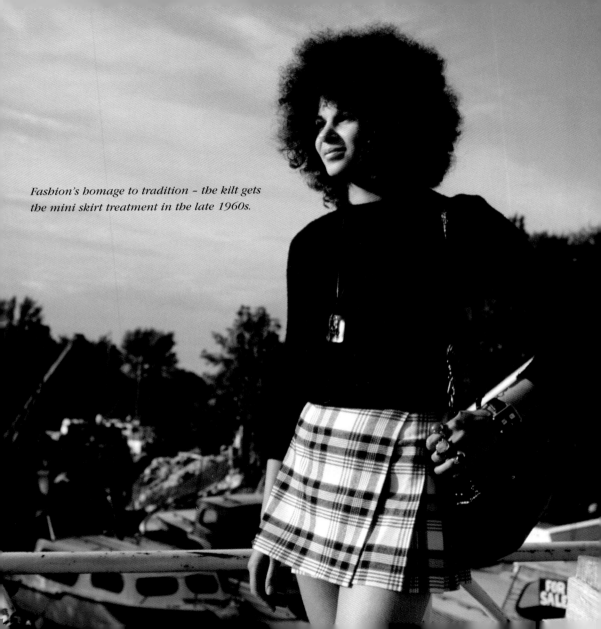

Fashion's homage to tradition – the kilt gets the mini skirt treatment in the late 1960s.

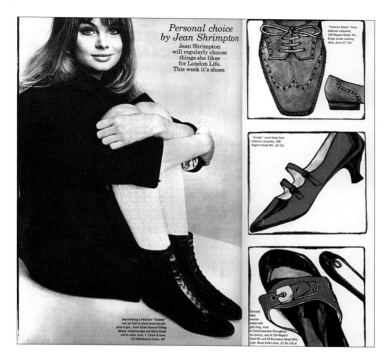

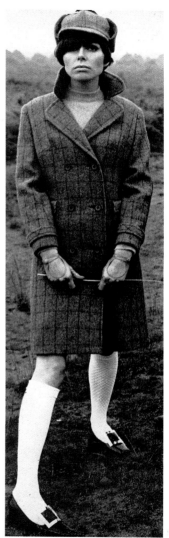

ABOVE: *Spread from the short-lived, but impossibly cool magazine,* London Life, *with a column by sixties supermodel Jean Shrimpton who regularly wrote about the clothes she liked. For the first issue, Shrimpton selected some classic shoes including some Gucci two tone pumps (top right), suede brogues and some Scholl sandals drawn by Barney Wan.*

RIGHT: *Inspiration from countryside tradition. A double-breasted Tattersall checked Harris Tweed coat with flap pockets by Mark Russell, with matching deerstalker hat. The black patent silver buckled shoes are by Charles Jourdan – another fashion classic.*

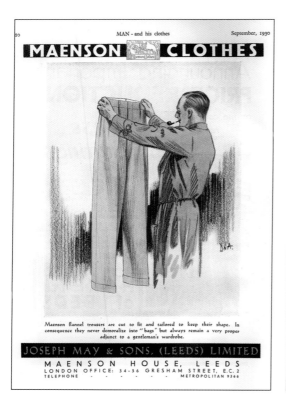

MAENSON CLOTHES

Maenson flannel trousers are cut to fit and tailored to keep their shape. In consequence they never demoralize into "bags" but always remain a very proper adjunct to a gentleman's wardrobe.

JOSEPH MAY & SONS, (LEEDS) LIMITED

MAENSON HOUSE, LEEDS
LONDON OFFICE: 34-36 GRESHAM STREET, E.C. 2
TELEPHONE - - - - - METROPOLITAN 9366

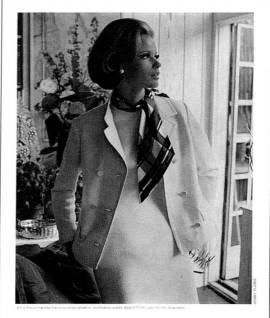

She doesn't give a damn what she wears

as long as it's

Susan Small

ABOVE: 1930 Advertisement for Maenson flannel trousers, 'cut to fit and tailored to keep their shape. In consequence they never demoralise into "bags" but always remain a very proper adjunct to the gentleman's wardrobe.' The importance of well-made, quality garments is at the heart of classic dressing.

ABOVE: 1965 Advertisement for the fashion house, Susan Small, featuring a model wearing a dress and jacket in fine worsted twill with a scarf tied around her neck. A successful ready-to-wear label since the early 1940s, Susan Small specialized in well-cut classics with a twist. Their head designer, Maureen Baker would go on to design Princess Anne's wedding gown for her 1973 marriage to Captain Mark Phillips.

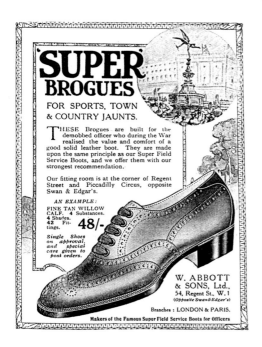

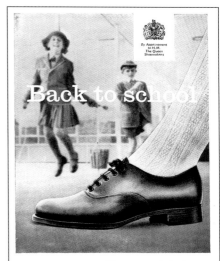

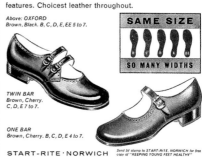

ABOVE: Advertisement for 'super' brogues 'for sports, town and country jaunts'. Built by W. Abbott and Sons Ltd for the demobbed officer who, 'during the war realised the value and comfort of a good solid leather boot.' The brogue shoe has enjoyed repeated revivals in the decades since this 1919 advertisement.

RIGHT: Advertisement from 1961 for Start-rite shoes of Norwich, the choice of classic shoe for children (the one bar style seen at the bottom of this advert is still being sold in various colours today). Priding themselves on fit, the leather shoes were, and are, available in a number of width fittings.

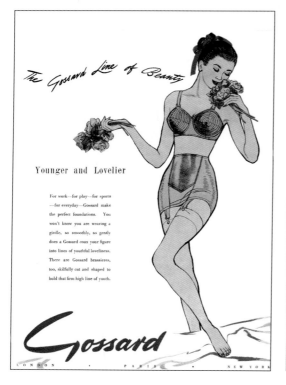

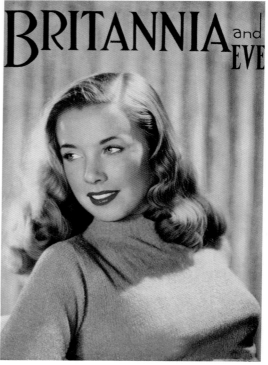

ABOVE LEFT: Gossard advertisement from 1948 for underwear to coax your curves into 'lines of youthful loveliness'. The circular spoke stitching was typical of the bullet bra, giving ultimate bust uplift and creating the perfect figure underneath sweaters.

ABOVE RIGHT: Front cover of Britannia and Eve magazine from February 1951 with a model sporting the classic 'sweater girl' look. First attributed to the actress Lana Turner in the film, 'They Won't Forget', the figure-hugging fashion was sported by screen sirens such as Marilyn Monroe and Jane Russell, and was characterised by a tight fitting sweater worn over a torpedo shaped bust, as formed by a bullet style bra.

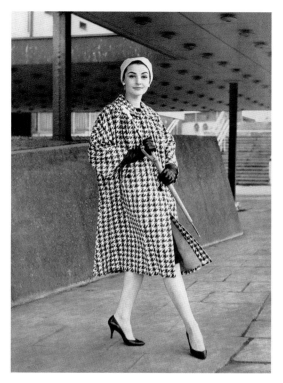

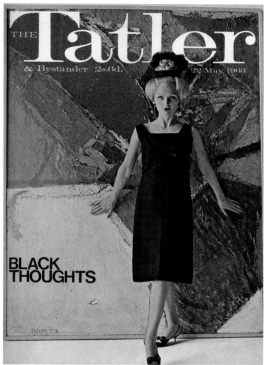

ABOVE: From practical beginings, by mid-20th century, Burberry was a stylish and sensible choice for women's outerwear as proven by this French cotton coat printed in large black and white houndstooth design, fully shower proof and lined with cherry taffeta. The collarless neckline and and three quarter sleeves 'make it a smart choice for town' declared The Tatler.

ABOVE: The invention of the 'little black dress' is attributed to Coco Chanel, and this democratic piece of evening wear has been the touchstone of elegant evening wear since the 1920s. This cover of The Tatler from 1963 features a simple black shift by Belville and Cie, worn with a made-to-measure osprey plume and Charles Jourdan sling back kitten heels.

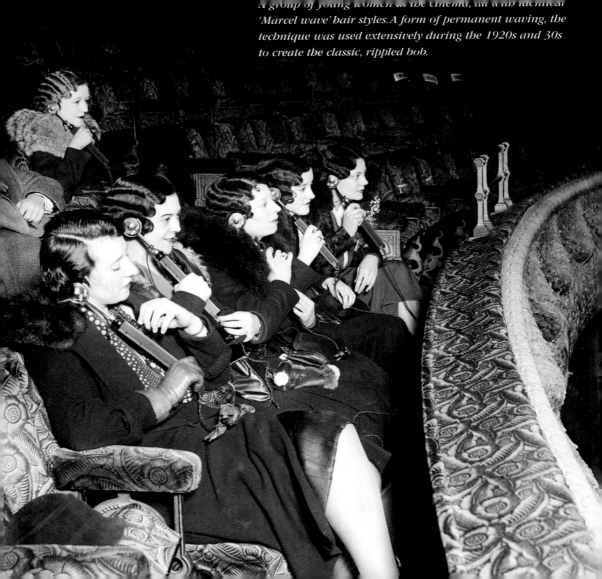

A group of young women at the cinema, all with fashionable 'Marcel wave' hair styles. A form of permanent waving, the technique was used extensively during the 1920s and 30s to create the classic, rippled bob.

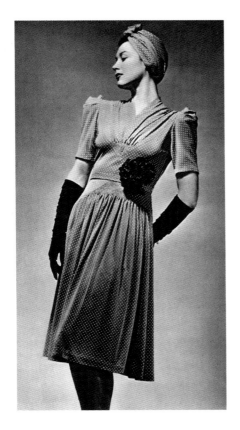

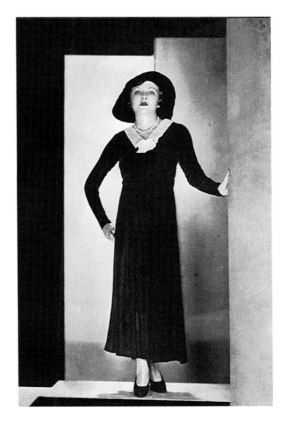

ABOVE LEFT: A classic 1940s knee-length dress in a grey and white spotted fabric, worn with a matching turban and black gloves. The style, often called a 'tea dress' today, has inspired numerous copies by high street retailers.

ABOVE RIGHT: An outfit by Jean Patou called *'Castiglione' in black velvet, 'daringly reminiscent with its high waistline, long skirt, tight-fitting sleeves and wide-brimmed hat.' Presumably inspired by the Countess of Castiglione, mistress of Napoleon III. Black has been a perenially chic choice for day or evening dresses throughout most of the 20th century.*

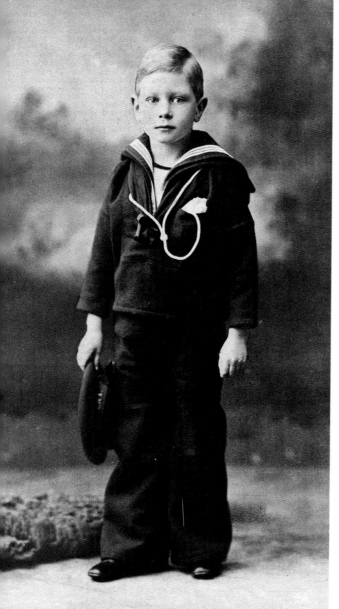

ROWE

Sailor Suits

for

Winter Wear

There's a Rowe Sailor Suit for chilly weather—of real Naval Serge, irreproachably tailored, correct in fit, authentic in style and detail—in a word all that goes to make the miniature Jack Tar.

When you buy a Rowe Outfit you can obtain "spare parts" from any Rowe Agent; with a definite certainty of fit and match, and at a fixed price.

Rowe *of Gosport*

78, High Street,
GOSPORT

106, New Bond Street,
LONDON, W. 1

Rowe—Boys' Tailor to Her Majesty the Queen

LEFT: *The future King George VI in a sailor suit, c.1900.*

ABOVE: *First popularised by the royal family, the sailor suit was a classic choice for little boys throughout the 19th and early 20th century. This 1919 version, by children's outfitters, Rowe, ('Boys' Tailor to Her Majesty the Queen'), is made up in navy serge for warm winter wear.*

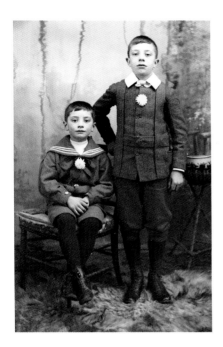

ABOVE: Two boys from the Edwardian era sporting two of its most popular styles for children – the sailor suit and the Norfolk jacket (right).

RIGHT: Young boy in a sailor suit wearing a cap from HMS Orion, a dreadnought that took part in the Battle of Jutland in 1916.

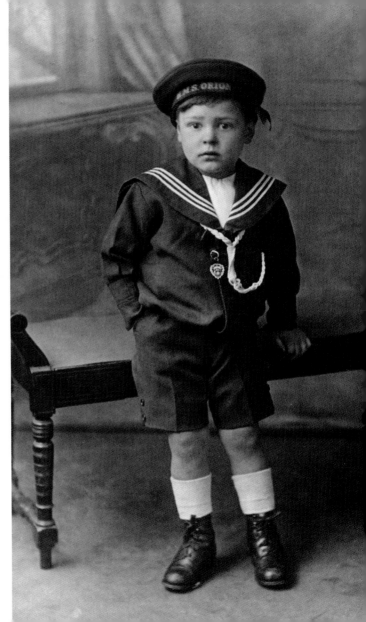

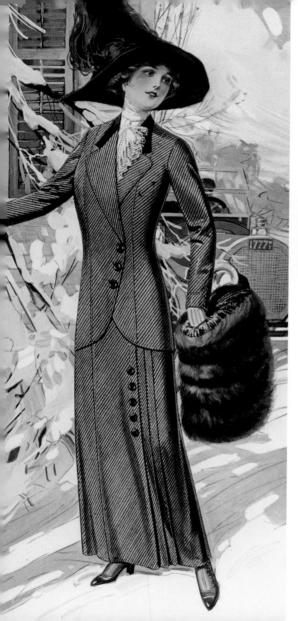

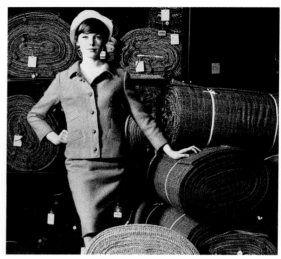

LEFT: Tailor-made suit, c.1910 featuring button detailing, box pleated skirt and long line jacket with velvet collar & western style pocket, a blouse with lace jabot, broad brimmed hat and fur muff. The 'tailor-made' – a matching tailored jacket and skirt for women – had a long history dating back to the 1860s, and was generally made up in sturdy fabrics such as tweed or serge. It offered women a practical way of smart daily dressing, without ostentation.

ABOVE: The 'tailor-made' updated. Model wearing a Jaeger wool suit worn with a sleeveless white wool sweater and white linen hat. She is posed in the stock order department at Dormeuil, London, woollen merchants for 150 years.

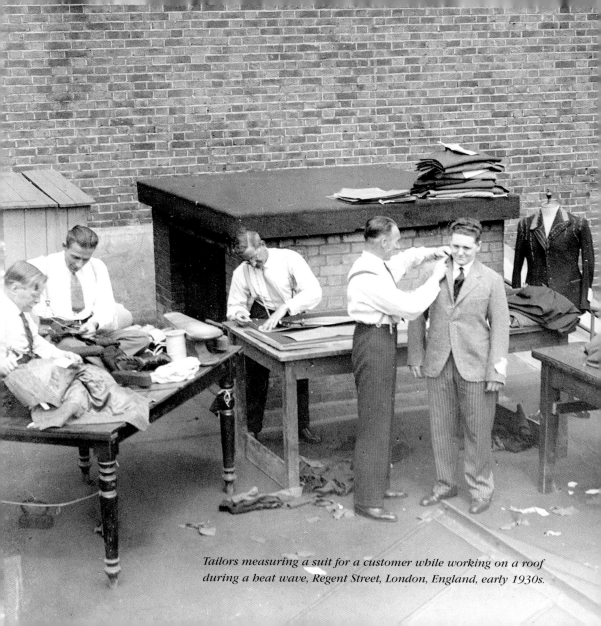

Tailors measuring a suit for a customer while working on a roof during a heat wave, Regent Street, London, England, early 1930s.

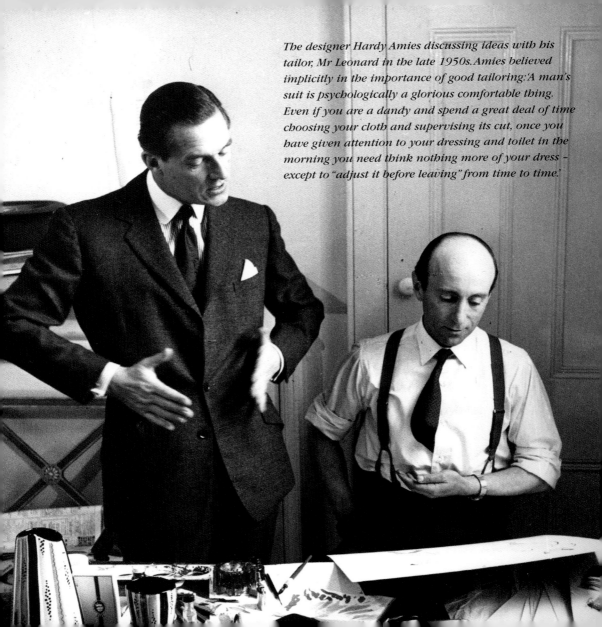

The designer Hardy Amies discussing ideas with his tailor, Mr Leonard in the late 1950s. Amies believed implicitly in the importance of good tailoring: 'A man's suit is psychologically a glorious comfortable thing. Even if you are a dandy and spend a great deal of time choosing your cloth and supervising its cut, once you have given attention to your dressing and toilet in the morning you need think nothing more of your dress – except to "adjust it before leaving" from time to time.'

ABOVE: Tailors working in Savile Row in the 1970s. Prices for a bespoke Savile Row suit today start from around £3000 to £4000.

RIGHT: Prince George, later Duke of Kent (1902–1942), pictured wearing a smart, double-breasted suit in a brown mixture cheviot with a bold twill ground and large overcheck of a lighter shade. Featured in the 1930s trade magazine, Man and his Clothes *which was prescriptive about men's tailoring. A 1930 issue advises that a man should always ensure the top button of his suit was undone and the 'seat of the trousers covered'.*

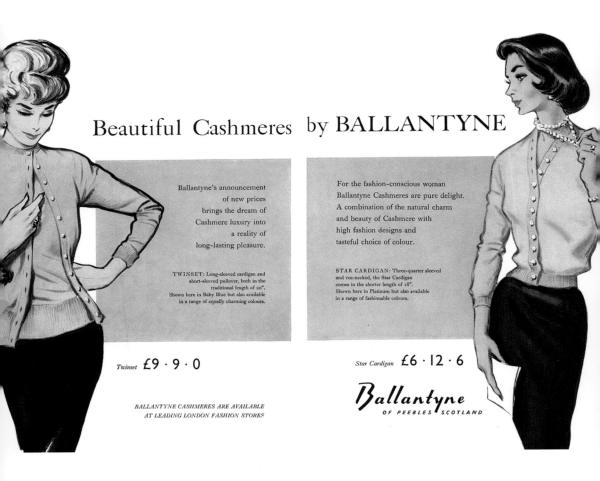

Beautiful Cashmeres by BALLANTYNE

Ballantyne's announcement
of new prices
brings the dream of
Cashmere luxury into
a reality of
long-lasting pleasure.

TWINSET: Long-sleeved cardigan and
short-sleeved pullover, both in the
traditional length of 20".
Shown here in Baby Blue but also available
in a range of equally charming colours.

Twinset **£9 · 9 · 0**

BALLANTYNE CASHMERES ARE AVAILABLE
AT LEADING LONDON FASHION STORES

For the fashion-conscious woman
Ballantyne Cashmeres are pure delight.
A combination of the natural charm
and beauty of Cashmere with
high fashion designs and
tasteful choice of colour.

STAR CARDIGAN: Three-quarter sleeved
and vee-necked, the Star Cardigan
comes in the shorter length of 18".
Shown here in Platinum but also available
in a range of fashionable colours.

Star Cardigan **£6 · 12 · 6**

Ballantyne
OF PEEBLES SCOTLAND

1959 advertisement for luxurious but affordable cashmere from Ballantyne of Peebles in Scotland featuring a twinset in baby blue and a star cardigan in platinum. Worn with pearls of course.

RIGHT: A model wearing cashmere knitwear by Pringle of Scotland, the classic knitwear brand. The intarsia-patterned sleeveless sweater in pineapple and white is teamed with a classic pineapple cardigan. Worn with a Terylene and worsted skirt by Daks. Photographed at Rayne's shoe factory, 1965.

BELOW: Advertisement for cashmere womenswear from Simpson of Piccadilly, modelled by Jean Shrimpton, November 1965.

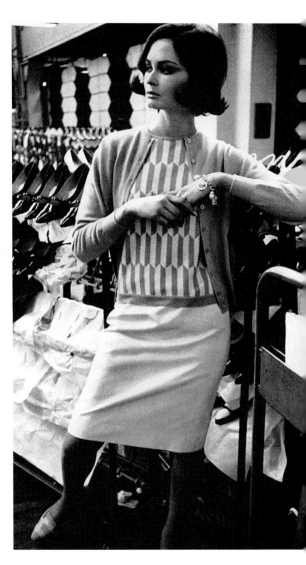

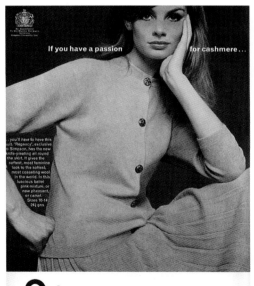

If you have a passion for cashmere...

...you'll have to have this suit. 'Regency', exclusive to Simpson, has the new knife-pleating all round the skirt. It gives the softest, most feminine look to the softest, most caressing wool in the world. In this luscious ballet pink mixture, or new pheasant, or camel. Sizes 10-14 24½ gns.

Simpson
PICCADILLY

Simpson (Piccadilly) Ltd London W1 REgent 2002

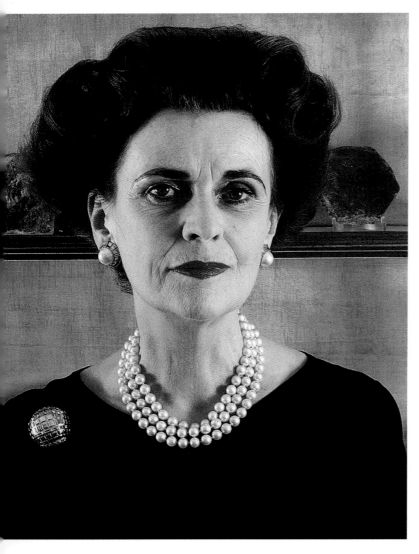

Margaret, Duchess of Argyll, born Ethel Margaret Whigham) (1912–1993), a notorious British socialite, infamous for her marriage and subsequent divorce to Ian Campbell, 11th Duke of Argyll. As a young woman, she was a celebrated society figure and clotheshorse, helping to launch the careers of Norman Hartnell and Victor Stiebel through her patronage. Pictured in 1980 still exhibiting classic style, notably in her three strand pearl necklace.

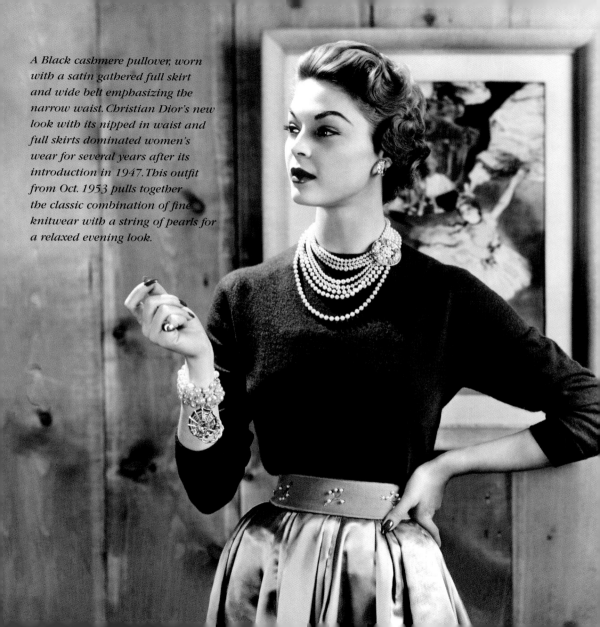

A Black cashmere pullover, worn with a satin gathered full skirt and wide belt emphasizing the narrow waist. Christian Dior's new look with its nipped in waist and full skirts dominated women's wear for several years after its introduction in 1947. This outfit from Oct. 1953 pulls together the classic combination of fine knitwear with a string of pearls for a relaxed evening look.

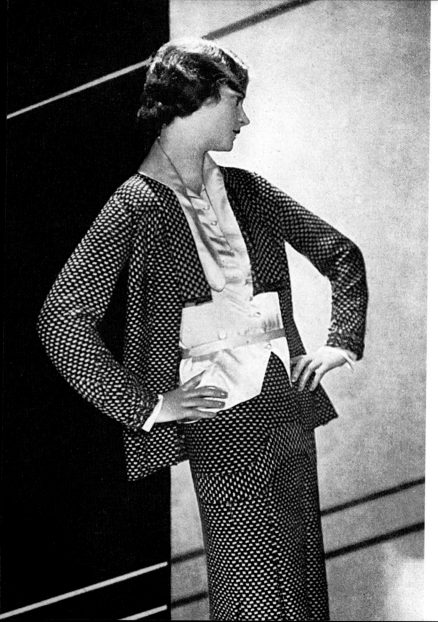

A black and white tweed suit in Chanel's inimitable manner, with fitted hips and pleated skirt featured in The Bystander magazine in October 1929.

A 1965 Chanel suit in sooty black chenille, the jacket with three high buttons and a wrap across skirt. The blouse is of pintucked white satin with a floppy black satin bow and the jacket cuffs are slit high. Adhering to the Chanel style established back in the 1920s, this 1960s version proves its timelessness.

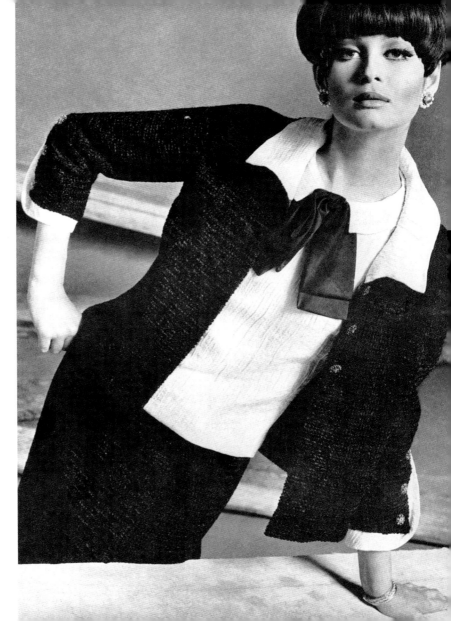

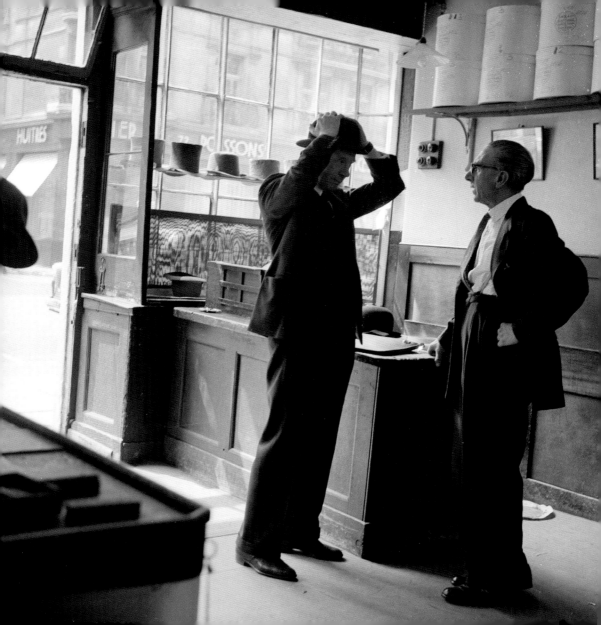

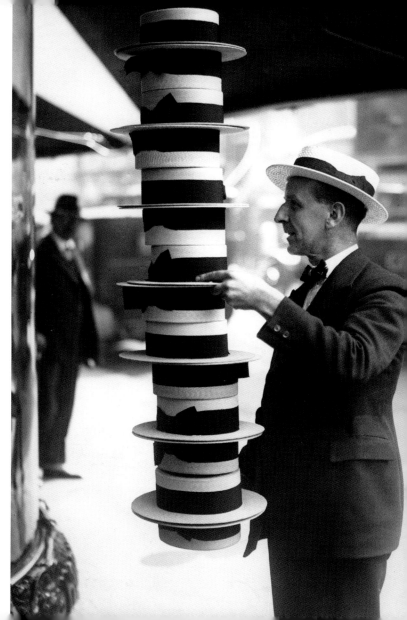

LEFT: A man tries on a bowler hat for size at the traditional hatters, James Lock and Company in St. James, London in the early 1960s. The bowler was invented in the 1850s at the request of a Norfolk landowner who wanted a hat to protect his head from low branches while riding. Manufactured by the Bowler brothers, the hat was a popular choice, being less formal than the top hat and was adopted by all strata of society from gamekeepers and city workers to the trend-setting Prince of Wales.

RIGHT: In the early 20th century, hats were an important element of everyday wear. The straw boater was a popular summer option for men. Here, a hat salesman with a new batch of straw boaters stands outside a hat shop in London in the 1920s – soaring temperatures had boosted the sales of light summer hats.

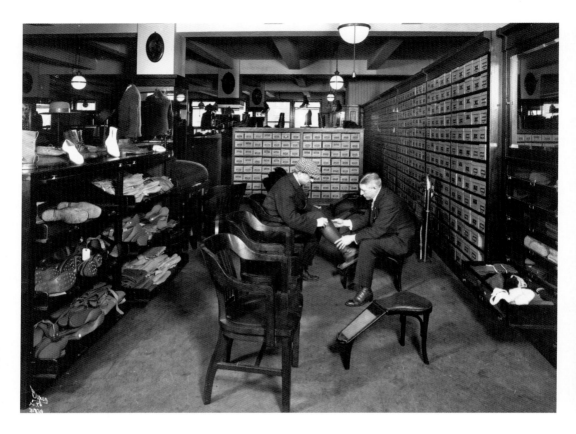

ABOVE: *Abercrombie and Fitch in New York, c. 1913 showing a customer being fitted with a pair of riding boots. Originally opened as an upmarket sports goods store, the Abercrombie and Fitch brand today sells smart leisure clothing to the teenage market.*

OPPOSITE: *Described by* Esquire *magazine as, 'the most beautiful shop in the world', the interior of John Lobb in St. James's in 1973, showing sparkling display cabinets of boots, shoes and spurs. The firm currently holds two Royal warrants and has been supplying the finest handmade shoes for 150 years.*

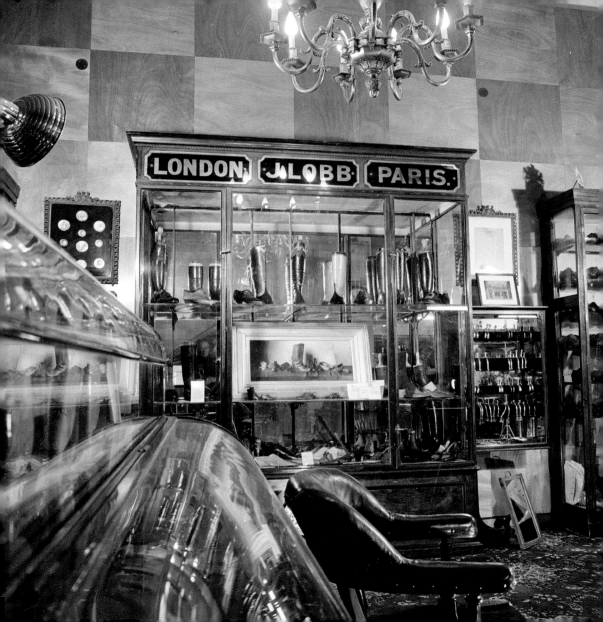

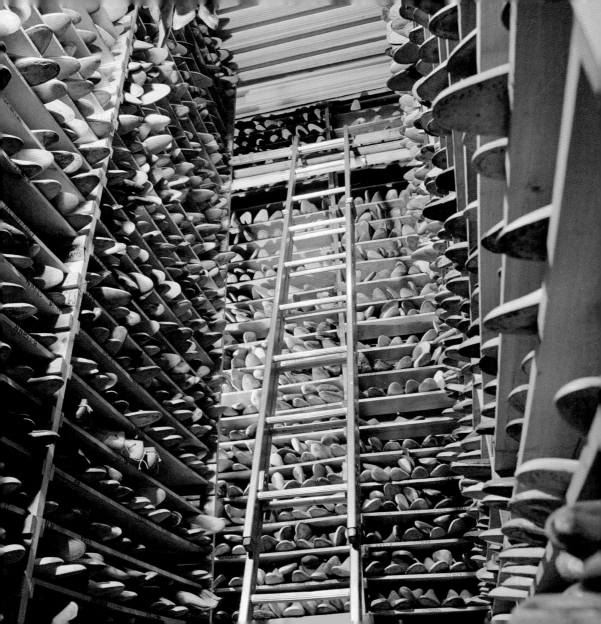

*OPPOSITE: Shelves
of shoe lasts
(wooden models
based on precise
foot measurements)
arranged in order of
customers' names at
John Lobb.*

*RIGHT: The archetypal
Frenchman wearing
a traditional beret.
Emblematic of the
French nation, the hat
has been adopted and
adapted as a classic in
the world of fashion.*

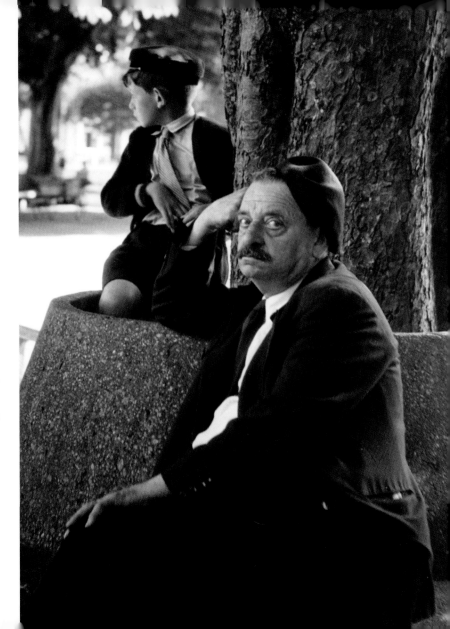

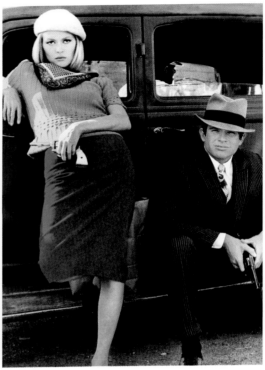

ABOVE: A red beret worn at a jaunty angle in this 1933 advertisement for Carreras cigarettes.

ABOVE: For the 1967 film, Bonnie and Clyde, Faye Dunaway's costumes gave the world a modern take on 1930s style. Central to the look was the beret she wore over her blonde shoulder-length hair.

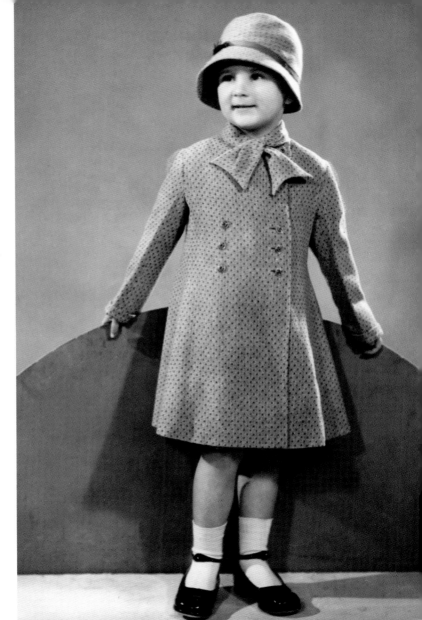

Princess style spring coat for a little girl, double-breasted with a scarf collar, tailored at the waist and with a full, flared skirt, early 1930s.

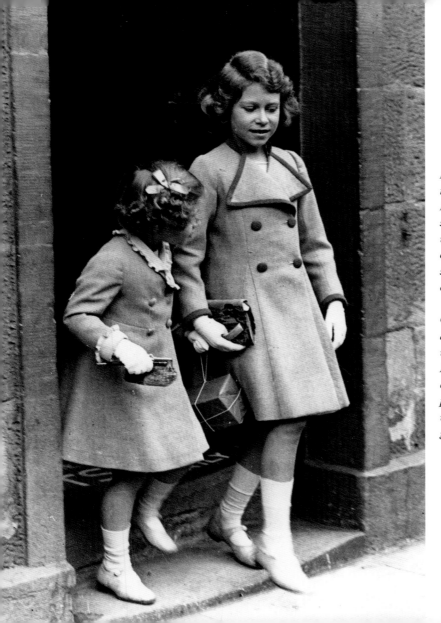

Princess Elizabeth, the future Queen Elizabeth II, and her sister Princess Margaret wearing the classic coats that became a staple in the wardrobes of many little girls.

OPPOSITE PAGE: Mother and her two daughters waiting at a bus stop in Maida Vale, London W9 c. 1950. Note the smart, pastel coloured coats worn by the two little girls.

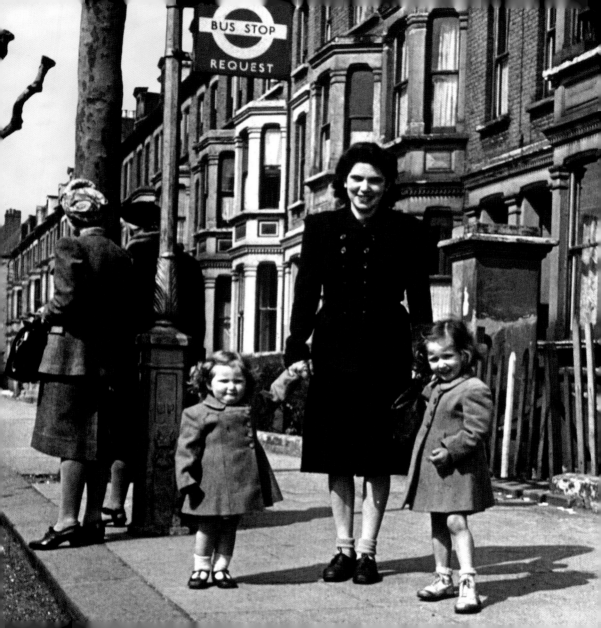

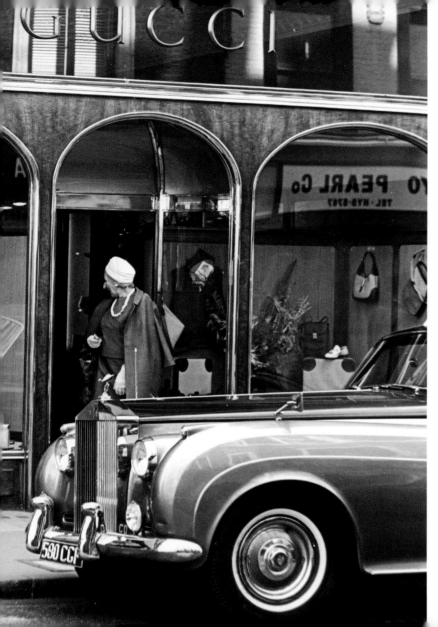

A smartly-dressed lady in turban, pearls and gloves, leaves the Gucci shop in Bond Street to step into her waiting Rolls Royce parked outside. Gucci, one of the most desirable luxury brands of the 21st century, began in Florence in 1921. It opened its London branch during a period of rapid expansion in the 1960s.

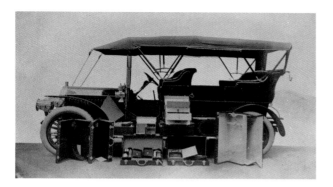

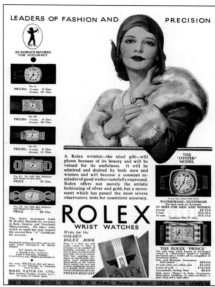

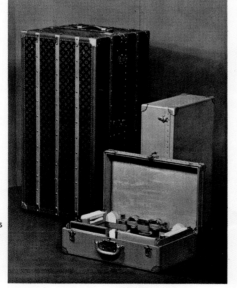

NÉCESSAIRES
VALISES
MALLES
ET
TOUS
ARTICLES
DE VOYAGE
CHEZ

LOUIS VUITTON
70, CHAMPS-ÉLYSÉES, PARIS
NICE – VICHY – LONDON

LEFT TOP: Louis Vuitton trunks and suitcases arranged in front of an early motor car in 1905. In the 21st century, Louis Vuitton is one of the world's most valuable fashion brands.

LEFT BOTTOM: Advertisement for Louis Vuitton luggage, 1935.

ABOVE: 1930 advertisement for the prestigious luxury brand of watches by Rolex, 'leaders of fashion and precision', featuring an elegant lady distractedly caressing the time piece on her wrist.

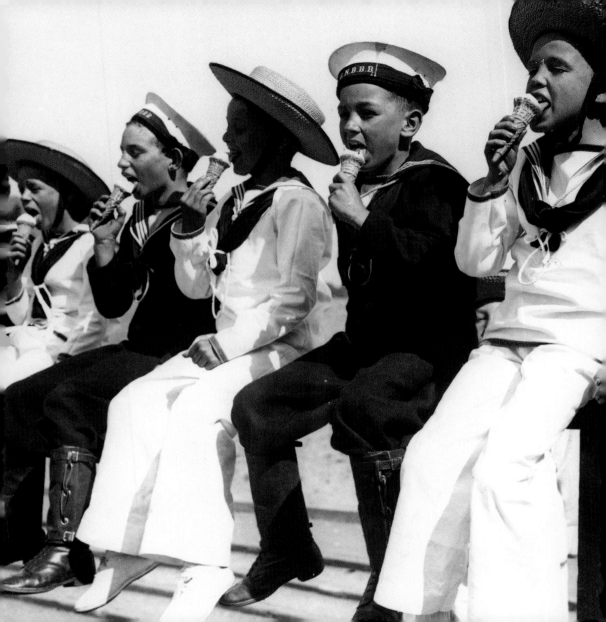

OPPOSITE PAGE: Children in sailor suits eating ice-cream, c.1930.

ABOVE: Five little boys clad entirely in Western style denim jeans and jackets, 1950s.

RIGHT: In 1956, Levis decided to give their denim jeans an update and launched the Elvis Presley jean in black, as worn by the King in the movie, 'Jailhouse Rock'. Jeans and denim have undergone endless overhauls and re-inventions since.

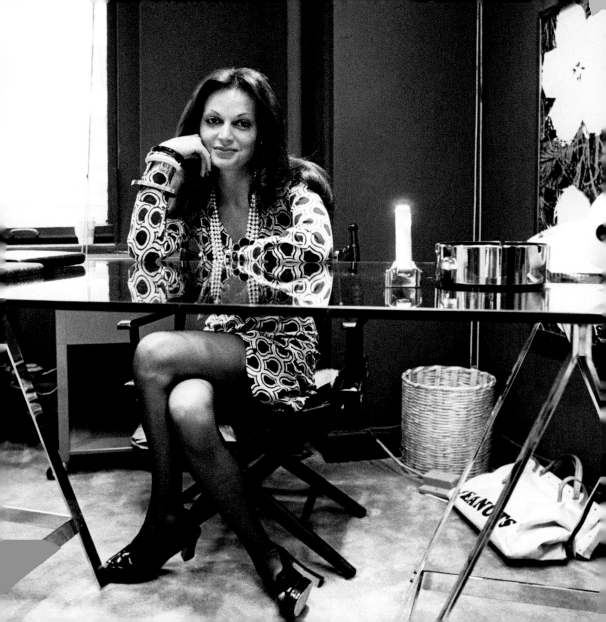

OPPOSITE: Diane von Furstenberg pictured in her New York office in the 1970s. In 1974, Furstenberg launched the jersey wrap dress, cornering the market in easy and flattering sophisticated dressing. Re-launched in 1997, the wrap dress has become a covetable classic.

RIGHT: Graphic illustration by Anne Zielinski-Old, from 1985 for the famous 501 jeans by Levis Strauss. The classic brand with the distinctive red tab on the rear pocket had a renaissance in the 1980s following a hugely successful marketing campaign. Levis TV adverts married classic tracks with nostalgic scenarios, the most famous of which featured male model Nick Kamen stripping down to his boxer shorts in a 1950s launderette to the tune of Marvin Gaye's 'I Heard It Through the Grapevine'.

Everyday Fashion

'Anyone can get dressed up and glamorous, but it is how people dress in their days off that are the most intriguing.' Alexander Wang

Since the advent of photography, it has been the preference of sitters to be captured for posterity looking their best. Weddings, special occasions, or a specific trip to the photographer's studio tend to show us at our most preened and perfect, but not, necessarily, as our most familiar selves. What we choose or are expected to wear on the other, more ordinary days of the year is a more honest reflection of personality, status, taste and vocation. Fashion historian Elizabeth Wilson quotes a nineteenth century servant, Hannah Cullwick who recounted the comments of a photographer who took her photograph. He claimed of the female workers he photographed that: 'So very few care for pictures in their working dress – they all want to be as smart as can be. I ax'd him about pitgirls' likeness, but he said, 'La' bless you, I couldn't get 'em in their right dress – they're as fine as anybody, drest up.'

Fortunately, there were some pit girls willing to pose in their work clothes, and indeed, there is an example included in this chapter. There are other 'uniforms' too, from a bowler-hatted city gent to the housewife in her perennial floral apron. There are urbane chaps relaxing at home in their smoking jackets, and ladies out shopping in their curlers; men seated in deckchairs at the seaside wearing full three-piece suits and little boys wearing shorts in all kinds of weather. Each contrast is evidence of the oddly prosaic diversity in the art of everyday dressing. My own late grandfather, who spent a vast proportion of his retirement working away on his vegetable garden, did so attired in a shirt and two piece suit, albeit an old one. He would hang his jacket on his garden fork when temperatures got a little muggy, and it is only on reflection that I wonder why he did not wear something more casual or workmanlike in which to dig and hoe. But he was not unusual among men of his generation who spent the majority of their lives in shirt, tie and jacket, whatever the activity.

Everyday dressing does not necessarily equate to careless or shabby. Manual workers might strike a grimy appearance, or need overalls to protect their own clothes underneath, but the majority of our ancestors looked far smarter as they went about their daily lives than we do today. Before the advent of

OPPOSITE: The 1950s shirtwaist, or shirtwaister dress with its nipped in waist and full skirt became the go-to garment for the brisk and breezy housewife of the decade.

mass-produced clothing, garments were carefully looked after to extend their longevity and those who could afford to invest in quality sensibly understood its long-term benefits. Until the 1960s ushered in a new informality, many women continued to wear a hat if out shopping. Even during rationing of the Second World War, the sharp skirt suit, pioneered by the former MGM costume designer Adrian in America, and by several British designers such as Digby Morton in Britain, kept up a very high standard of appearances. Dressing well but frugally in wartime was seen a patriotic duty, a belief fostered by Winston Churchill himself, and a utility range of clothing designed by a coterie of British design's big-hitters Hardy Amies, Edward Molyneux and Norman Hartnell made chic and practical clothes within the reach of many. Utility clothes were price-controlled, exempt from purchase tax and made in accordance with the specifications laid down by the Board of Trade, but skilful and streamlined designs in a variety of enticing colours and patterns earned plaudits among fashion writers and the public alike.

These were designers too; who forged a way for everyone to enjoy their clothes. Hardy Amies in particular was a pioneer in the ready-to-wear market. He designed successful diffusion lines for Hepworths, the country's leading mens' tailoring firm, and licensed his designs for sewing patterns distributed through popular women's magazines. It was the kind of dissemination that allowed everyone to own a little piece of designer fashion. Clothing in the post-war era continued to become more democratic as mass production brought a cheaper, wider variety of garments to shoppers. Fashion in magazines might still be aspirational and beyond the purse of most, but accessible versions of clothes inspired by the design houses of Paris, London and New York were becoming increasingly available at all price points. American designer Clare McCardell always claimed she designed clothes she liked to wear herself and was pleasantly surprised to discover that other women wanted them to wear them too. Her clean-cut, easy-to-wear style, epitomised by the classic belted shirtwaister dress was a look that was not only easily copied, but was also a truly wearable style for ordinary women wanting to look fresh, smart and current as they went about their daily lives. 1950s fashion worshipped women's curves but ensured they were clad in something wholesome and practical. With nipped in waists and abundant skirts, often protected by a crisp, frilly apron, these were clothes made for domestic goddesses.

New manmade fibres were making clothes not only affordable, but also easier to care for, offering alternatives to expensive, delicate or simply unobtainable textiles. In January 1941, Vogue ran a feature heralding the imminent arrival of rayon stockings in Britain, an inferior option compared to silk and nylon but in the absence of either of the latter; they at least avoided the painting of legs with gravy browning. Over the next two decades, there was an increase in fabrics that came with exotic, scientific brand names such as Terylene, Bri-Nylon and Celanese, all with magical shape retaining and drip-dry properties that

would make day to day living easier. Artificial fibres were ideally suited to lingerie and nightwear, with Celanese negligees injecting a little glamour into bedtime, and nylon foundation garments smoothing tummies or lifting and separating busts in order to mould figures to current fashions.

As the decades pass, the definition of everyday dressing becomes more intangible. By the 1960s and 70s, it might mean striding down a high street sporting a thigh high mini skirt, going out in a floral anorak, hot pants, flared jeans, a jump-suit, a Crimplene dress or relaxing at home in capri pants and a sloppy sweater or a printed kaftan. It might equally mean, for less fashion-conscious types, wearing the same suit to work every day, or donning a fifteen year old overcoat and headscarf to catch a bus to the other side of town. The march of children's fashion is considerably less rapid. School uniforms change little from the 1920s to the 1960s, and it was not unusual for children to wear their school blazers on holidays or outings with parents. The imminent arrival of a baby has continued to prompt expectant mothers (and grandmothers) to reach for knitting patterns and generations of babies have spent their first few months dressed in hand knitted matinee jackets, cardigans and bonnets. It is fascinating to note the advertisements for maternity fashion from the 1920s and 30s, showing illustrations of slim women whose happy state is barely discernible. Fast forward to the 1960s and retailers in London such as Motherhood or Elegance Maternelle were selling clothes that recognised a growing bump was something to be celebrated and adequately accommodated rather than discreetly disguised.

Worn frequently and often worn out, we are far less likely to keep the everyday clothes that see us through daily life. Most women will have their old wedding dress hanging up at the back of a wardrobe, but are less sentimental about a trusty dress worn for work, or a winter coat that is no longer in fashion. They become destined for charity shops or recycling, yet these are the clothes that have been part of us and part of who we are. Pick up an old family photograph album, and the rush of nostalgia felt while turning its pages will, in no small part, be down to that sudden exposure to those clothes that you had perhaps forgotten, but now remember with a newly discovered fondness.

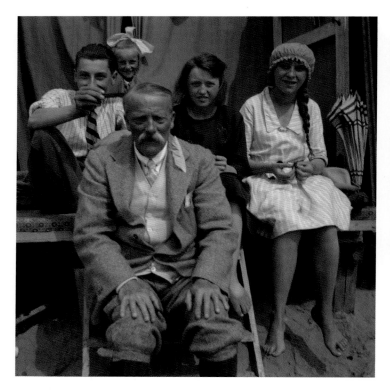

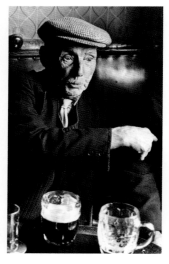

ABOVE: Man with his pint in a Birmingham pub by Roger Mayne, 1964. The flat cap was once ubiquitous, worn by the working classes to such an extent it came to be the symbol of a stereotype. Ironically, the wool flat cap fell out of favour with its traditional market and is today more likely to be worn by affluent country dwellers and city hipsters.

ABOVE: Family seated outside a beach hut, c.1925. While it was the vogue during the inter-war years for wealthy followers of fashion to invest in clothes specifically for the beach (see chapter on Sport & Leisure), more ordinary folk wore their usual clothes for a day out at the British seaside, such as this gentleman who sits in the sunshine wearing a full three-piece suit with shirt and tie.

Coupon wizards. Advertisement for British brand Wolsey from 1943, suggesting some economical buys to make ration coupons go further - a shirtwaist dress, sheer stockings and cosy underwear.

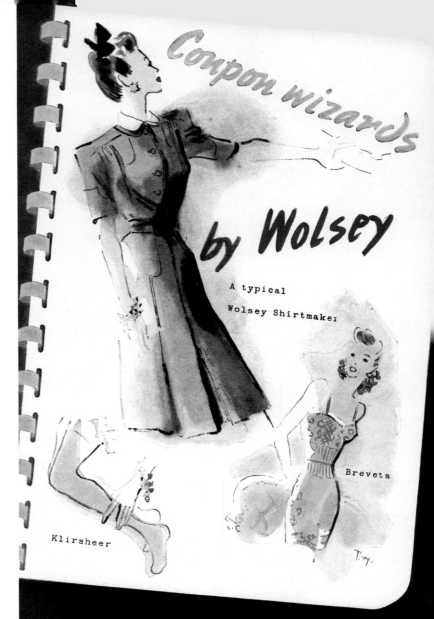

Coupon wizards

by Wolsey

A typical

Wolsey Shirtmaker

Brevets

Klirsheer

LEFT: A coat of soft dove grey piped with scarlet featuring broad shoulders, loose sleeves and useful pockets – part of a number of examples of Utility models exhibition at the International Wool Secretariat in 1942 in order to encourage people to buy Utility clothes.

OPPOSITE LEFT: Utility clothing even extended to lingerie. This advertisement for this Celanese slip in 1943 features the Utility logo in the bottom right corner.

OPPOSITE MIDDLE: Advertisement for a Cordrory House Coat from Swan and Edgar, 1940 – 'a practical garment for any place, anytime, anywhere'. During the Second World War, when many women were engaged in war work, clothing retailers recognised a market for of easy clothes or cover-ups to wear when off-duty.

OPPOSITE RIGHT: A pair of bib and braces (dungarees) for women in navy drill, part of a range of Utility clothing available from Peter Robinson's of Oxford Street in 1943, procured for three coupons.

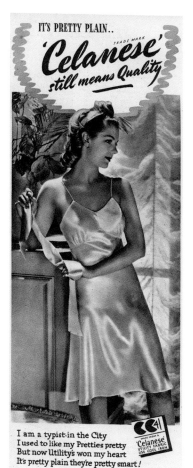

IT'S PRETTY PLAIN..

'Celanese'
still means Quality

I am a typist·in the City
I used to like my Pretties pretty
But now Utility's won my heart
It's pretty plain they're pretty smart!

'Celanese'
UTILITY FABRIC
USA. COOL IRON

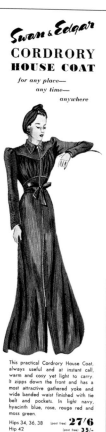

Swan & Edgar

CORDROY
HOUSE COAT

for any place—
any time—
anywhere

This practical Cordroy House Coat,
always useful and at instant call,
warm and cosy yet light to carry.
It zipps down the front and has a
most attractive gathered yoke and
wide banded waist finished with tie
belt and pockets. In light navy,
hyacinth blue, rose, rouge red and
moss green.

Hips 34, 36, 38 (post free) **27/6**
Hip 42 (post free) **35/-**

Order now because prices are rising.
Please state second choice of colour

Dressing Gowns, Third Floor

Swan & Edgar Ltd., Piccadilly Circus, W.1

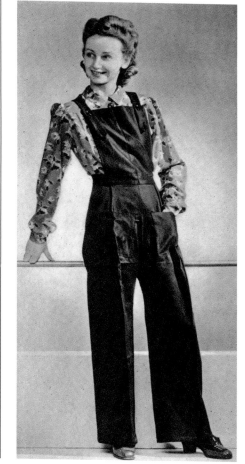

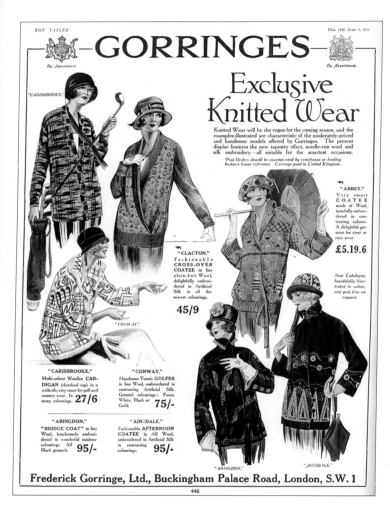

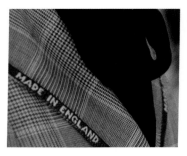

LEFT: 1924 advertisement for Frederick Gorringe of Buckingham Palace Road, London SW1 illustrated with examples of the various knitted items which 'will be in vogue for the winter'.

ABOVE: Hardy Amies' 'Made in England' womens suit, with the printed selvedge trimming the jacket revers, was a witty piece of patriotic design during the Second World War. Worn by the American actress Mildred Shay on a trip a London it is a piece that symbolises British fashion's resolution to keep up appearances and adapt design to wartime conditions.

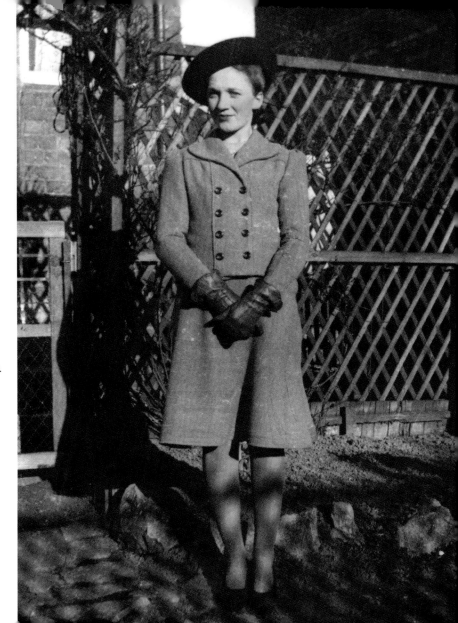

A woman poses by a trellis and arch in a garden wearing a typical 1940s skirt suit, with a double-breasted jacket, leather gloves and hat at a jaunty angle.

LEFT: A 1963 maternity summer dress in black and white paisley printed Boussac cotton, fully lined with a tie belt and shoe string straps from Elegance Maternelle, worn with a large bag and sunglasses by this particularly chic expectant mother.

ABOVE: The smock dress or pinafore was a staple for pregnant women in the 1970s. Body conscious maternity wear in stretchy fabrics did not become fashionable until the 1990s.

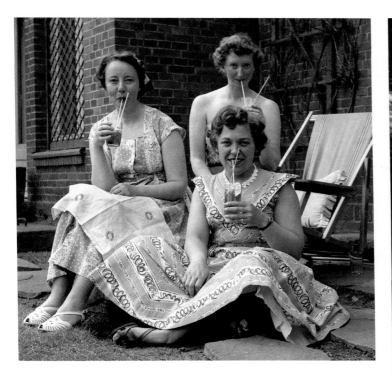

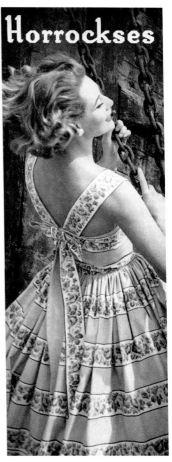

ABOVE AND RIGHT: Horrockses began life as a cotton manufacturer in Preston, Lancashire in England, in 1791. In 1946, it launched a clothing business, Horrockses Fashions, designed in London and manufactured in Preston. Horrockses' frocks were produced in large quantities during the 1950s, when their cotton prints were a perfect fit for the wholesome, feminine aesthetic. Retailing for between £4 and £7, the dresses were considered expensive, and might often be bought for a special occasion before being relegated to more everyday wear.

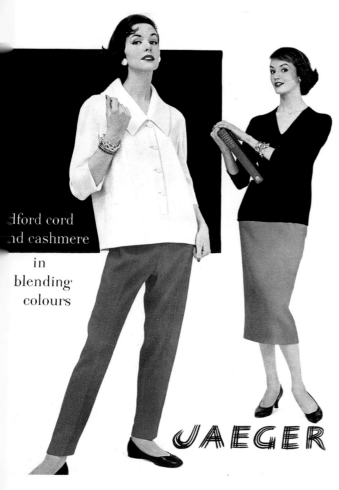

dford cord
nd cashmere

in
blending
colours

JAEGER

LEFT: *Jaeger advertisement from 1956 featuring a classic but casual mix of separates in cashmere and Bedford cord.*

OPPOSITE TOP LEFT: *Easy-care manmade textiles such as Crimplene were a mainstay of 1960s dressing. These monochrome outfits are by Lapidus of Sweden, 1966.*

OPPOSITE BOTTOM LEFT: *A bold-checked nine-tenths coat buttoned with discs of ocean pearl by Pierre Balmain available at Debenhams (Debenham and Freebody) of Wigmore Street, London in 1959. Most leading dress designers offered ready-to-wear collections and many licensed their designs so that cheaper, off-the-peg versions could be found in department stores, allowing women to buy into the designer dream. Photographed in the fabulous apartment of cosmetics magnate Helena Rubinstein on the Quai de Bethune in Paris.*

OPPOSITE RIGHT: *Advertisement for the fragrance Charlie by Revlon, one of the most popular, era-defining scents of the 1970s – an everyday fragrance for women to spritz and go. Its advertisement showing the American model Shelley Hack looking carefree and beaming in a chic boiler suit was just as famous.*

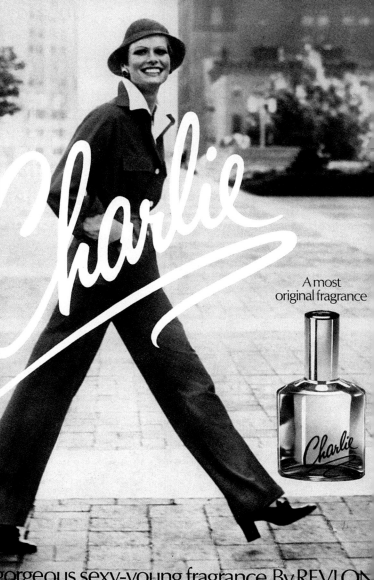

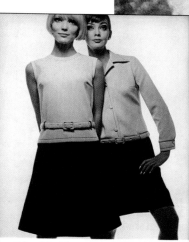

The black and white 'Crimplene' show ⇛

We chose this in Paris

... for its debonair dash ... for the new shoulder-line, dropped from the curve of the horseshoe collar. Bold-checked nine-tenths coat, buttoned with discs of ocean pearl, feature of the Collections. Pictured among treasures in the fabulous apartment of Helena Rubinstein on the Quai de Bethune.

Available from Model Coats towards the end of March.

Photographed especially for Debenhams by Peter Clark

Pierre Balmain at 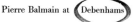 Debenhams

Debenham & Freebody Wigmore Street London W1 Langham 4444

A most
original fragrance

The gorgeous, sexy-young fragrance. By REVLON

Concentrated cologne, concentrated cologne spray, concentrated perfume spray and other original Charlies

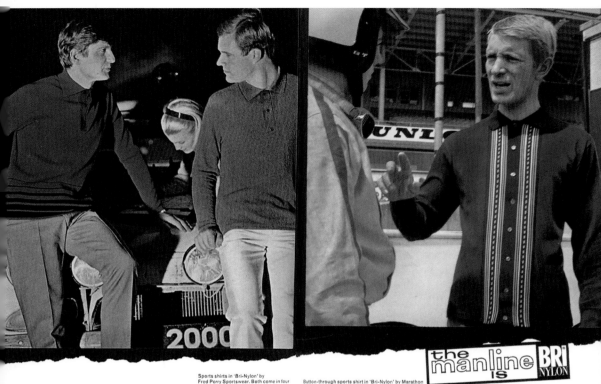

LLY TO GOOD LOOKS -

the manline is BRI NYLON

- MOVE IN TOP GEA

*Advertisement for sports shirts in Bri-Nylon by Fred Perry
Sportswear, and on the right, a button-through sports shirt
in Bri-Nylon by Marathon.*

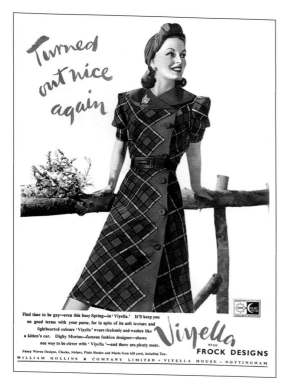

ABOVE: Advertisement for Viyella frocks designed by Digby Morton during the Second World War.

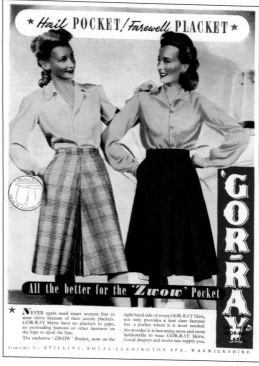

ABOVE: Advertisement for Gor-ray Koneray pocket skirts, 1943. 'Hail pocket! Farewell placket'. Never again need smart women fear to wear skirts because of their untidy plackets. Gor-ray skirts have no plackets to gape.

LEFT: Then as now, fashions looked fabulous when worn by mannequins or drawn by magazine illustrators in the 1920s, but their gamine charm did not always translate well when worn by real women and could appear shapeless and unflattering.

OPPOSITE LEFT: First World War advertisement for clothing from Mrs Oliver Ltd of 39 Old Bond Street, featuring some suggested, 'garments for women who work'. Illustrated is the Olva "Gardacom, a combined skirt and knickers made in workman's jeans or other serviceable washing materials.

OPPOSITE RIGHT: Two female workmates pose outside the factory gates at Burrows & Sturgess soft drinks manufacturer, Frederick Street, Derby in the 1930s. Although they are wearing crossover aprons, their appearance is otherwise smart, with calf-length skirts, heeled shoes and neatly waved hair.

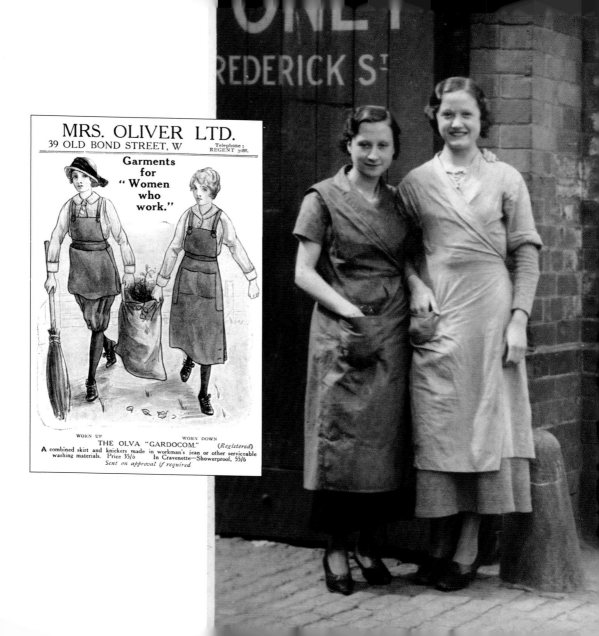

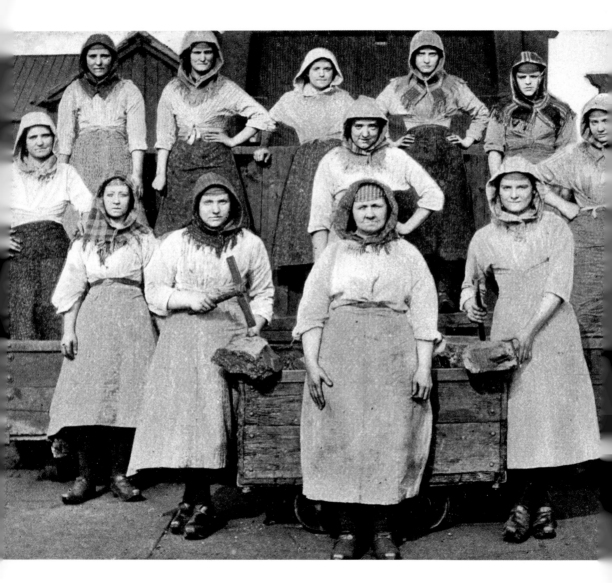

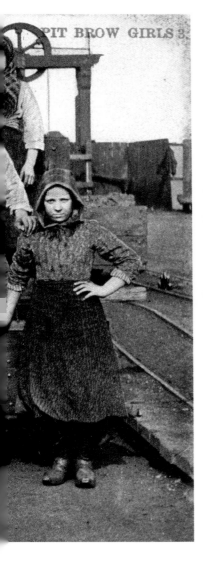

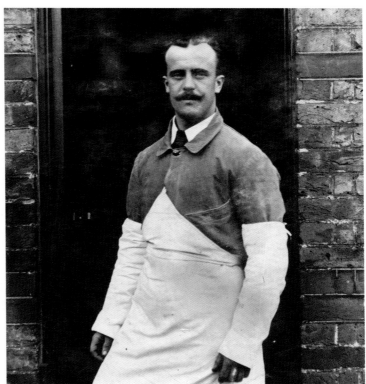

LEFT: Pit Brow lasses, c.1905 whose job was to push wagons from the mineshaft to a stock heap, stack the coal and rake out any stones. The dress of the pit-brow girls and women gave them a distinctive look. Some wore a pair of trousers covered with a skirt, a headscarf to protect their hair from coal dust, and a flannel jacket.

ABOVE: Portrait of a gentleman wearing his civilian working outfit in his job as a butcher on return from the Great War in 1919.

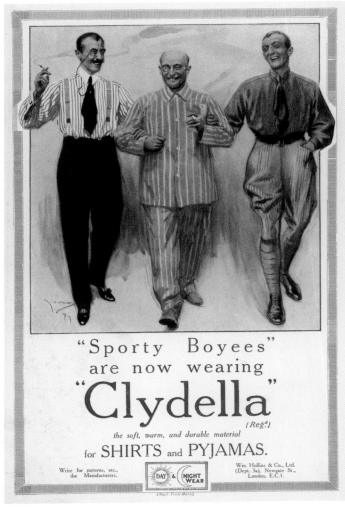

OPPOSITE LEFT: Up until the 1970s, the daily work 'uniform' of the London City gent consisted of bowler hat and a pinstripe suit, such as this one by Hepton's available from the department store Marshall and Snelgrove in 1962.

OPPOSITE RIGHT: Three "sporty boyees" stroll together enjoying the fact that their shirts and pyjamas are made from soft, warm and durable Clydella material. Advertisement in The Bystander *magazine from November 1918.*

RIGHT: Robin knitting pattern for a fetching tank top for the dapper gent in your life c.1955. Just the ticket for a chap to wear at home when relaxing with his pipe.

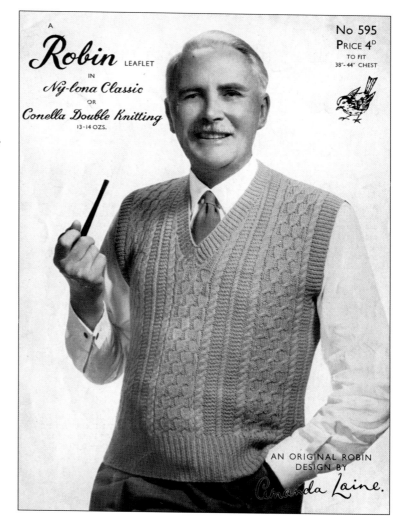

A Robin LEAFLET

IN

Ny-lona Classic

OR

Conella Double Knitting

13-14 OZS.

No 595
PRICE 4D
TO FIT
38"-44" CHEST

AN ORIGINAL ROBIN
DESIGN BY

Amanda Laine.

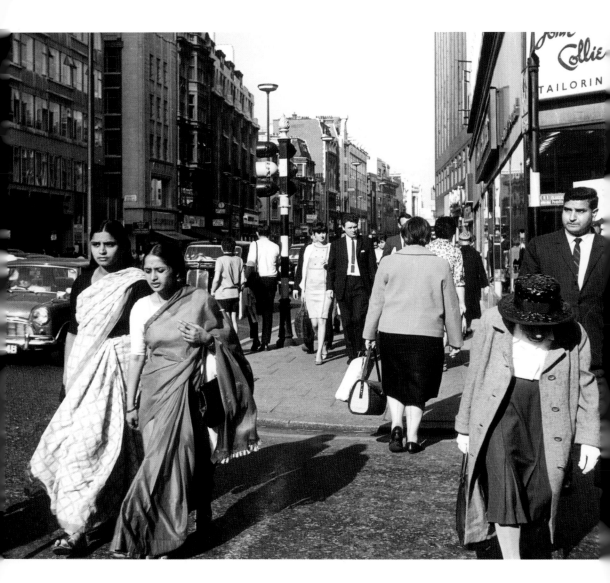

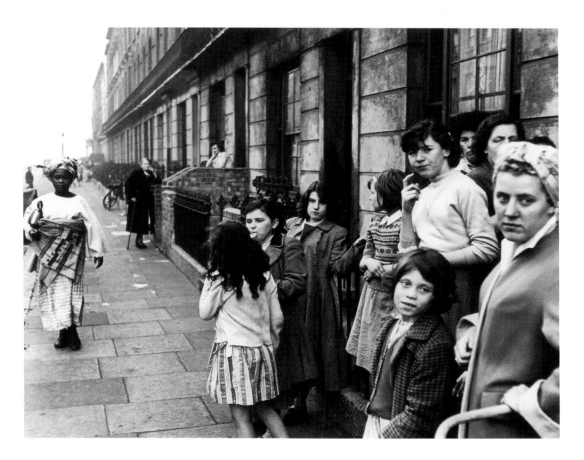

OPPOSITE AND ABOVE: Saris on Oxford Street. Successive waves of immigrants into Britain during the 1950s and 60s introduced ethnic fashions into the urban landscape. They must have seemed an exotic novelty at the time and Roger Mayne's photograph of an African woman in traditional dress passing a group of white working class women conveys this acute contrast in cultures.

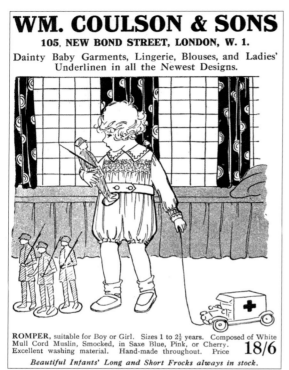

WM. COULSON & SONS

105, NEW BOND STREET, LONDON, W. 1.

Dainty Baby Garments, Lingerie, Blouses, and Ladies' Underlinen in all the Newest Designs.

ROMPER, suitable for Boy or Girl. Sizes 1 to 2½ years. Composed of White Mull Cord Muslin, Smocked, in Saxe Blue, Pink, or Cherry. Excellent washing material. Hand-made throughout. Price **18/6**

Beautiful Infants' Long and Short Frocks always in stock.

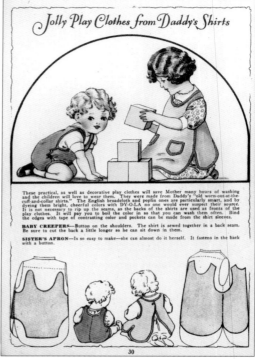

Jolly Play Clothes from Daddy's Shirts

These practical, as well as decorative play clothes will save Mother many hours of washing and the children will love to wear them. They were made from Daddy's "old worn-out-at-the-cuff-and-collar shirts." The English broadcloth and poplin ones are particularly smart, and by dyeing them bright, cheerful colors with DY-O-LA no one would ever suspect their source. It is not necessary to rip up the seams, as the backs of the shirts are used as fronts of the play clothes. It will pay you to boil the color in so that you can wash them often. Bind the edges with tape of contrasting color and pockets can be made from the shirt sleeves.

BABY CREEPERS—Button on the shoulders. The shirt is sewed together in a back seam. Be sure to cut the back a little longer so he can sit down in them.

SISTER'S APRON—Is so easy to make—she can almost do it herself. It fastens in the back with a button.

30

ABOVE: *First World War era advertisement for William Coulson & Sons of New Bond Street, London, purveyors of 'dainty baby garments, lingerie, blouses and ladies' underlinen in all the newest designs.' The illustration shows a small toddler in a smocked romper suit with a miniature Red Cross ambulance and toy soldiers, playthings inspired by world events at the time.*

ABOVE: *Jolly play clothes from daddy's shirts. Recycling suggestions for a baby creeper and big sister's apron courtesy of a 1920s Dy-o-la Dyes brochure.*

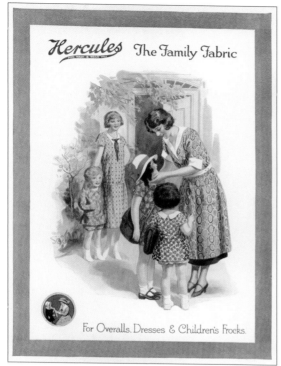

ABOVE: Hercules fabrics – the family fabric for overalls, dresses and children's frocks, 1920s.

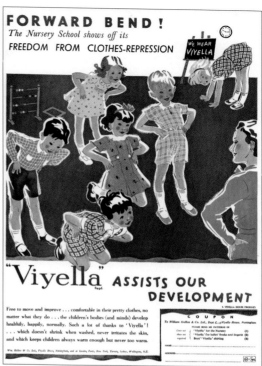

ABOVE: 'Forward bend! The Nursery school shows off its freedom from clothes-repression'. A Viyella childrenswear advertisement from 1936 claiming its clothes aid health and development.

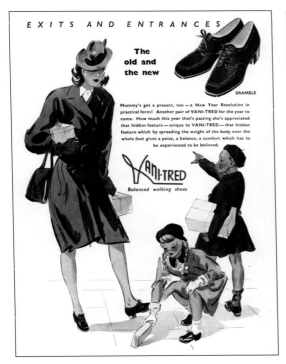

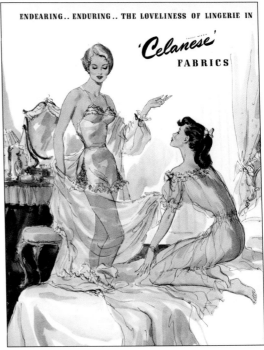

ABOVE: Advertisement for Vani-tred shoes, claiming to spread the wearer's weight of the body over the whole foot giving poise, balance and comfort. The Bramble design is perfect for busy 1945 mothers, out shopping with their children.

ABOVE: Everyday feminine glamour courtesy of Celanese fabrics, 1951.

OPPOSITE: Three school girls, c.1928, with two sporting the ubiquitous gym slip worn widely at the time and synonymous with the fictional school girls in books by Angela Brazil and Enid Blyton (not to mention St. Trinian's).

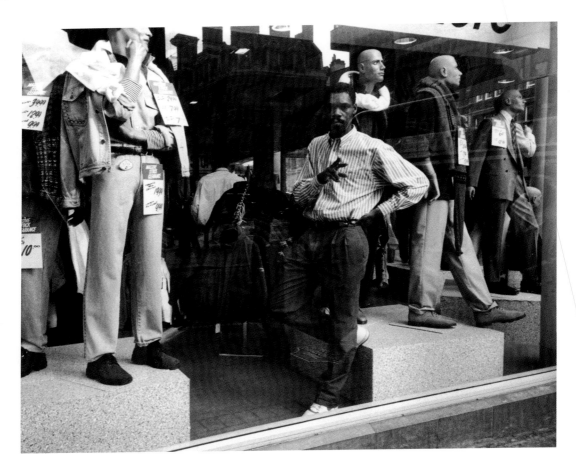

ABOVE: Male store attendant in a clothes store window on Oxford Street in 1989. The Chino style trousers, boxy jackets and denim and plaid fabrics sum up the smart casual style of those years.

OPPOSITE: A view looking out onto Kensington High Street from a clothes shop window on the north side of the road, early 1970s.

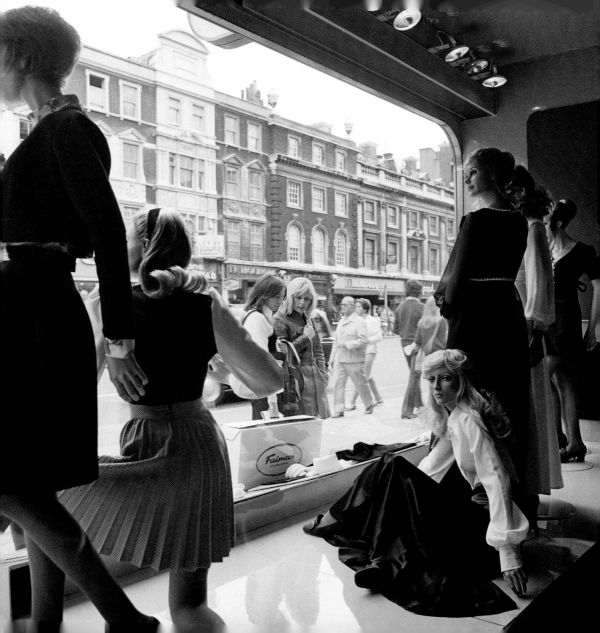

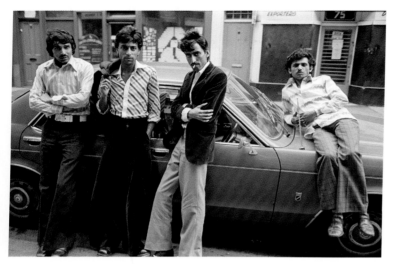

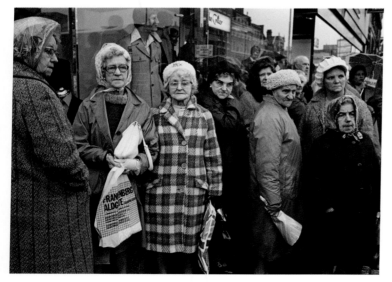

LEFT TOP: Four men in Brick Lane in 1977 sporting fashionable tight shirts and flared trousers.

LEFT BOTTOM: Hats, head scarves and overcoats predominate among this group of older women captured by photographer Paul Trevor on Whitechapel High Street, London in 1977.

OPPOSITE: Two fashionable young boys in the mid-1970s with long hair and flares, one of them wearing 'beetlecrusher' shoes.

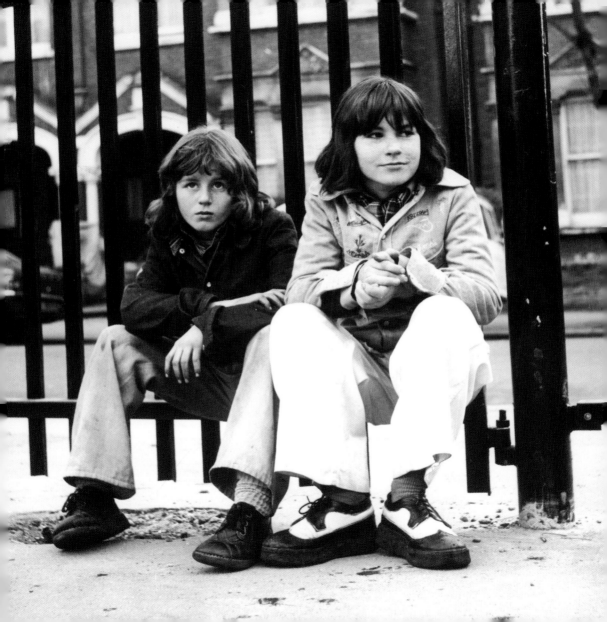

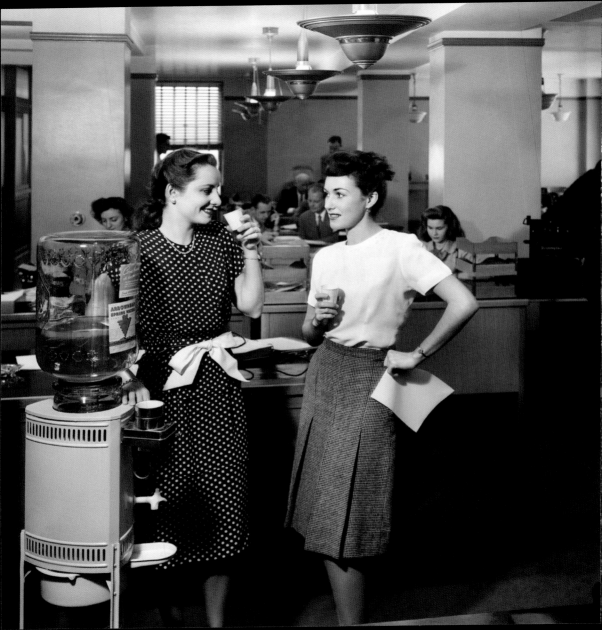

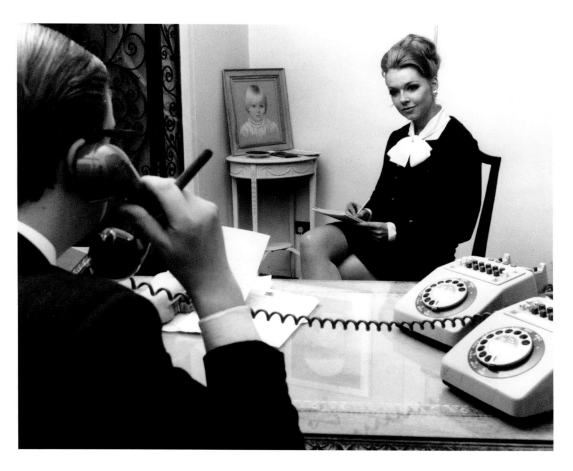

OPPOSITE: Two neatly turned out female workers in a 1940s office enjoy a water cooler moment.

ABOVE: A secretary in a short skirt and pussy bow blouse takes notes in the late 1960s.

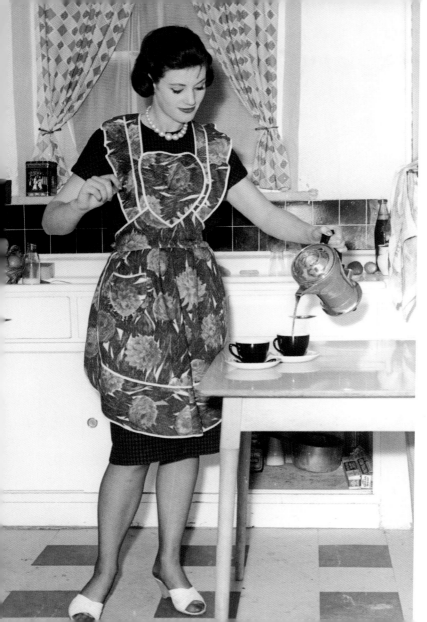

LEFT: An immaculate housewife, in a frilly apron pours coffee into two cups, and all seems right with the world. In an age before modern washing machines, the wearing of an apron was not only a symbol of house proud domesticity but an obvious aid to keeping clothing clean for as long as possible.

OPPOSITE: For a good proportion of the 20th century, it was usual for young boys to wear shorts all year round, regardless of the weather conditions. This 1950s photograph by John Gay shows a group of children sledging in the snow on the playing field near St Peter's Church in Brackley, Northamptonshire. Shorts are de rigeur, though chills are reduced somewhat by overcoats and caps.

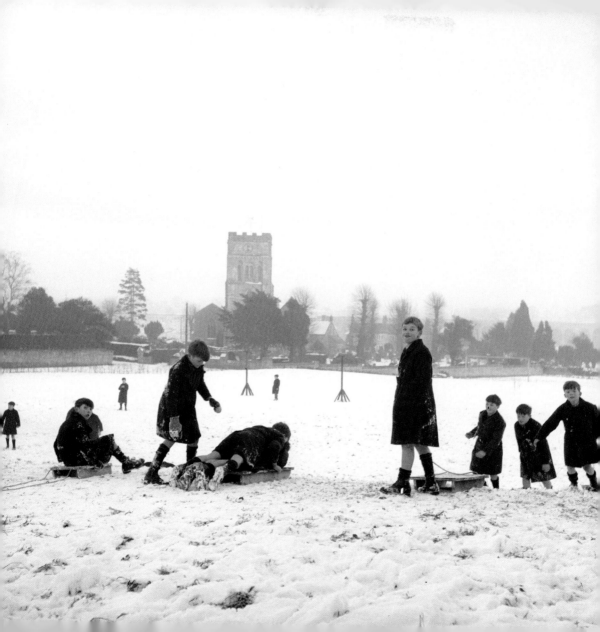

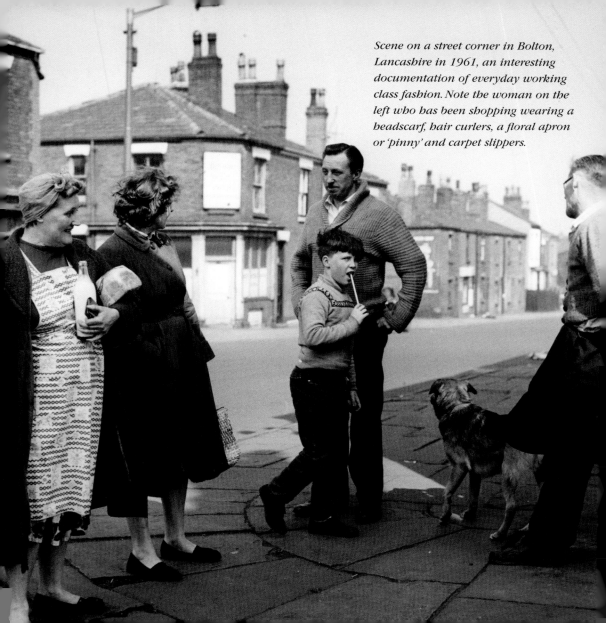

Scene on a street corner in Bolton, Lancashire in 1961, an interesting documentation of everyday working class fashion. Note the woman on the left who has been shopping wearing a headscarf, hair curlers, a floral apron or 'pinny' and carpet slippers.

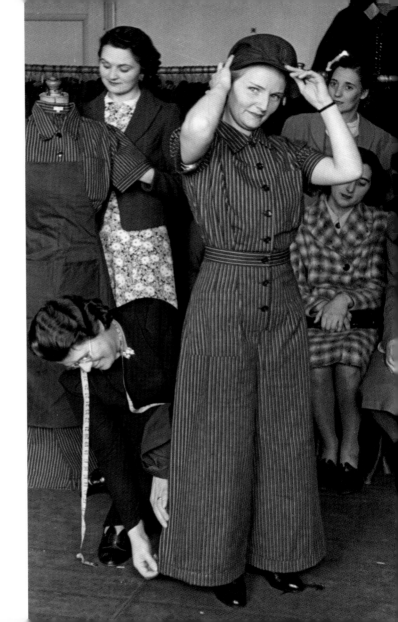

BAD FORM IN DRESS.

The National Organizing Committee for War Savings appeals against extravagance in women's dress.

Many women have already recognized that elaboration and variety in dress are bad form in the present crisis, but there is still a large section of the community, both amongst the rich and amongst the less well-to-do, who appear to make little or no difference in their habits.

New clothes should only be bought when absolutely necessary, and these should be durable and suitable for all occasions. Luxurious forms, for example, of hats, boots, shoes, stockings, gloves, and veils should be avoided.

It is essential, not only that money should be saved, but that labour employed in the clothing trades should be set free.

ABOVE: First World War poster warning against extravagance in dress in this time of crisis. Women were advised to shop prudently and invest in quality garments that would serve them well for the duration of the war.

RIGHT: Cleaning towards victory. Window cleaning "Georginas" during the Second World War being fitted individually with their smart uniforms which were issued along with a new cap, apron, overall and very comfortable shoes.

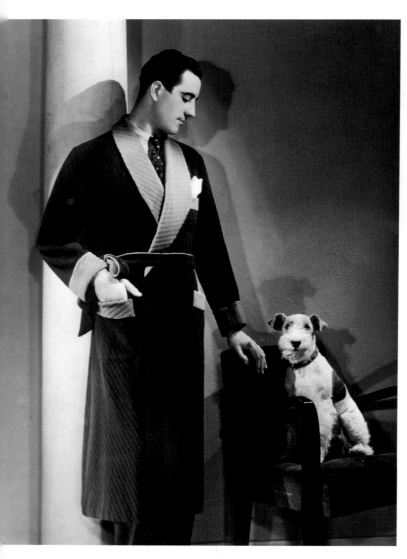

LEFT: *Relaxing at home in the 1930s was a stylish affair. Man in a dressing gown with quilted shawl collar, similar to that on a smoking jacket, worn over a shirt and tie and with a pocket handkerchief carefully arranged in the top pocket. Wire-haired fox terrier optional.*

ABOVE: *A typical British school boy of the 1930s wearing a jacket, shorts, long socks and school cap. Uniform was often worn outside of school, on holidays or for special occasions.*

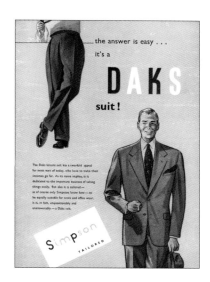

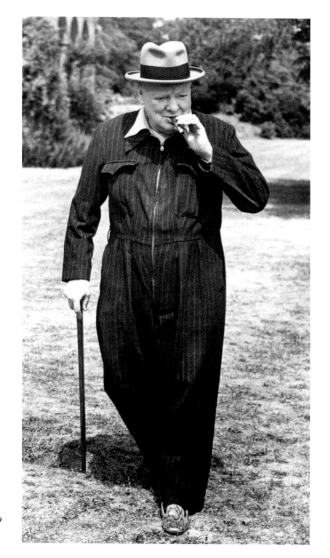

ABOVE: Advertisement for Daks suits from Simpson of Piccadilly, 1953, featuring a well turned out chap – a classic, quality choice for the working man in the 1950s.

RIGHT: Winston Churchill is pictured here wearing his siren suit at his home, Chartwell in Kent in 1944. Designed to be slipped on over his clothes in the event of an air raid, Churchill's penchant for the garment led to him having several designed, including one in green velvet made by Turnbull and Asser. He also wore this forerunner of the 'onesie' on the most of formal of occasions, such as on a visit to the White House in 1941.

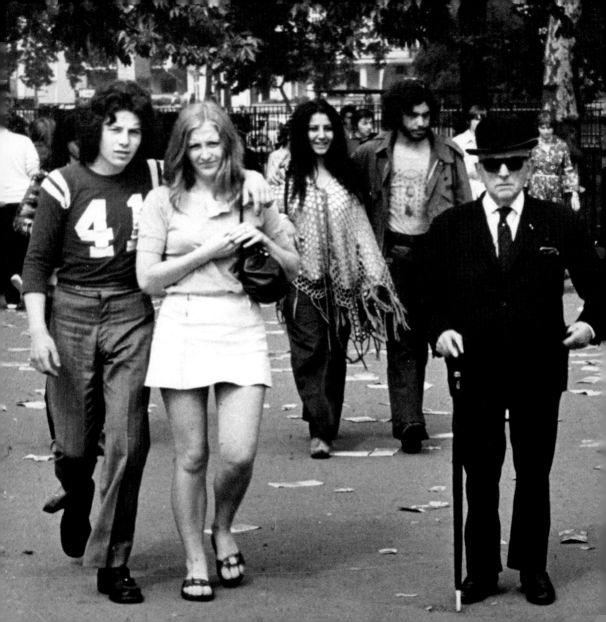

Throughout the 1930s, the popularity of the bowler hat was beginning to wane. Man and his Clothes *Magazine reported in 1930 that 56% of the male population wore the bowler hat, a 11% decline since the previous year, due to an increase in men opting to wear soft felt hats, 'since there are very few men who wear top hats'.*

A cool City gent in smart suit, bowler hat and dark sunglasses stands in stark contrast to a group of young hippies with their long hair, jeans, ponchos and miniskirts. London, early 1970s.

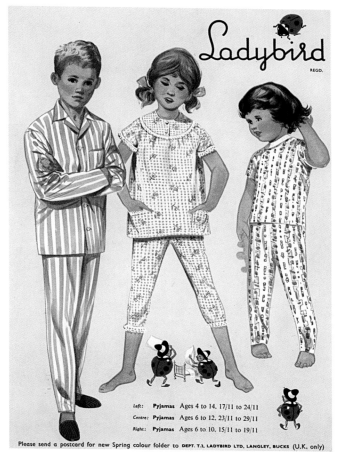

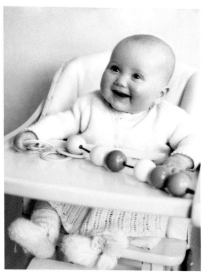

OPPOSITE: The 1970s saw daywear embrace flamboyant and eye-watering prints. These loud shirts are just one example.

ABOVE: A 1960s baby dressed head to toe in hand knits.

LEFT: 1965 advertisement for Ladybird nightwear for children. Ladybird was the childrenswear brand sold by high street chain Woolworths and offered a good value range that spanned baby clothes to school uniform.

ICONS OF STYLE

What is Style? It is an exhibition of good taste and individuality, without ostentation.'
Fonthill Beckford, Man and his Clothes *magazine, September 1930*

In 2006, a black cocktail dress designed by Hubert de Givenchy sold at Christie's for £467,200, the most ever paid at auction for a cinema costume. What set this dress apart and whipped bidders into a frenzy was its history, having draped elegantly from the shoulders of the late Audrey Hepburn in her career-defining role as Holly Golightly in the 1961 film of Truman Capote's novel, 'Breakfast at Tiffany's'. Somebody was willing to pay the price of a modest semi-detached house to possess this dress. It goes some way to explaining the elemental and definitive power of clothes when teamed with the right wearer and placed in the right setting. Even if nobody has actually seen 'Breakfast at Tiffany's', few people fail to recognise Hepburn's distinctive chic in the film from the elegant up-do, pearls and cigarette holder, to the Oliver Goldsmith sunglasses and, of course, that dress. Whoever bought it now owns, not only a piece of cinematic history but also a tangible and eternal reminder of Hepburn's immaculate style.

Back in the 1920s, whenever a girl was considered to possess that special something – that indefinable je ne sais quoi, – she was said to have 'it'. The term was first applied to the hugely popular silent film star, Clara Bow after her appearance in the film of the same name, Another star of the silent screen, Louise Brooks, with her dark silken hair cut into her trademark precision bob undoubtedly had 'it' too. Perhaps today we might suggest 'it' was subtext for sex appeal. But it ran deeper than that. It was that elusive quality that set an actress apart from the rest. Audrey Hepburn, with her Bambi eyes, gamine hair cut and elfin bone structure, had a face and poise that radiated grace and style. She also looked refreshingly different to other starlets, but it was her collaborative pairing with her friend Hubert de Givenchy that was to seal the designer's reputation, and to recast Hepburn as a style icon. After visiting his studio in 1954, Hepburn had it written into her contract that Givenchy would design all her costumes for future films. She would later tell the press, 'His are the only clothes in which I am myself.' The pair were to become lifelong friends.

No doubt without Givenchy's contribution, Hepburn would have still had a successful film career. But the combination of actress muse and fashion visionary was to immortalise her as one of the all-time greats. This type of alchemy, in varying equations, has been played out across the decades combining film stars, fictional characters, musicians and models with pioneering designers, groundbreaking haircuts or radically modern costumes to produce fashion gold. The suave silhouette of James Bond 007 could not

OPPOSITE: Audrey Hepburn as Holly Golightly in the classic 1961 film, 'Breakfast at Tiffany's'.

be achieved without the impeccable tailoring of his suits. Anthony Sinclair dressed Sean Connery in the early Bond films creating the pared back elegance of the Conduit suit, still available today. In more recent years, the Italian bespoke tailors Brioni as well as Tom Ford have given Bond that air of urbane refinement. Few can mention cult sixties television show 'The Avengers' without referring to somewhat lasciviously to Emma Peel (played by Diana Rigg) and her array of figure-hugging, ass-kicking outfits – the work of British designer John Bates. The same applies to Jane Fonda who wore an array of sexy space age outfits in the movie, 'Barbarella', that was to make her a poster girl, and the film a kitsch but cool high point of sixties cinema. And who could forget that moment of cinematic magic conjured when Marilyn Monroe stood over an air vent in 'The Seven Year Itch'? The white, halter-neck dress with the fluttering skirt designed by William Travilla remains almost as famous as Monroe herself, but with the star's curves filling it, the combined effect was dynamite.

Over the years, a chosen muse has inspired many designers and photographers, most frequently a fashion mannequin, but some models have become style icons in their own right. In the 1950s, the work of photographers such as Richard Avedon had made stars of models such as Dovima, Suzy Parker and Barbara Goalen. In the following decade, a new generation of faces – Jean Shrimpton, Peggy Moffatt, Jill Kennington, Penelope Tree and Leslie Hornby, forever known as Twiggy – projected a leggy, wide-eyed, flat-chested and doll-like quirkiness that everyone wanted to copy, and was to make them defining faces of an era.

Some fashion designers shy away from the limelight. Cristobal Balenciaga was one such name that, despite the confident and often flamboyant shapes evident in his designs, preferred to remain quietly behind the scenes. Others however, courted publicity to promote and consolidate their brand in the process. Early examples include Lucile, a.k.a. Lady Duff Gordon, whose society connections made her a natural publicist; she often appeared in magazines such as The Tatler in her own creations, or corralled her mannequins together to produce a mass effect wearing her signature design, the famous 'emotional gown'. Gabrielle 'Coco' Chanel rarely wore anything other than her own classic designs while Mary Quant did the same and in so doing was the personification of the cool, sixties chick. Yves St. Laurent is as memorable for his personal style as his classic 'Le Smoking' tuxedo suit (in turn inspired by the masculine style worn by Marlene Dietrich in the 1930s). YSL's spectacles were part of his individual look; both Buddy Holly and Michael Caine made glasses part of their image too, manipulating an everyday item to become an intrinsic and elemental part of personal style.

A signature style doesn't always have to be unique or flamboyant; often a memorable look has been created using the most commonplace item of clothing. Once upon a time, millions of straw boater hats were worn across the Western world. Adopted by actor-crooner Bing Crosby (who could even wear a

sun hat with panache), it was elevated to an individual style statement. Frank Sinatra's style was borne not out of his trilby hat (a ubiquitous item in 1950s America) but instead by the way he wore it – with characteristic confidence and aplomb. His daughter Nancy was known to say, "His hat is like an extension of him."

Jacqueline Kennedy spent an enormous fortune on her wardrobe to create an image of neat sophistication that married her much-vaunted French heritage with a breezy American style. Choosing a variety of feminine shift dresses, skirt suits and pillbox hats, all in candy shades and cut on simple lines, her disciplined and demure elegance chimed effortlessly with the youthful optimism of her husband's administration, a period that she herself dubbed, 'Camelot'. Extravagant but never ostentatious, she favoured a firmament of European designers including Dior, Givenchy, Yves St Laurent, Valentino and Chanel (she was wearing a pink boucle Chanel suit on the day of her husband's assassination). Rarely putting a sartorial foot wrong, Jackie moved effortlessly to a more relaxed style in the 1970s wearing easy 'sportif' tops with flared trousers, sandals and her distinctive Jackie 'O' sunglasses. Whether it is her ice-cool tailored First Lady look, or the insouciant glamour of her later life, the style of the former Jacqueline Bouvier has endured beyond her lifetime, still regularly analysed and celebrated by fashion magazines twenty years since her death. 'She had a very definite style,' said Alexandra Shulman, editor of British Vogue when asked to comment on Jackie's style legacy after her death in 1994: 'and that's been proven by the iconic images of her. These are enduring images and that's what real style is about. I don't believe she set a style though, she just embodied an understated, contemporary elegance.'

We can draw clear parallels between the lives, careers and personal style of Jacqueline Kennedy Onassis and her contemporary, Audrey Hepburn. Both were born in 1929, rose to fame (for very different reasons) during the 1950s reaching an apogee of celebrity during the early 1960s. Polly Mellen of Allure magazine said of both women that, 'they dressed in an eliminated way – not garish or glitter! It was the most refined WASP way of dressing.' But their fashion sense was only part of what made them style icons. Both women exhibited self-possession, grace, and poise and underwent personal re-inventions without ever losing the essence, which had gained them such success in the first place. Whatever 'it' was, Jackie and Audrey most certainly had it, in bucket loads.

WELCOME BACK!

MRS. IRENE CASTLE-TREMAN

Charlotte Fairchild, New York

The latest photograph taken in New York shortly before leaving for London on a trip in which the famous dancer will combine business with pleasure. Mrs. Irene Castle-Treman has always justly enjoyed the reputation of being the best-dressed woman in two continents, and in this picture she is wearing the last word in smart tailormades by Lucile

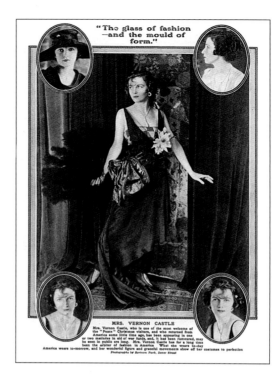

"The glass of fashion —and the mould of form."

MRS. VERNON CASTLE

Mrs. Vernon Castle, who is one of the most welcome of the "Peace" Christmas visitors, and who returned from America some little time ago, has been appearing in one or two matinées in aid of war funds, and, it has been rumoured, may be seen in public ere long. Mrs. Vernon Castle has for a long time been the arbiter of fashion in America. What she wears to-day America wears to-morrow, and her wonderful figure and graceful movements show off her costumes to perfection
Photographs by Bertram Park, Dover Street

ABOVE LEFT: The dancer Irene Castle may not immediately spring to mind when compiling a list of style icons but in her day, was widely considered an influential leader of fashion. She and her husband were known as 'America's Dancing Sweethearts' and enjoyed a successful and lucrative career. Vernon was killed in a flying accident in 1918 but Irene remarried and remained a well-known figure on the fashion scene during the 1920s. She is pictured here wearing the last word in tailormades by Lucile.

ABOVE RIGHT: Page from The Tatler in 1918 featuring Irene wearing an unattributed but very elegant black evening dress. The magazine writes, 'Mrs Vernon Castle has for a long time been the arbiter of fashion in America. What she wears today America wears tomorrow, and her wonderful figure and graceful movements show off her costumes to perfection.'

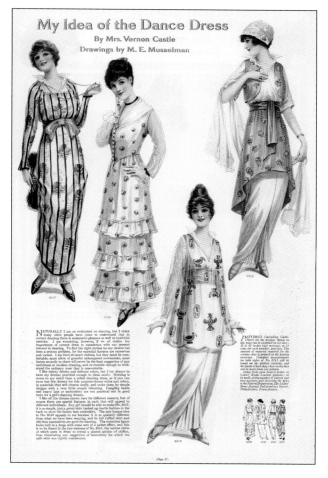

Magazine spreads proving Irene Castle's status as a fashion icon - recommended dance dresses in Ladies' Home Journal, *1914 and American fashions modelled by her in* Eve *magazine, 1927. Irene's image and reputation as a tastemaker resulted in a number of profitable business ventures including the manufacture of a specific lace named 'Vernon Castle Lace.'*

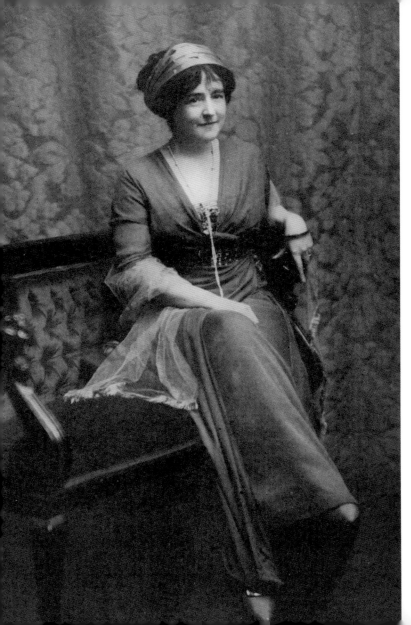

LEFT: Lady Duff Gordon, aka the dress designer, Lucile. Famous for her 'emotional gown', Lucile's upper class connections (her sister was the novelist, Elinor Glyn) ensured her business gained regular publicity in glossy magazines of the period.

OPPOSITE LEFT: .
The world-famous cabaret act The Dolly Sisters, aka Jenny and Rosie Dolly, were renowned for their sense of style and leading dressmakers were keen to ally their creations with the twins' fame and charisma. In 1924, the French couturier Jeanne Patou (also well-known for dressing the French tennis star Suzanne Lenglen) provided them with a complete wardrobe for their tour of America.

OPPOSITE RIGHT:
Jenny and Rosie Dolly wearing Lucile gowns in the League of Notions revue in London, 1921

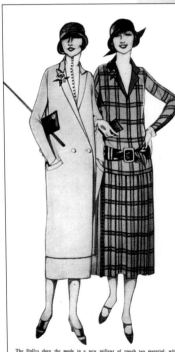

The Dollys show the mode in a new tailleur of rough tan material, with wrap-around skirt and long coat, and a frock for the young girl of English plaid with navy trimmings and a patent leather belt. As important features as the clothes themselves are the accessories of short lacquered cane, boutonnières and flat pocket-books of suède with monograms of marcasite

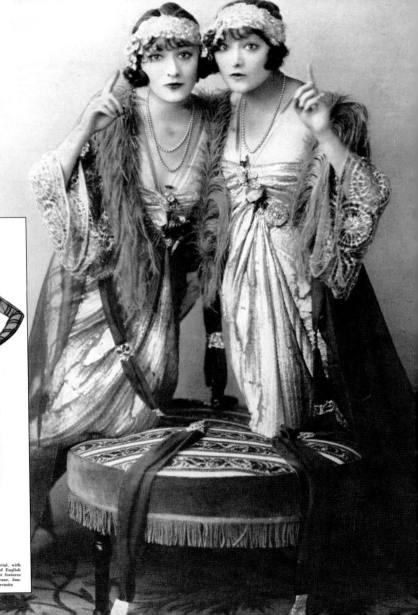

Purple and Blue Wigs to Complete the Colour=Schemes of Dresses: Gowns that Express Poetic Ideas.

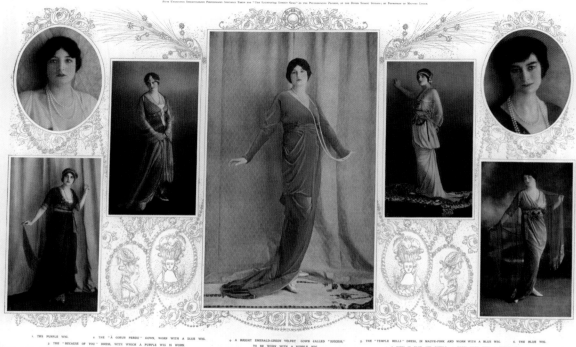

A spread of Lucile designs in The Illustrated London News in 1913, with purple and blue wigs to complete the colour schemes of gowns that express poetic ideas.

LEFT: As well as an off-duty wardrobe, Patou also designed extravagant stage costumes for the sisters such as those worn in this 1925 Paris revue.

ABOVE: Daisy Fellowes nee Margeurite Severine Philippine Decazes de Glucksbierg (1890–1962), celebrated society figure, acclaimed beauty, novelist, poet, editor in chief of French Harper's Bazaar magazine, fashion icon and heiress to the Singer sewing machine fortune, wearing a simple, white silk dress and a string of pearls. Daisy led a dissipated life, dabbling in drugs and embarking on a string of affairs with married men. But her sense of style never left her. Her jewellery collection included many pieces by Cartier, while Schiaparelli created her shocking pink colour especially for her.

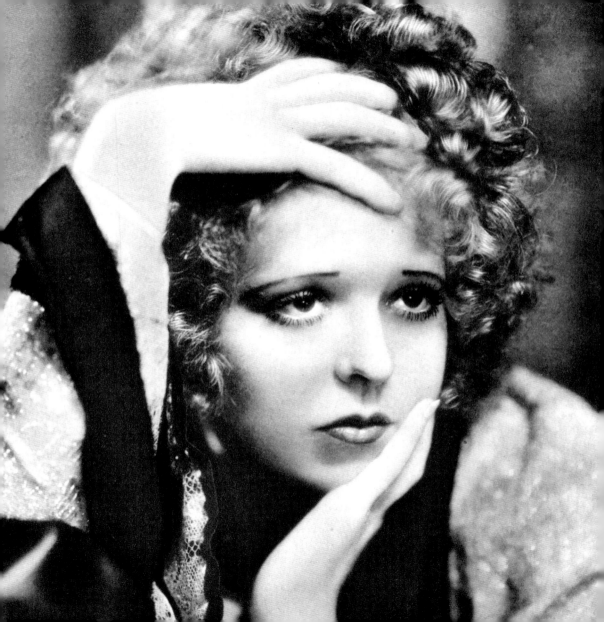

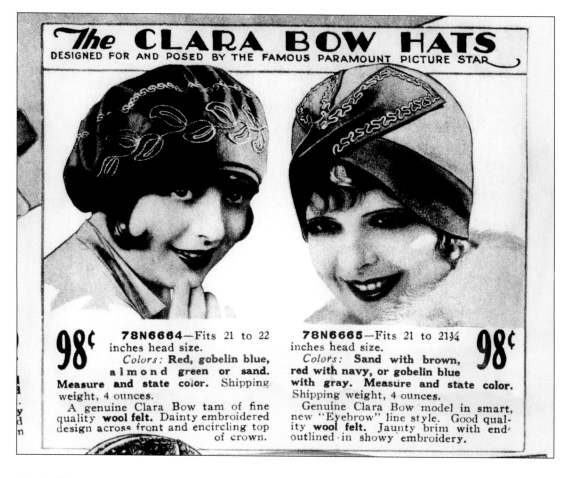

The CLARA BOW HATS
DESIGNED FOR AND POSED BY THE FAMOUS PARAMOUNT PICTURE STAR

98¢ **78N6664**—Fits 21 to 22 inches head size.
Colors: **Red, gobelin blue, almond green or sand.** **Measure and state color.** Shipping weight, 4 ounces.
A genuine Clara Bow tam of fine quality **wool felt.** Dainty embroidered design across front and encircling top of crown.

78N6665—Fits 21 to 21¾ inches head size. **98¢**
Colors: **Sand with brown, red with navy, or gobelin blue with gray. Measure and state color.** Shipping weight, 4 ounces.
Genuine Clara Bow model in smart, new "Eyebrow" line style. Good quality **wool felt.** Jaunty brim with end outlined in showy embroidery.

OPPOSITE AND ABOVE: A page from a 1928 Sears Roebuck catalog offering 'Clara Bow Hats: Designed For and Posed by the Famous Paramount Picture Star', costing 98 cents each. At the height of her fame and following her appearance in the 1927 movie, 'It', Bow was Paramount studio's most bankable star, rated the biggest box office draw in 1928 and 1929.

OPPOSITE: Cecil Beaton (1904–1980), photographer, stage and costume designer, writer, diarist and tastemaker, responsible for creating some of the most memorable portrait photographs of the 20th century from the fairytale romance of Queen Elizabeth (later the Queen Mother) in the 1930s to the fashionable and outre members of the 1920s society of which he was part. Blending established soft focus techniques with props that included mirrors and theatrical or painterly backdrops, Beaton imbued his sitters with glamour and otherworldliness. He wrote his own chronicle of fashion in 1954 - 'The Glass of Fashion' and was a perennially elegant and stylish figure.

RIGHT: Front cover of The Sketch in 1929 featuring a photograph by Beaton of Miss Nancy Cunard (1896 - 1965), heiress, poet, political activist and owner of the Hours Printing Press. Nancy's individuality is expressed by the masses of African bangles she wears and against a modern, dotted background, Beaton captures her rebellious spirit perfectly.

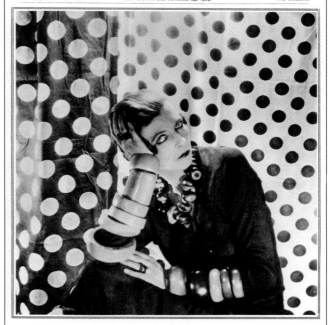

The *Sketch*

REGISTERED AS A NEWSPAPER FOR TRANSMISSION IN THE UNITED KINGDOM AND TO CANADA AND NEWFOUNDLAND BY MAGAZINE POST.

No. 1913.— Vol. CXLVII. WEDNESDAY, SEPTEMBER 25, 1929. ONE SHILLING.

THE LADY OF THE BROBDINGNAGIAN BANGLES: MISS NANCY CUNARD.

The vogue for wooden jewellery is here seen in all its glory and lavishness. Miss Nancy Cunard, the poet daughter of Maud Lady Cunard, and owner of the Hours Printing Press, was evidently fascinated by the beautifully painted and enamelled wooden bracelets and beads sold in that Mecca of the *chic*—Paris—as she bought some of the very largest ornaments she could find. Painted in all colours, they certainly become her extraordinarily well, and, well supported by the imposing background of polka-dots, they give a remarkably handsome and baroque effect to this portrait of her.

PHOTOGRAPH BY CECIL BEATON, EXCLUSIVE TO "THE SKETCH."

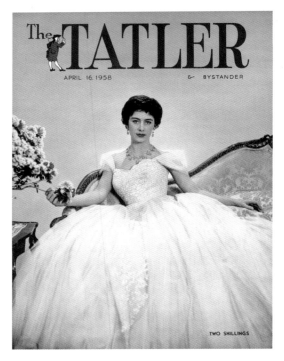

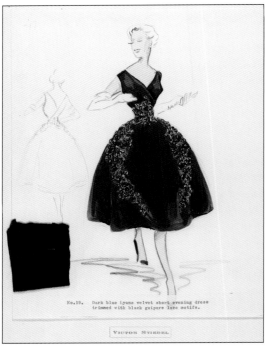

ABOVE: *Princess Margaret on the front cover of* The Tatler *in 1958, photographed by Cecil Beaton in a voluminous ball gown. With her slim waist and a more finely tuned interest in clothes than her elder sister, Margaret was the glamorous torch-bearer for fashion in the royal family during the 1950s and 1960s.*

ABOVE: *A design by Victor Stiebel (1907–1976) for an evening dress for Princess Margaret in dark blue Lyons velvet trimmed with black guipure lace motifs. Stiebel also designed the Princess's going-away outfit when she married Antony Armstrong-Jones in 1960.*

When Lady Diana Spencer began to be romantically linked with Prince Charles in 1980, it was the beginning of a forensic examination of her personal style by the world's press. From her early Sloane Ranger look to the poised and glamorous image she projected following her divorce, Diana's status as a style icon was cemented well before her tragic and untimely death in 1997. Seen here while on a visit to St Columb, Cornwall in 1983 wearing her hair in her trademark flicked style and a frilled stand-up collar and side-buttoning jacket – a formal version of the New Romantic style of the early 1980s.

Edward with his younger brother, Prince George, later Duke of Kent (1902–1942) during a holiday on the Riviera at Biarritz, France in 1932. Both royal brothers are dressed fashionably in casual clothes. The Prince of Wales rakishly adopts a French beret.

Edward, Prince of Wales (1894–1972), later King Edward VIII and Duke of Windsor, photographed in colour (Finlay process) in 1930 sporting a casual combination of coloured shirt and tie worn with a pullover and sports jacket. The Prince's style was acutely observed and the smallest changes noted with interest by the press. In 1928, Man and His Clothes *magazine reported that, 'At the Derby, the Prince of Wales launched a new tie. It has a broader wide-end, stitched solidly up the back, ties in a larger knot and has a fuller apron.' It also mentioned his double collar and the double-breasted, putty-grey waistcoat he was wearing adding, 'this lead will give the desired fillip to the increasing popularity of light coloured waistcoats.'*

The Prince of Wales leaving a ship in February 1931 looking immaculately tailored in his double-breasted suit. His suits were made by Frederick Scholte of Savile Row who created a softer style worn by the Prince known as the 'English drape'. The Prince favoured sartorial twists such as turn-ups (much to the dismay of his father George V) or midnight blue evening wear as opposed to black. In his autobiographical book, 'A Family Album' he reminisced extensively about his life in clothes, declaring, 'I was in fact 'produced' as a leader of fashion with the clothiers as my showmen and the world as my audience.'

Hardy Amies (1909–2003), British designer best known as dressmaker by Appointment to the Queen. Amies was particularly renowned for his precision tailoring, and he practised what he preached never looking anything less than the epitome of sophisticated elegance in his dress. Pictured in the Grand Salon of 14, Savile Row in 1946.

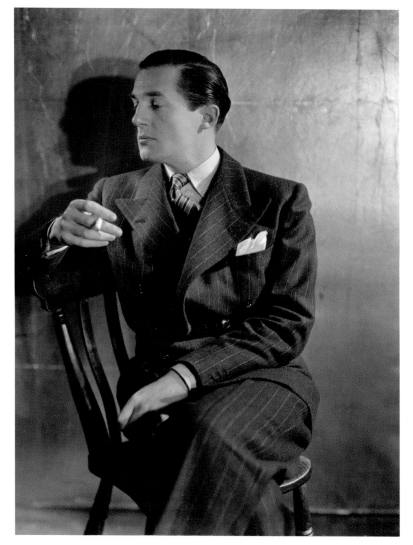

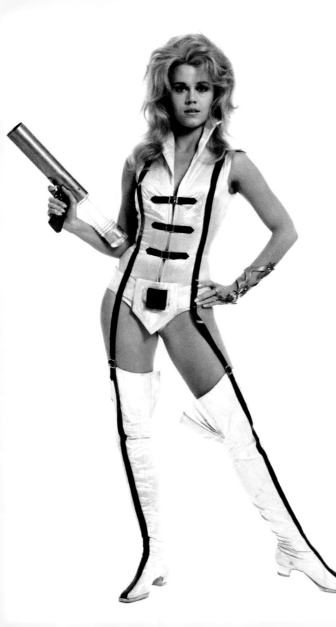

In the cult 1968 film, 'Barbarella', the central character played by Jane Fonda wears a succession of skimpy and revealing outfits designed by Jacques Fonteroy with contributions from Paco Rabanne. Barbarella's costumes appeared in parallel with the space age catwalk designs of André Courrèges, Pierre Cardin and Rabanne, but were the stuff of pure, futuristic fantasy contributing to its status as a cult film today.

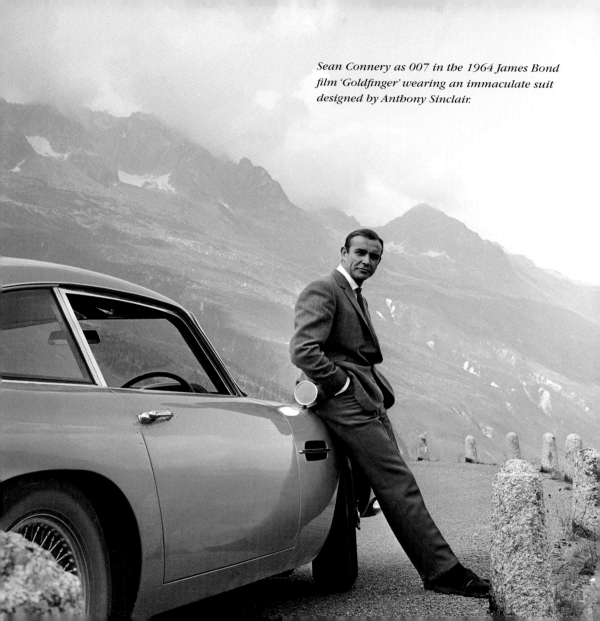

Sean Connery as 007 in the 1964 James Bond film 'Goldfinger' wearing an immaculate suit designed by Anthony Sinclair.

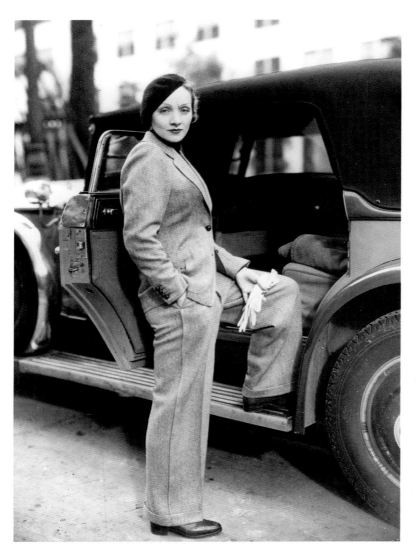

Marlene Dietrich constructed a powerful image by appropriating traditional masculine dress, a decision that served to intensify her sexual mystique. She appeared in a top hat, tuxedo and stockings in the 1930 film, 'The Blue Angel' and during a trip to Paris in 1933, wearing an outfit similar to this tailored suit, she was warned that she was liable to be prosecuted (owing to an 1800 law forbidding female to male cross-dressing). Nevertheless, the flair and confidence she exhibited when wearing men's tailoring was to result in an iconic style statement.

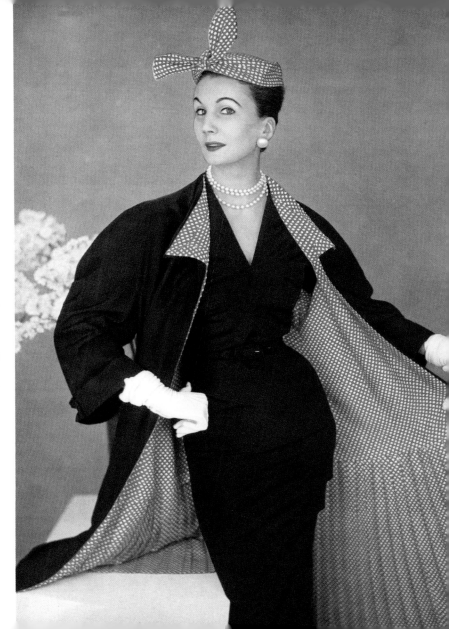

The fashion model of the 1950s, as captured by photographers such as Richard Avedon, John French and Norman Parkinson, was tall, elegant and patrician, all the better to show off the carefully constructed, wasp-waisted clothes of the post-war era. Barbara Goalen (1921–2002), with her haughty expression, arched eyebrows and tiny 18 inch waist was described in Vogue as personifying the 'mink and diamonds' look. Pictured here by John French for The Tatler, modelling a dress and coat trimmed with an Ascher print in 1954, the year she retired from modelling after her second marriage.

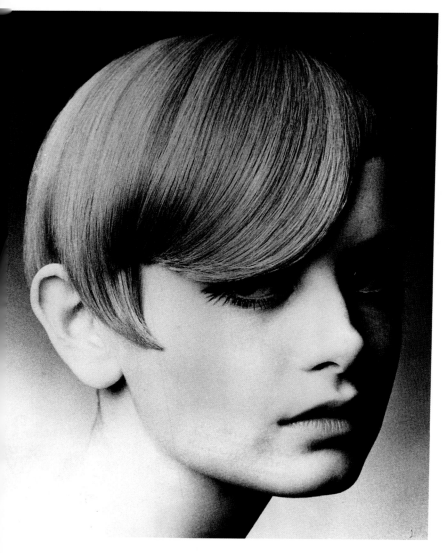

*LEFT AND OPPOSITE:
Twiggy, born Lesley
Hornby in Neasden
in 1949, became the
face of the swinging
sixties after she was
discovered in 1966. With
her distinctive, boyish
haircut by Leonard of
Mayfair, waif-like figure
and gangly legs, the
Twiggy look became an
aspiration of thousands
of teenage girls during
the decade.*

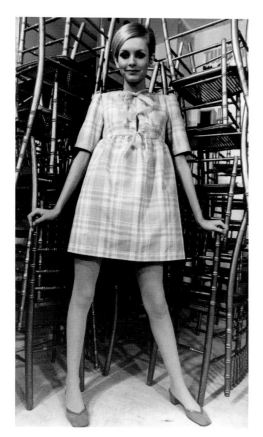

ABOVE: Twiggy appearing in the Ken Russell film adaptation of 'The Boyfriend' in 1971. The role prompted a change of image, and the art deco sets and costumes reflected the style inspiration behind the Biba store, for which Twiggy often modelled.

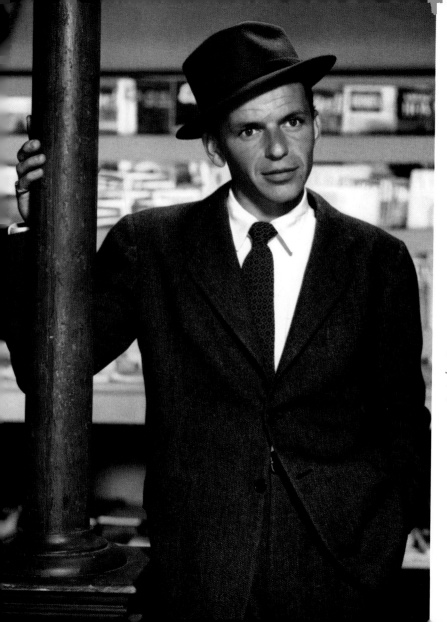

Frank Sinatra (1915–1998) in his trademark trilby hat. His daughter Nancy explained that he wore hats with increasing frequency due to his receding hairline but headwear became an intrinsic element of the Sinatra mythology. Most of his hats, black or grey felt in winter, straw in summer, came from Cavanagh, the New York gentleman's hatter.

Grace Kelly's cool, classic beauty and understated, elegant dress sense were celebrated in 2010 by an exhibition at the V&A museum in London entitled simply, 'Grace Kelly: Style Icon'. Kelly embodied a natural, understated femininity projected through a wardrobe of shirtwaister dresses, crisp slimline separates and classic twinsets by Pringle of Scotland. She also had a penchant for sophisticated dresses by Marc Bohan at Christian Dior. Having previously worked as a model, she wore clothes with an easy elegance both on-screen and off.

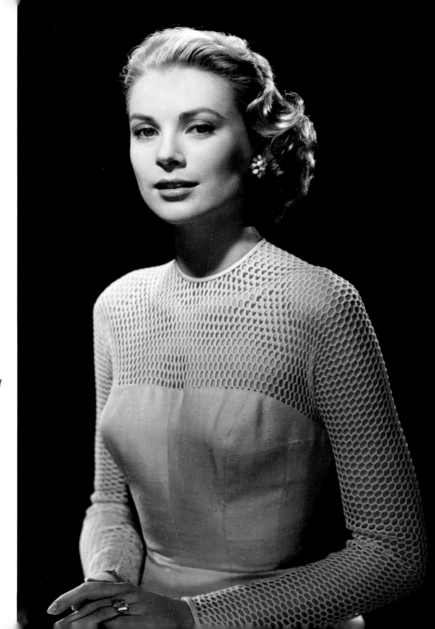

LEFT: *Grace Kelly with Frank Sinatra in 'High Society', 1956. The chiffon gown was designed by MGM's lead costume designer, Helen Rose who would also create Kelly's exquisite wedding gown for her marriage to Prince Rainier of Monaco.*

OPPOSITE: *Grace Kelly with the fashion designer Oleg Cassini in 1954. Cassini (1913-2006) began his career as a designer in Hollywood in 1940, quickly capturing the heart of the actress Gene Tierney who he married. They divorced in 1952, after which Cassini, a handsome and debonair playboy, was linked with a string of beautiful women. Cassini and Kelly were engaged briefly before her marriage to Prince Rainier. He later became a favourite designer of Jackie Kennedy, designing over 300 of the outfits she wore throughout her husband's administration.*

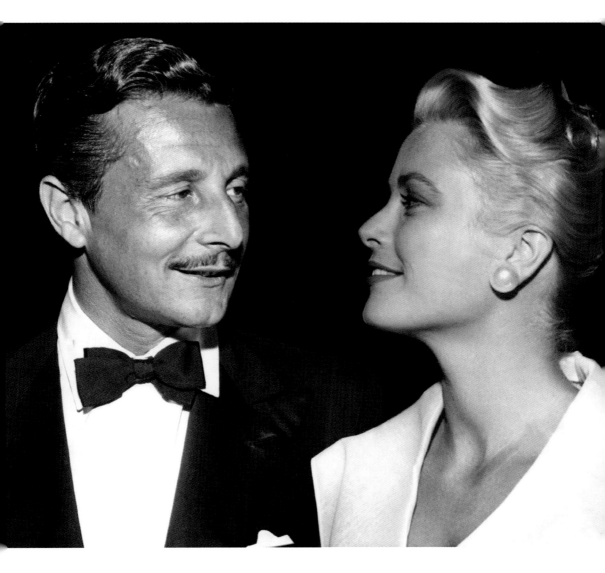

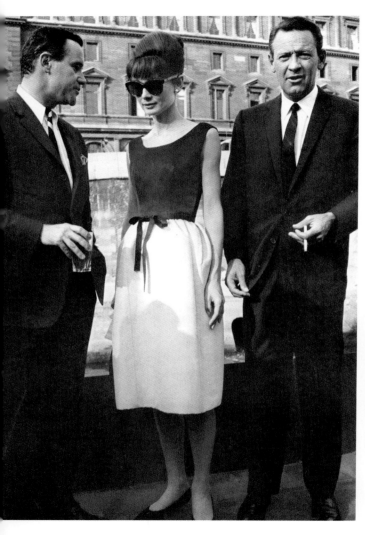

LEFT: Classic Audrey style. Audrey Hepburn attending a cocktail party on a hired bateau mouche *on the Seine, Paris in 1962. She is pictured with Jack Lemmon (left) and William Holden (right) with whom she was starring in the film, 'Paris When It Sizzles'.*

BELOW: 'Six o'clock sophisticate'. A 1961 advertisement for a black cocktail dress by Frederica bears more than a passing resemblance to the style worn by Audrey Hepburn in the film, 'Breakfast at Tiffany's', released in the same year.

Six o'clock sophisticate

fredrica

Time stands still for this bewitchingly simple close-of-day dress in fine wool. Irresistible in Ocean Green, French Mustard, Carnation, Barel Sienna, Deep Violet, Ivory and Black.

7 gns

Member of the Fashion House Group of London.

for your nearest stockist write to: Frederick Starke, 39 Grafton Street, W.1

the foundation of summer beauty

Delicate skins can be a problem during the summer months, especially at holiday time. The cumulative effects of sun, sea or air tend to remove the natural bloom of the skin, which consequently becomes harsh and dry.

An application of Lacto-Calamine after sunbathing brings immediate, soothing relief. Its soft, cool milkiness penetrates deep down into the pores and encourages 'skin-response', a natural reaction of the pores and cells to the stimulating, healing influence from outside.

Lacto-Calamine is a medically prescribed healing lotion, and can be used with the utmost confidence in all cases of minor skin ailments. It also makes the perfect powder base for particularly sensitive skins.

CROOKES
Lacto-Calamine

ABOVE: The Lacto-Calamine lotion advertisement is from 1951 and was photographed in a sandy surreal landscape by Angus McBean.

RIGHT: Before Hepburn's film career took off, she performed as a chorus girl in West End musicals and earned extra money by taking on modelling jobs. The advertisement for Marshall and Snelgrove (right) is from The Tatler, *1949.*

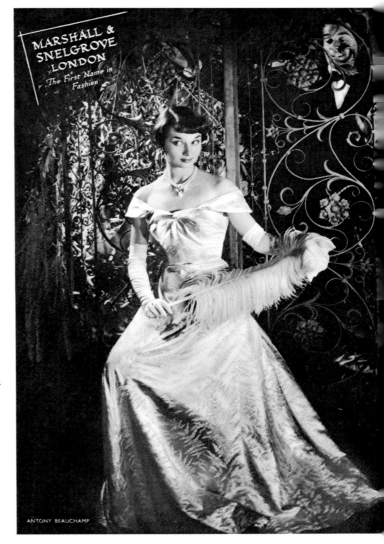

MARSHALL &
SNELGROVE
LONDON
The First Name in
Fashion

ANTONY BEAUCHAMP

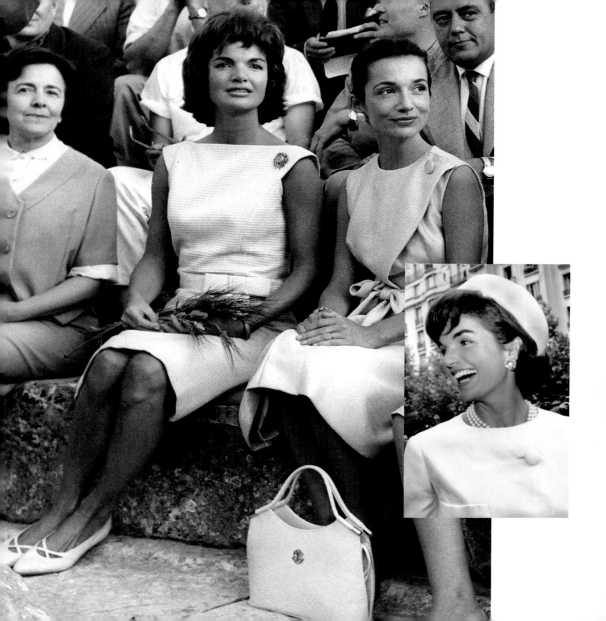

OPPOSITE LEFT: Jackie Kennedy and her sister, Princess Lee Radziwill, attend a performance of the Greek tragedy, Electra, at the Epidaurus theatre in Greece. The simple shift dress in pastel shades was part of Jackie's immaculate uniform.

OPPOSITE RIGHT: American First lady, Jackie Kennedy (1929– 1994), wearing an Alaskine (wool and silk) suit by Oleg Cassini, one of her favourite designers, and pillbox hat by Roy Halston Frowick, during an official visit to Paris in 1961.

RIGHT: The 1970s saw the former First Lady adopt a more casual, effortless 'Jackie O' style characterised by slim-fitting trousers and huge sunglasses. Pictured with the Italian designer and friend Valentino in Capri in August 1970, she is wearing capri pants and sandals.
Valentino designed the dress she wore for her marriage to Aristotle Onassis in 1968.

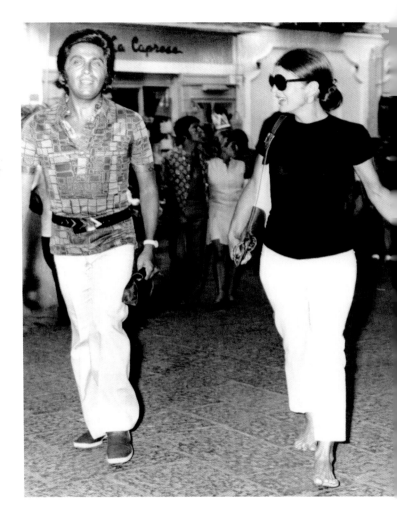

Actress Jean Seberg (1938-1979) cultivated a chic, effortless style in the 1960 New Wave Jean Luc Goddard film, 'Breathless' (A Bout de Souffle) combining oversized shirts and nautical T-shirts with cigarette pants, loafers and her signature gamine, pixie hair cut.

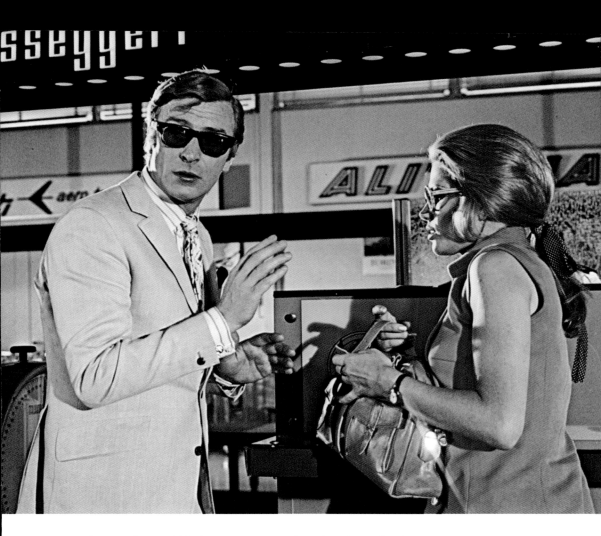

Sir Michael Caine (born 1933) has a reputation, forged in the 1960s, for representing British sartorial style at its best. In the 1969 film, 'The Italian Job', his suits were the work of celebrity Mayfair tailor Douglas "Dougie" Hayward, whose clients also included Clint Eastwood and Sir Roger Moore. Hayward's suits were in the Italian style fashionable during the decade, but cut to fit the wearer like a glove.

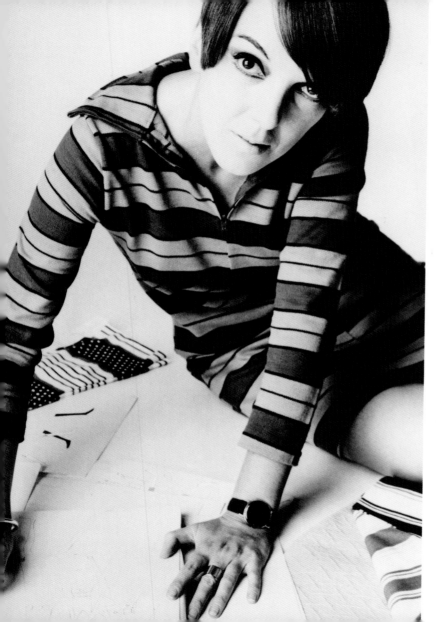

Mary Quant (born 1934), studied Art Education at Goldsmiths College in South East London. In 1955, she opened Bazaar, a boutique on the King's Road offering her modern take on beatnik styles through a combination of simple silhouettes and strong colours. Part-credited for the popularisation of the mini skirt, Quant, with her geometric Vidal Sassoon haircut personified the sixties image she had helped to create.

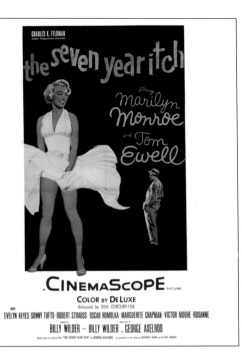

ABOVE: Neil Munro 'Bunny' Roger (1911–1997), British fashion designer and lifelong dandy. Bunny Roger first set up as a dressmaker in Great Newport Street in London in 1937 listing Vivien Leigh as one of his clients. He later moved to become the in-house designer at Fortnum and Mason before becoming a financial backer of Hardy Amies. He reputedly owned over 150 bespoke Savile Row suits, favouring an Edwardian cut with four buttons and high waisted trousers dressed up with various flamboyant accessories. A legendary party-giver and hedonist, Roger's peacock finery and retrospective tailoring made him a unique and quintessentially British style icon.

ABOVE: One of the most famous on-screen dresses of all time, worn by one of the most famous women of all time. The white dress designed by William Trevilla and worn by Marilyn Monroe in 'The Seven Year Itch' is an icon of film history.

Fashion Movements, Fashion Moments

Once in a while, something happens in fashion that completely re-writes the rules, and sets it on an alternative course. One such moment occurred on the 12 February 1947 inside 30 Avenue Montaigne in Paris, the home of a new designer, Christian Dior. As Dior's models entered the salon those who were present were treated to what amounted to a fashion epiphany. The war years had forced fashion to conform to the exigencies of rationing and shortages, while styles were inspired by the military mood with masculine shoulders and tailoring. Dior sent out his models in voluminous skirts made from acres of fabric, made more exaggerated by nipped in waists. Shoulders were sloping, busts were high – it was a return to absolute femininity and a bold antidote to what had gone before.

Dior's friend, the British designer John Cavanagh was present at the show and described it as a, 'total glorification of the female form.' Carmel Snow, influential editor-in-chief of American Harper's Bazaar declared, 'It is quite a revolution, dear Christian. Your dresses have such a new look.'

Within months, the New Look had spread like wildfire among other designers who embraced this voluptuousness with a newfound zeal. Winifred Lewis, writing in *The Tatler* in October that year talked of a 'revolution raging in Paris' and described the Dior silhouette as, 'breathlessly beautiful … shoulders softly rounded, full bosoms and tiny waists springing into incredible fullness of skirt. His hemline is about 10 inches from the ground.' Marcel Rochas, she observed, 'now holds the record for longer skirts – (he) claims to have found the answer to the fabric shortage by the simple expedient of lengthening skirts and shortening coats.' Of course, despite the name given by Snow – the 'New Look' – there was nothing particularly new about the style that would dominate fashion for the next decade. Tiny waists and full skirts had been the unswerving components of female dressing for centuries from the Tudor era through

OPPOSITE: Maggie Rouff fashion show – a model displays a white organdie evening gown with large white polka dots and a slender waistline accentuated by the fullness of the skirt. Dior's New Look, which introduced an 18" waist and focused attention on the bust and hips, paved the way for other designers who welcomed this return to luxury and glamour. Madame Maggy Besancon de Wagner, like many designers, took inspiration from Dior's collection, following the same principles in her 1948 show.

to the Victorians in their crinolines. It seems paradoxical to describe a fashion that in essence is backward looking and nostalgic, as revolutionary, but Dior's daring lay in his timing. Less than two years after the end of the war, he brought feminine beauty and luxury back into fashion when nobody else would have dared to whisper the idea and in so doing, put French couture back on the map, stamping its authority as the world leader.

The New Look is often regarded as a metaphor for 1950s society, its feminine outline, once diluted and filtered down to the mass market, signifying the domestic, 'homemaker' status of the post-war woman. But it is as much to do with the ebb and flow of fashion, of seeking out in a contrary way, a riposte to the styles of the previous few years. What might the fashion followers of the 1920s, with their knee-high hemlines and shingled hair have thought of this return to demure domesticity? They too were a post-war generation, but their experience produced a very different sort of fashion – one that reflected a generation of women who had been part of the war effort and who had finally won the vote. The sporty, casual styles of Chanel and Patou were easy, chic and allowed a freedom of movement. But just a few years later, hemlines lowered once more, briefly to the ankles, a signifier if nothing else, of fashion's fickleness.

After the New Look, the next major shift came in the 1960s, when fashion suddenly became part of another revolution, converging with music and art to produce what is often termed a 'youth quake'. The dictators of style were no longer the couturiers of Paris in their lofty ateliers, but the upcoming designers and boutique owners of swinging London – Mary Quant, John Bates, Alice Pollock, Foale and Tuffin, to name but a few. Shops like Bazaar (Mary Quant's pioneering forerunner), Quorum, Top Gear and Bus Stop catered to a generation of baby boomers who wanted something modern, current and affordable – mini skirts, op-art prints, trouser suits, tights replacing girdles and stockings. It was a look that was kooky and child-like, with a touch of beatnik art student. In comparison to the sophisticated silhouette of the previous decade, sixties style was playful with items such as knee high socks, Mary Jane shoes and pinafores redolent of school girls or rag dolls. An angular Vidal Sassoon haircut was an essential component to completing the look. As the decade progressed hemlines continued to rise higher and higher, an everyday symbol of a more permissive society. James Laver, writing in his 'Concise History of Fashion' in 1969, mused, 'Women in the 1920s were thought very daring to expose their legs to the knee, but the young woman of today exposes the greater part of her thighs. Every year it was thought impossible for the mini-skirt to become any shorter, but shorter it has become. We have reached a degree of permissiveness in society, which even the Twenties never attained. We are really, it would seem, at the eve of a social revolution the magnitude of which is only just beginning to be understood.' Mini-skirts did seem to be a rebellion against an older, more staid generation. While Mary Quant had been raising the hemlines on her clothes higher each season, the mini

first hit the headlines in 1965 when model Jean Shrimpton wore an above-the-knee skirt to the Melbourne Cup, shocking onlookers with not just the brevity of her dress but her lack of stockings and gloves too. As it was quickly adopted by young women of the decade, the alluring style made good newspaper headlines. In 1968, *The Guardian* newspaper reported on a warning given by Mr Frederick Smith, head teacher at St. John Fisher Roman Catholic school in Chatham, Kent, against girls wearing them; 'mini-skirts bordered on immodesty,' he declared, while 'micro-skirts bordered on indecency.' In the same article, Miss Mona Matthews of Peterborough County Grammar school had banned her pupils from wearing 'kinky boots.'

While some pioneers were re-writing fashion, and many more people following in their wake, there were others who created their own rules. Back in the 19th century, there was a minority movement promoting the idea of rational, 'artistic' dress for women – clothes that allowed movement free of constricting corsetry as promoted by groups such as the Pre-Raphaelites and an organisation known the Healthy and Artistic Dress Union. By the 1900s, the concept of the 'New Woman' began to introduce the notion of trousers for women, though it was not until forty years later that many women began to adopt the style.

Wide trouser styles, known as Oxford bags, were a fashion during the 1920s and 30s, a trend originating from students at Oxford University, where a flamboyant aesthetic among certain groups meant the adoption of other niche ideas such as verandah suits or luridly coloured pyjamas. All were indicators of a more privileged, leisured lifestyle. No working class man could usefully carry out a job wearing a flapping pair of Oxford bags.

The desire to step aside from mainstream fashion and yet continue to be defined by choice of clothes is characteristic of the notable subcultures that originated during the 20th century. The Teddy Boys of the 1950s wore clothes that were homage to the Edwardian dandy with long line jackets, velvet lapels and drainpipe trousers. Despite their splendour, often bought from tailors on the never-never, their working class roots and affinity with American rock 'n' roll music gave them a streetwise edge. The same applies to the Zoot suit wearers of 1940s America. The Zoot Suit look adopted by black Americans, comprised of ample peg trousers, cut wide in the leg but tapering to the ankle with generously cut jackets, an image that signalled a sartorial defiance and swagger that caused tension in a country still deeply racially divided.

The Mod movement also followed a smart, clean-cut line. Boys wore tailored Italian style suits and Army surplus parkas; girls adopted pencil skirts and classic knitwear, and scooters were the vehicles of choice. Whereas the Mods' rivals, Rockers, rode motorbikes, dressed in biker leathers and wore their hair greased back. Mods favoured feathered styles and fringes cut in a salon. Punk, perhaps the ultimate rebellious tribal group took elements of the rocker style but subverted it further with spiked, coloured hair or 'mohicans' and extensive body piercing. Fashion's cyclical nature saw the waning of the punk movement give way

to the foppish, androgynous style of the New Romantics in the early 1980s, melding together historical references from the late 18th century and early 19th century with elements of glam rock.

To gather together Dior's New Look and Punk Rock style in the same place may seem incongruous, but Dior, in his own way, was a fashion rebel, boldly taking couture down an ambitious path of lush, unimagined extravagance. Some create trends; others set out to break the rules. Either way, they forge their own way through fashion. This chapter celebrates those pioneers and rebels, those happenings and revolutions. From flappers and bobbysoxers to Mods, hippies and disco, fashion's movements and landmark moments are gathered together here.

.New Woman.

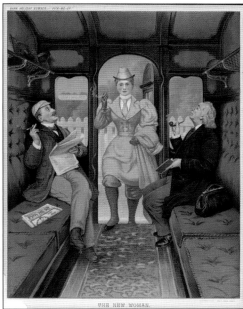

THE NEW WOMAN.

OPPOSITE: Subcultures in Camden, side by side. A skinhead in a bowler hat sits outside the 'Haircut House', offering haircuts for £10, while two elaborately dressed and coiffured punks stand outside a clothes and bondage accessories stall on the right, in stark style contrast to the booted and tattooed skinhead.

ABOVE: The rise of the 'New Woman' in the late 19ᵗʰ century – educated, intellectual, independent and feminist – was to result in a host of cartoons and satirical imagery. The idea of women in bifurcated skirts, or bloomers, was acceptable if the woman was wearing them for cycling (a popular pastime), but the prospect of women in breeches was also something to be feared and ridiculed in equal measure.

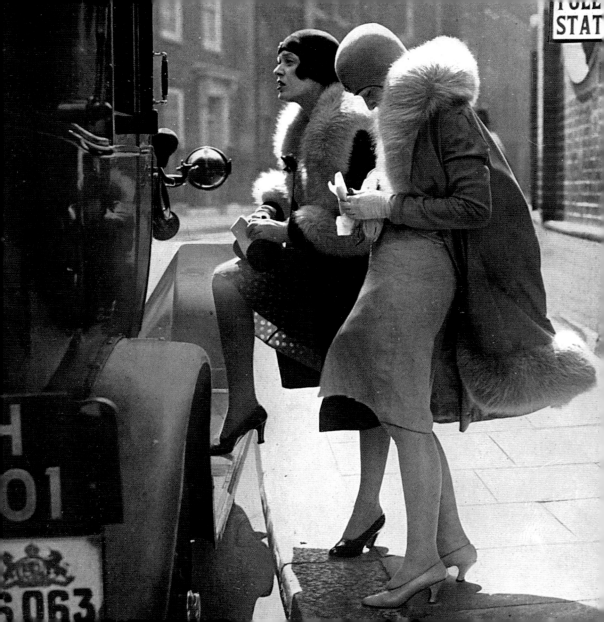

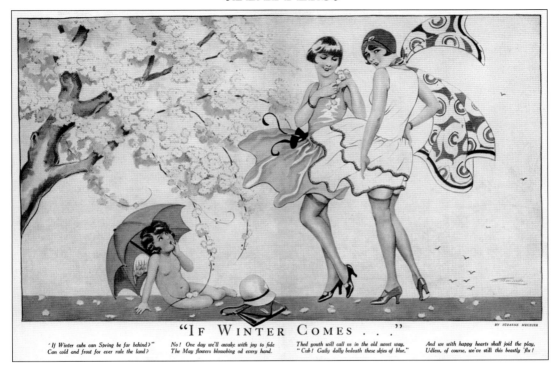

"IF WINTER COMES . . ."

" If Winter cubs can Spring be far behind?"
Can cold and frost for ever rule the land?

No! One day we'll awake with joy to fide
The May flowers blossobing od every hand.

Thed youth will call us in the old sweet way,
" Cub! Gaily dally bedeath these skies of blue,"

And we with happy hearts shall joid the play,
Udless, of course, we've still this beastly 'flu!

BY SUZANNE MEUNIER

OPPOSITE: Two sophisticated and fashionable ladies in heels, helmet style cloche hats and fur trimmed coats alight from a taxi at a polling station where they will vote for the first time in the UK General Election of May 1929. Their appearance reflects their status as modern, confident and, of course, newly enfranchised.

ABOVE: The flapper provided endless inspiration for illustrators of the period. This picture, by French woman Suzanne Meunier (a regular contributor to risqué magazines, La Vie Parisienne *and* Eros) *was published in* The Bystander *magazine in 1929 and focuses on the erotic possibilities of rising hemlines.*

OO-LA-LA! Lancers
Arranged by R. S. STODDON

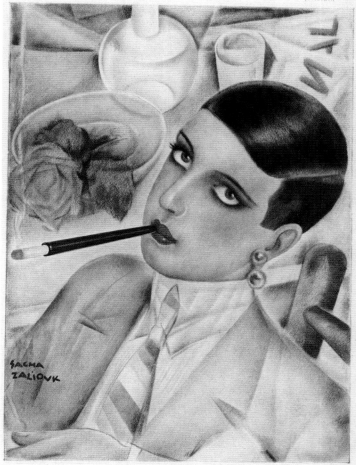

Madame se meurt, Madame est morte
(BOSSUET.)

SACHA
ZALIOUK

Ève Adamisée

ABOVE: A Music cover designed by British artist Tom Purvis featuring a typical flapper girl confidently posing in accoutrements of masculinity – a top hat, monocle and a cigarette.

RIGHT: 'Eve Adamised' – a new woman in a liberated age dons male attire of suit & tie with hair in an Eton crop, but signals her gender with make-up, earrings & a cigarette holder.

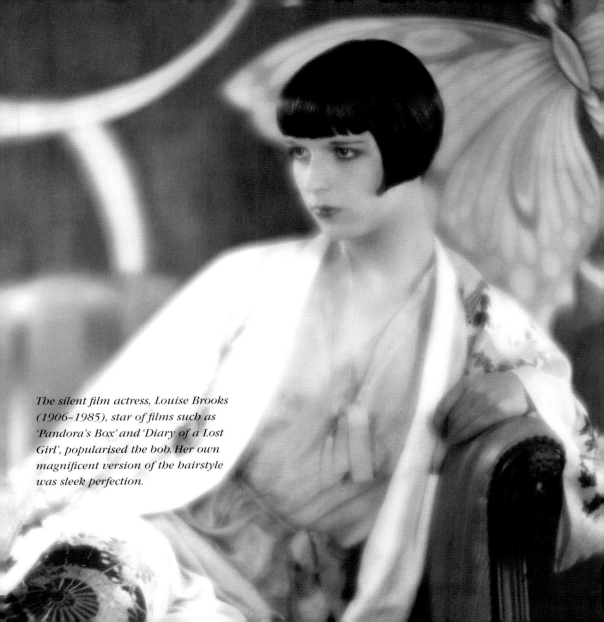

The silent film actress, Louise Brooks (1906–1985), star of films such as 'Pandora's Box' and 'Diary of a Lost Girl', popularised the bob. Her own magnificent version of the hairstyle was sleek perfection.

LEFT: *A fashion homage to the flapper. A woman models a silk crepe blouse and skirt, circa 1927. The print is called 'Gentlemen Prefer Blondes' by illustrator Ralph Barton, who did drawings for* The New Yorker, Vanity Fair *and other magazines in the 1920s.*

BELOW: *Advertisement for lingerie available from Gorringes, London in 1923 including 'elastic wear' and bust bodices. The growing popularity of the flat-chested flapper girl look is reflected in the underwear shown here with breasts and curves notably less defined than in previous decades.*

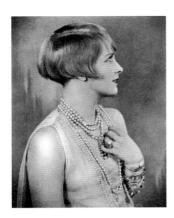

ABOVE: Joan Bourdelle as Lorelei Lee in the stage adaptation of Gentlemen Prefer Blondes by Anita Loos. The novella had begun life as a serialisation in the pages of American Harper's Bazaar *and was an instant hit, chronicling as it did, in diarised form, the adventures of a gold-digging blonde. A jazz age classic, Lorelei is at the heart of the novel and is an unwitting flag bearer for the decade's style and sass.*

RIGHT: Gordon Conway (1894–1956). Prolific costume designer for theatre and film, and contributor to magazines such as The Tatler *and* Eve. *With her bobbed hair and chic sense of style, Gordon personified the 1920s fashions she illustrated.*

.Teenagers.

LEFT: Elements of mod and beatnik styles evident. Two girls at Hampstead Heath Fair, 1961, in fashions of knitted cardigans, polo shirts, shades and the obligatory high beehive peroxide blonde hairdo.

BELOW: The concept of the teenager was not really recognised in the 1920s and so this selection of clothes in a 1924 American catalogue, "The National Money Saving Style Book", are described as being for 'misses or small women.'

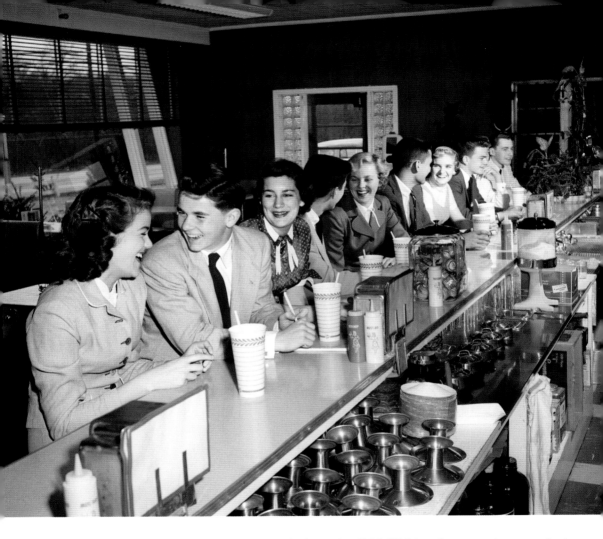

Wholesome looking American teenagers at a soda fountain, 1950s. Within a few years, teenagers had become their own, more defined, social group, often embodying an independent and rebellious style.

OPPOSITE: Teenage girls in the 1970s gain some tuition from a saleswoman at a cosmetics counter. For young girls to wear make-up in the early part of the 20th century would have been unthinkable.

ABOVE : The Ivy League varsity style in the United States was a look borne out of the sporty, casual clothes worn by the (often wealthy) elite of the country's top universities. This clean-cut, all-American image comprised chino trousers, loafers and the essential letter sweater denoting the sporting representatives of a college. The college look for girls consisted of demure knitwear, peter pan collars and a pleated or swing skirt, worn with loafers or bobby socks – resulting in the term 'bobbysoxer'.

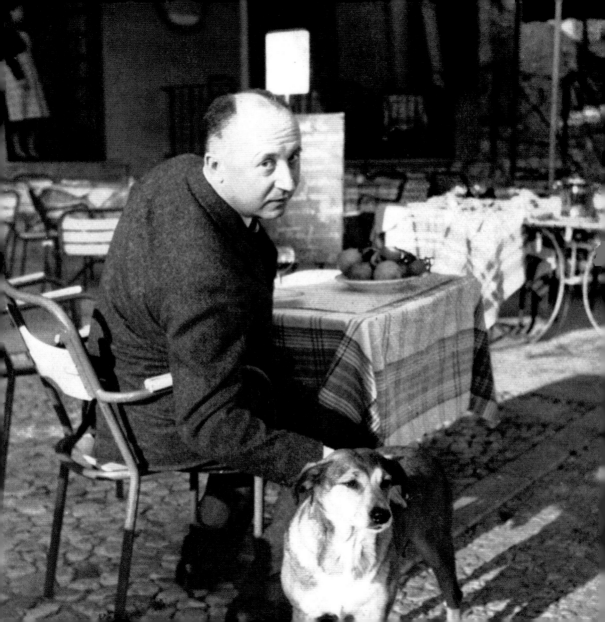

.DIOR & THE NEW LOOK.

OPPOSITE: Christian Dior (1905–1957), French couturier and founder of one of the greatest of fashion houses. Credited with launching the extravagant post-war New Look. Dior famously said, 'My dream is to save women from nature,' meaning his clothes could mould and create an hourglass shape beyond any nature was able to bestow upon the female population.

RIGHT: The 'New Look' was to be the defining shape of the 1950s. Here, outfits by Victor Stiebel on the left, and Ronald Paterson on the right are sketched by Ruth Freeman for Britannia *and* Eve *magazine, 1954. Straighter skirts did give women an alternative such as in the 1920s-inspired outfit by Worth in the middle but the nipped in waist and full skirt were to predominate for much of the decade.*

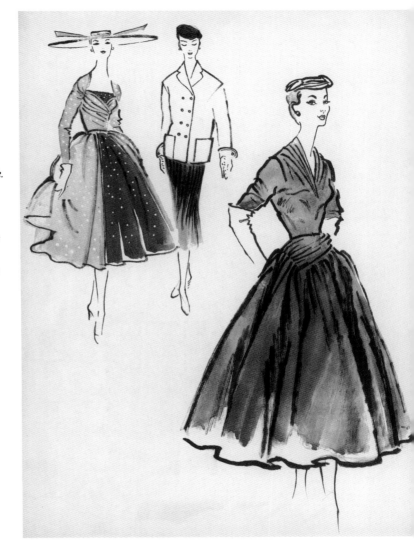

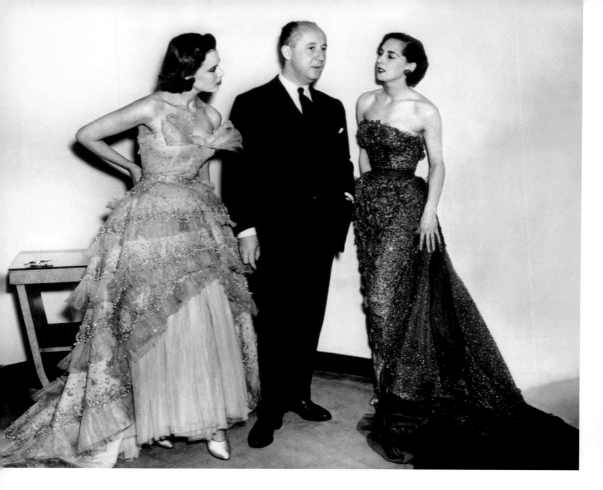

French couturier Christian Dior (1905–1957) with two of his models, late 1940s. Dior worked for Robert Piguet and Lucien Lelong before setting up his own couture house in 1946, bankrolled by French textile tycoon Marcel Boussac. Though elements of the New Look had begun to appear before the outbreak of war (Marcel Rochas had begun to revive the corseted torso for example). Dior's audacious debut collection of 1947 thrilled an audience starved of sumptuous, womanly fashion.

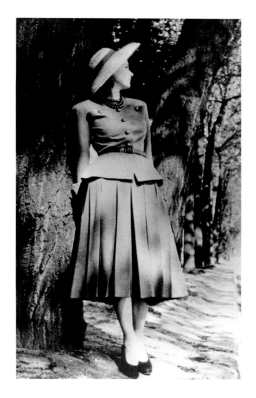

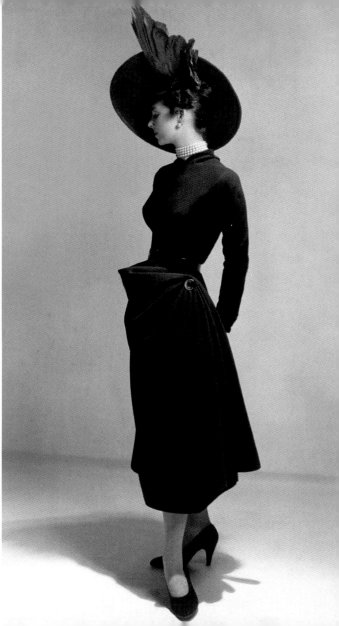

ABOVE: Dior's 'New Look' caused a sensation when it was shown in Paris in February 1947. With nipped in waists and extravagant, full skirts, Dior contrived to construct a more feminine silhouette for the post-war woman.

RIGHT: An elegant Dior costume from 1948.

THE MODERN LOOK

LEFT: Leather barrel-shaped skirts with suspenders and cowl necked blouses designed by André Courrèges, 1965. Courrèges designs were characterised by rigid fabrics, modern shapes and precision cutting. Hats were a homage to astronaut helmets, standing away from the head in an exaggerated fashion.

ABOVE: André Courrèges with two of his 1968 mini-dress creations.

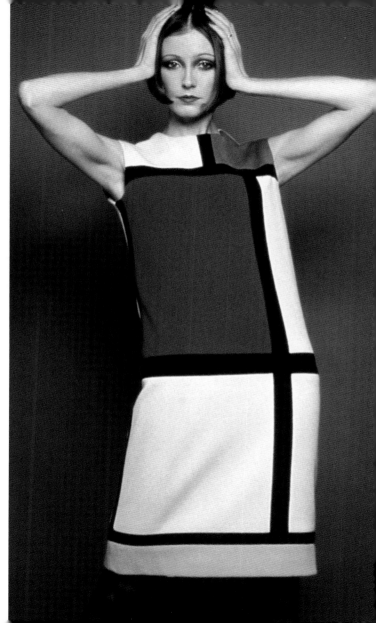

ABOVE AND RIGHT: The 'Robe Mondrian' from the Yves Saint-Laurent Autumn /Winter collection 1965–1966. Saint-Laurent's tribute to the 1930s Neo-Plasticist paintings of Piet Mondrian became a seminal fashion moment when the dress was featured on the front cover of French Vogue *in September 1965. It quickly spawned imitations such as this Neatawear version, which was photographed for* London Life *magazine in November that year.*

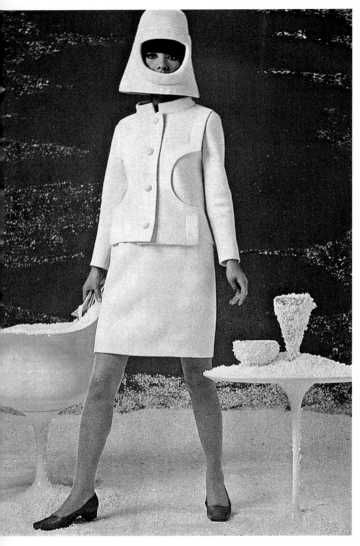

LEFT: *A white wool gabardine suit by Pierre Cardin, single-breasted with an officer collar and a front panel of semi-circular cutouts worn with a welder's helmet in white felt. Cardin was one of a trio of fashion designers, along with Paco Rabanne and Andre Courreges whose clothes took direct inspiration from 1960s space exploration. The futuristic details could be subtle, such as in the modern cut of this suit, or radical like the helmet style hat.*

OPPOSITE: *Audrey Hepburn in 1966 during the filming of 'Two for the Road' wearing a sheath dress by Spanish designer, Paco Rabanne constructed of metal paillettes (actually rhodoid – a cellulose acetate plastic). The dress had been part of the designer's 'body jewellery' collection in the same year, which was inspired by his background in industrial design. Rabanne's dresses have become part of the iconography of the 1960s, couture's boundary-pushing answer to the 'youthquake' fashion of swinging London.*

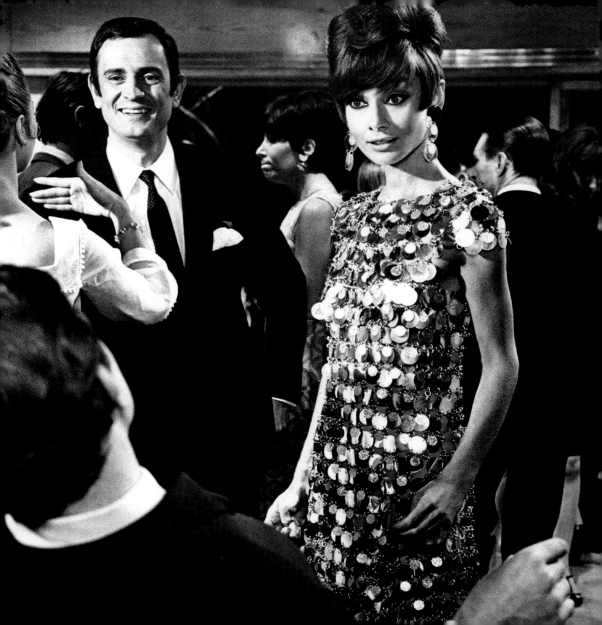

.The British Boutique Boom.

OPPOSITE: Jean Muir (1928–1995), the English fashion designer and dressmaker sporting a Vidal Sassoon haircut in 1966. Muir began her life in fashion at Liberty of London, moving to Jaeger before setting up her own label, Jane & Jane in 1962, followed by Jean Muir Ltd in 1967. Renowned for a pared-down, beautifully tailored and deceptively simple designs, Muir's clothes have stood the test of time and are a masterclass in minimalist understatement.

RIGHT: Vidal Sassoon (1928–2012), British hairdresser, renowned for creating sharp, geometric wedge cuts during the 1960s. A hairdressing legend, Sassoon's precision bobs and wedges became the essential look for the fashion-conscious.

LEFT: Robin Steadman – hair stylist at The House of Leonard *in Grosvenor Street, London, wearing a tweed jacket that he had made to measure at John Stephen Custom Built Clothes in Carnaby Street. A great example of the peacock style of clothing adopted by fashionable chaps in the 1960s.*

ABOVE: Menswear illustration by Fischer in London Life *magazine, 1965, showing two fine cotton shirts, crisply collared, fly-fronted and cuffed in white, both by James Douglas from Clobber in Blackheath, the boutique opened by Jeff Banks in 1964.*

LEFT: A 1966 outfit of scarlet and navy suede and leather butch cap with stitched peak, worn with scarlet and navy suede boots by Terry de Havilland, both from The Yellow Room. *The black cube earrings are by Jewelcraft at Bourne and Hollingsworth. Terry de Havilland's shoes clad the feet of some of the glam rock era's most iconic characters including David Bowie.*

RIGHT: Hylan Booker, Detroit born American dress designer, studied at the Royal College of Art and won the Yardley Award for designer of the year in 1967. A year later he was appointed head designer at the 111-year-old House of Worth where he proceeded to show daring, figure-baring clothes. Notable for being the only black couturier working in the UK at the time, he described 1960s Britain as 'bursting with artistic energy'.

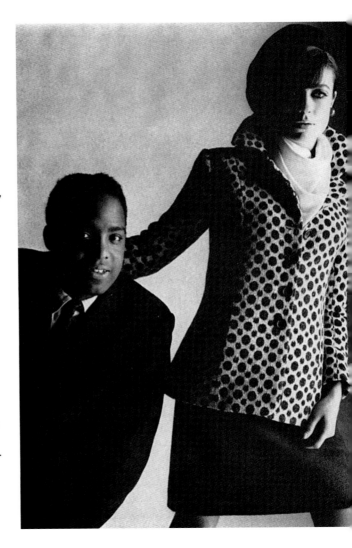

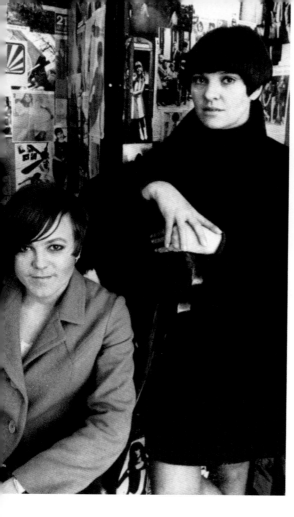

LEFT: Central to the sixties London fashion scene was the British design duo, Sally Tuffin (born 1938) and Marion Foale (born 1939) founders of the fashion label Foale and Tuffin. They designed fun, easy fashion in bright or geometric prints, and especially pioneered a new style of trousers, cut low on the hip to flatter and hug the figure. Pictured here in their store, wearing their own designs. Sally, on the left, is wearing a camel coat called 'Hoot', Marion's wine colored coat is called 'Cooper'.

ABOVE: Vidal Sassoon posing on the cover of the short-lived London Life *magazine together with the French couturier, Emanuel Ungaro in October 1965. A model sports a trademark Sassoon sleek bob and an emerald green Ungaro coat. When Ungaro set up his couture house in the same year he boldly chose not to include evening wear declaring, '"They are not my style. I am a man of this age and I will design for women of this age."*

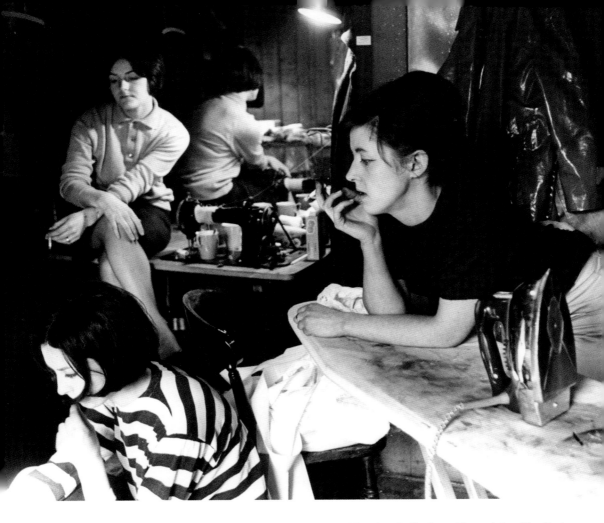

Interior of Kensington fashion boutique Quorum, founded by Alice Pollock and later joined by Ossie Clark and Celia Birtwell; here a break from the sewing machine and ironing board. Quorum was one of the labels at the forefront of the London boutique revolution in the 1960s.

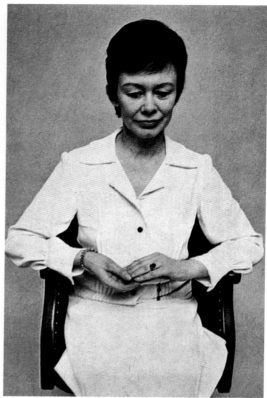

ABOVE: Biruta Stewart-Ure, younger sister of Barbara Hulanicki who founded the mega successful London fashion store, Biba. The shop was named after Biruta, whose nickname was Biba. She is pictured here in the shop in 1966 wearing a navy blue linen coat with off white collar and cuffs, and matching skirt.

ABOVE: Janey Ironside (1919–1979), Professor of Fashion at the Roya College of Art from 1956–1967. She pioneered an understanding of fashion as an academic subject and among her students were Bill Gibb, Sally Tuffin, and Marion Foale. The white crepe suit with black jet buttons was designed by former student Ossie Clarke.

join the switched on set
join the switched on set at the

John Stephen Shops Carnaby Street

Advertisement from 1966 for John Stephen Shops in Carnaby Street, London where you can 'join the switched on set'. John Stephen, at that time just 29 years old was a fashion tycoon, who owned two clothing factories, an estate agency, property around Earl's Court, a vegetarian restaurant in Chelsea, a Jaguar car hire firm and a driving school. He owned eight stores around Carnaby Street specialising in youthful clothing.

LEFT: Sandy Moss, liaison officer between young British designers and a shop called 'Paraphernalia' in London in the mid-1960s. Her dress, in a black and white geometric patterned satin, is by Foale and Tuffin.

ABOVE and OPPOSITE PAGE: A fashion 'happening' in Kensington. A highly publicised moving day for the Biba boutique of Barbara Hulanicki as around 60 models and well-known sixties personalities help to move the shop from its original Abingdon Road location to larger premises on Church Street. Girls can be seen hanging out of the back of the lorry emblazoned with the Biba name while singer Cilla Black and Ready, Steady, Go! presenter Cathy McGowan have been roped in to help out. Hulanicki cites McGowan's patronage of Biba as one of the secrets of the boutique's incredible success.

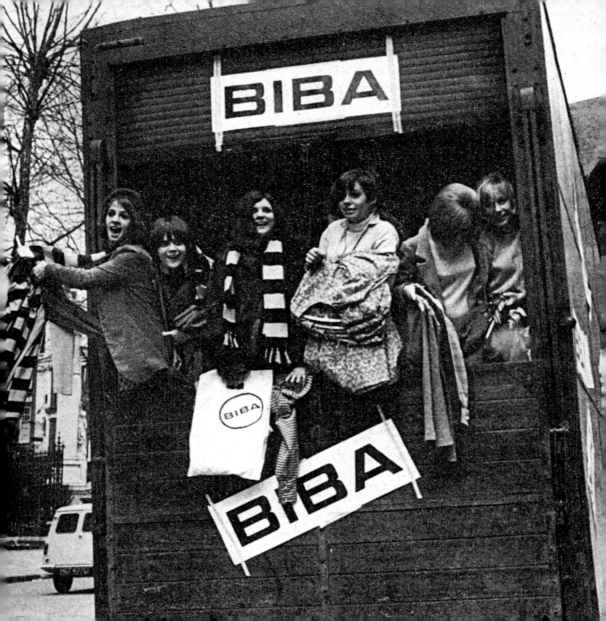

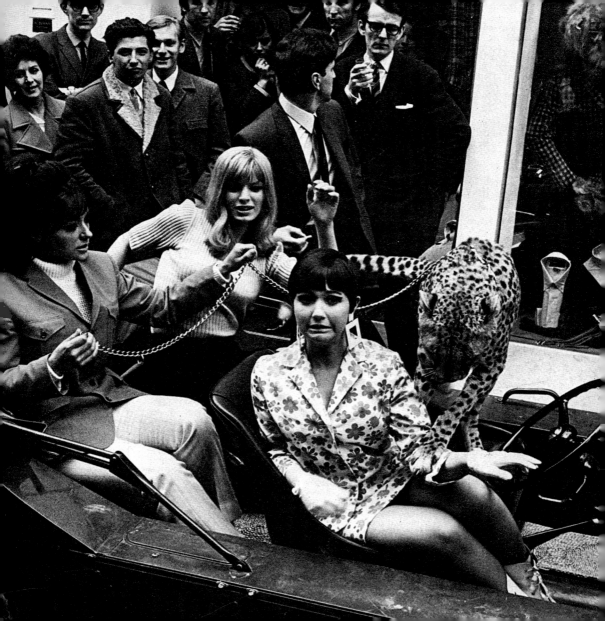

OPPOSITE PAGE: A publicity stunt for the opening of Irvine Sellers' new boutique, Tomcat, in Carnaby Street in 1966 attended by the singer Adrienne Posta who looks a little unsettled to find herself sharing a ride with a furry friend.

RIGHT: Four British models pose for the camera in Paris in the Boulevard St. Germain, 1966. They had flown over along with Alice Pollack and Ossie Clark of the Quorum boutique and staff from London Life *magazine (fashion editor Shuna Harwood and photographer Peter Akehurst) in order to showcase British style and fashions at the opening of a new nightclub, the Gaff.* London Life *magazine reported that, 'from the time London arrived the scene of the Great Couture was all agog at the girls' skirt lengths and owl sunglasses. Ironic really, that London should show them how!'*

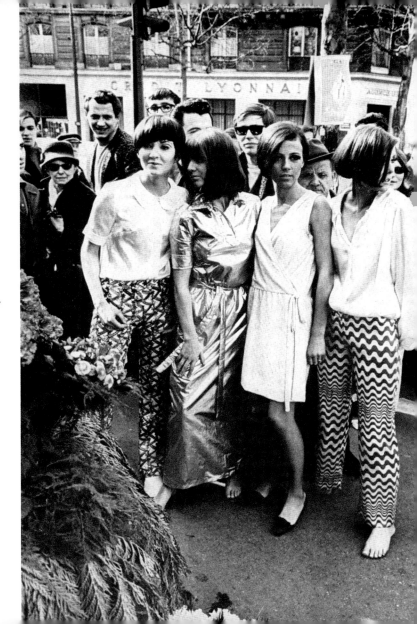

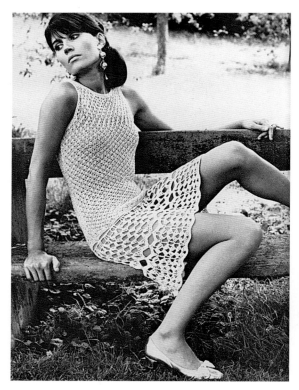

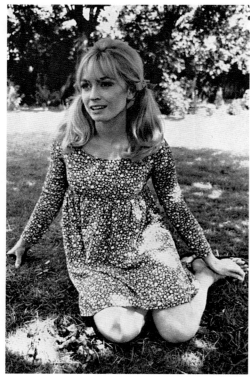

ABOVE: Silver crochet moonray dress, a trade mark of Clobber, the boutique launched by designer and fashion tycoon Jeff Banks in Blackheath in 1964 (the same year Mary Evans Picture Library also launched in Blackheath). Worn with silver planet earrings from Harrods and silver kid shoes by Eliot.

ABOVE: Actress Suzy Kendall wearing an Empire line Biba dress in a floral print of blue, pink and lemon on black - part of a regular feature, 'One Woman's Wardrobe' in London Life magazine which looked at the clothes of fashionable women in the capital.

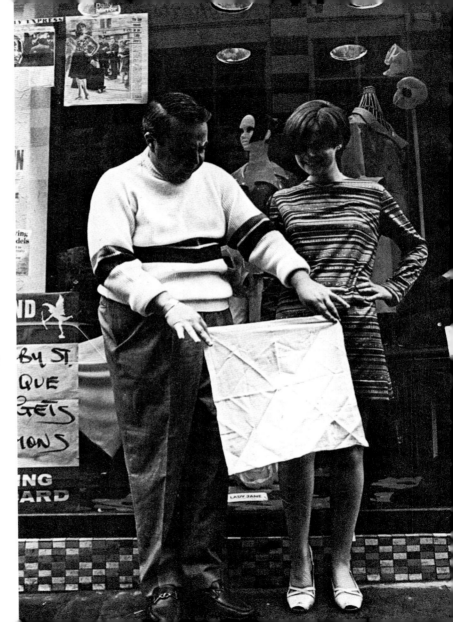

American comedian Allan Sherman poses with Tina Birch (wearing a mini-dress) outside the Lady Jane boutique in Carnaby Street, London in 1966. Sherman was writing a picture feature on whether London was as swinging as Time *magazine had claimed it was that year and tries to preserve Miss Birch's modesty with a handkerchief.*

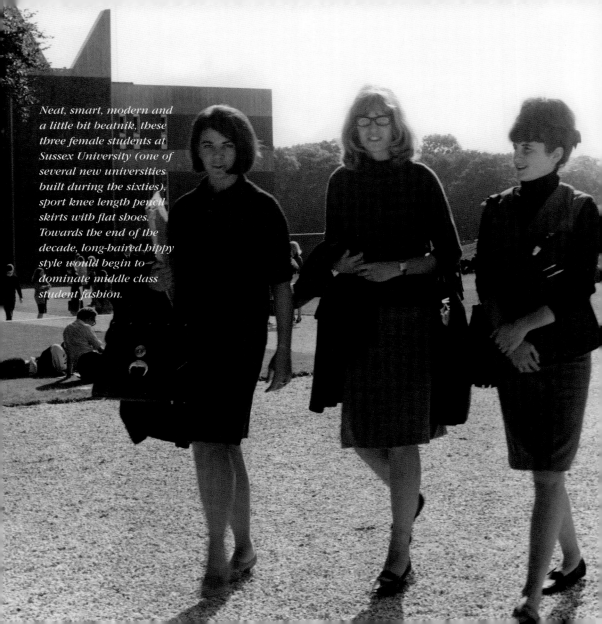

Neat, smart, modern and a little bit beatnik, these three female students at Sussex University (one of several new universities built during the sixties), sport knee length pencil skirts with flat shoes. Towards the end of the decade, long-haired hippy style would begin to dominate middle class student fashion.

.Student Fashion.

RIGHT: A verandah suit in turkey or terry towelling – the very latest idea at Oxford in 1928, according to Man & His Clothes magazine. It also reported that, 'plain coloured pyjamas in new shades such as azalia, beetroot, pink, apricot and peach are the rage of the present term' and the popularity of grey flannel suits and trousers or 'bags'. Unusual trends and outrageous aestheticism were part of the student experience at Oxford in the inter-war years.

BELOW: The cast of a 1927 production entitled 'P.T.O' or 'Please Tell Others' of the Cambridge University "Footlights' Club which was played at the New Theatre, Cambridge in June that year. Significant among the cast is one V.Stiebel, dressed up in drag, second row seated, 3rd from right - the well known dress designer and couturier, Victor Stiebel. Footlights not only produced many of Britain's finest actors and comic talents, but encouraged the abilities of costume designers. Cecil Beaton and Norman Hartnell were also both alumni.

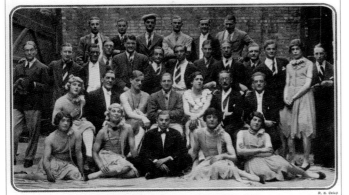

A MIXED BAG.

THE CAMBRIDGE UNIVERSITY "FOOTLIGHTS" CLUB

The cast in the recent production, "P.T.O.," which being interpreted means "Please Tell Others," and which was played with much success at the New Theatre, Cambridge, from June 6 to 11. The names, left to right, are: Back row—P. Orme, T. L. Jones, R. Pennington, J. D'Arcy-Hilgard, M. Phillips, H. Curtis. Second row—S. Livingstone-Learmonth, J. Gellatley, H. E. R. Mitchell, G. Vickers, S. A. N. Watney, C. B. Ford, B. Holroyd, C. L. Daris, R. Gillet, the Hon. S. Allsopp, P. Mills, P. Maturin, R. E. Ranny. Third row—O. F. McLaren, R. Glover, P. Holmes, H. E. Martineau, V. Stiebel, Sandy Rowe, J. Fell Clark. Front row—F. Scott, W. Schuster, C. O. B. Rees, O. F. Martineau, P. E. Scott

.Zoot Suit.

'Zoot Suit' styled trousers, called tramas, of three college students at
Bethune-Cookman College, USA. The high-waisted, wide-legged, tight-cuffed
pegged trousers fashion trend thrived in the American youth culture.

.Teds.

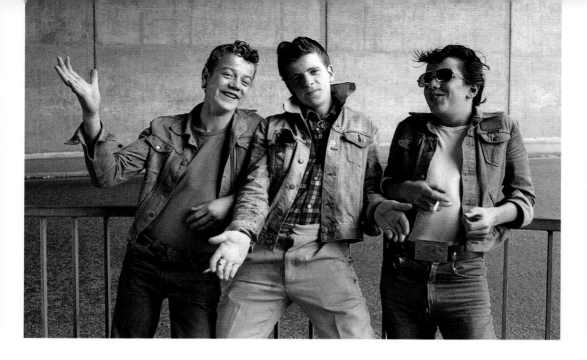

PREVIOUS PAGE: Teddy Boys (Ted's) hanging around the street in North Kensington, London in 1956. Teddy Boys were the original teen rebels. Inspired by the rock 'n' roll music of American, Teds dressed up in homage to the Edwardian dandy with long line jackets, drainpipe trousers, slim ties and brogues, or crepe soled shoes. Hair was greased into a quiff and combed into a 'duck's arse', otherwise known as a 'DA' at the back. Maintaining this tailored elegance did not come cheap and many jackets were paid for in installments. The photographer Roger Mayne, documenting the streets of 1950s London with his camera, took some of the most memorable photographs of Teddy Boys during the era.

ABOVE: The Ted tradition (with a touch of Rockabilly) still going strong in Eccles, Lancashire in the 1970s.

OPPOSITE: Some people find a certain style and stick to it. Teddy Boys in Darlington, Co. Durham in the 1980s.

.Mods.

OPPOSITE: A gang of young mods dancing outside the popular Cona Coffee Bar on Tib Lane, Manchester in 1965.

RIGHT: A teenage couple strike a pose on a quiet London street. He wears a short lounge style jacket; she wears a light coloured mac & flat ballet pumps.

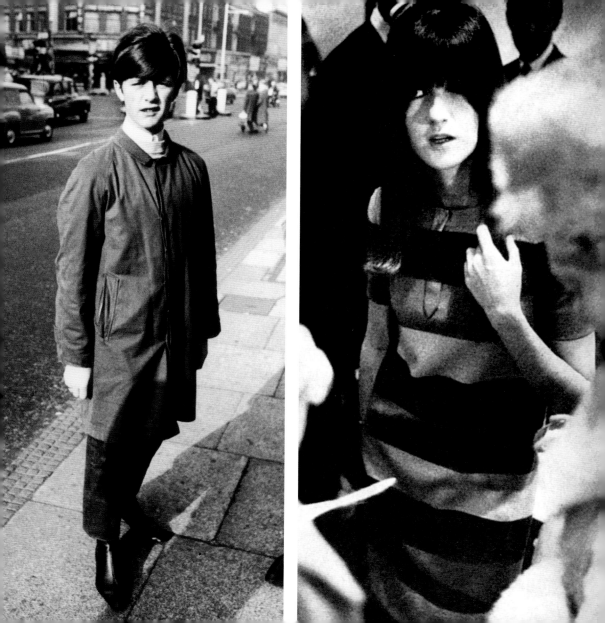

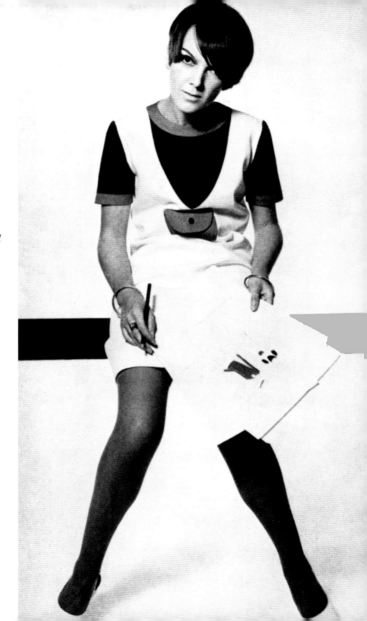

OPPOSITE PAGE LEFT: A young Mod teenager in Brixton, London, 1963. Mod fashion was smart and clean cut, featuring three-button Italian style suits, knitted ties, macs or parkas, desert boots and fine knitwear.

OPPOSITE PAGE RIGHT: Cathy McGowan (born 1943), journalist and TV presenter, found fame and iconic style status as the presenter of the cult pop programme 'Ready Steady Go!' McGowan's style was admired and copied by a legion of teenage fans and she was dubbed, 'Queen of the Mods.' Seen here at a launch of a new range of shoes at a branch of Dolcis on Oxford Street in 1965.

RIGHT: Mary Quant (Born 1934), British fashion designer and fashion icon. She became an instrumental figure in the 1960s London-based Mod and youth fashion movements and is credited with having invented mini-skirts and hot-pants.

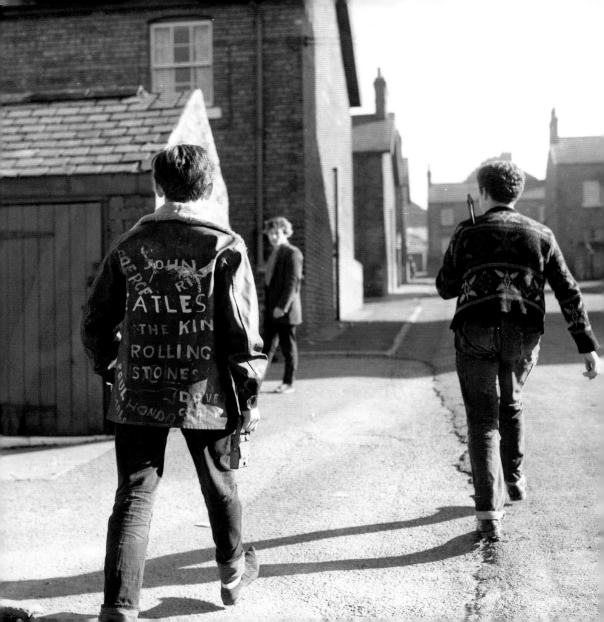

.ROCKERS.

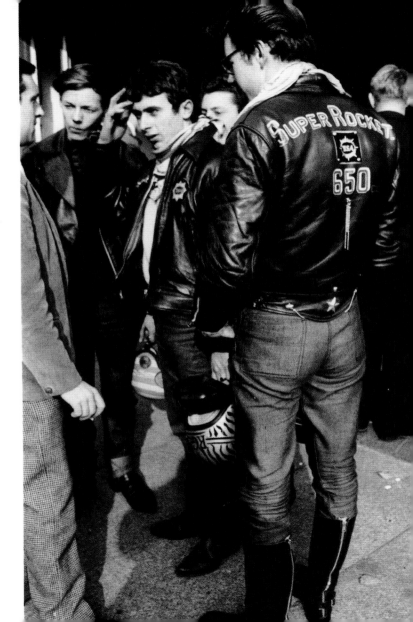

OPPOSITE: *Elements of rocker style, filtered down to the Derbyshire mining village of Doe Lea in the mid-1960s. The boy in the foreground wears 'winklepicker' shoes and a leather jacket with 'Rolling Stones' daubed on the back.*

RIGHT: *Rockers in Brixton, 1963. Rockers rode motorcycles, wore black leather protective jackets with denim jeans, biker boots and greased hair. Emerging at the same time as Mods, the two subcultures were traditionally rivals, with the Rockers considered rougher and tougher, the Mods cooler and better dressed.*

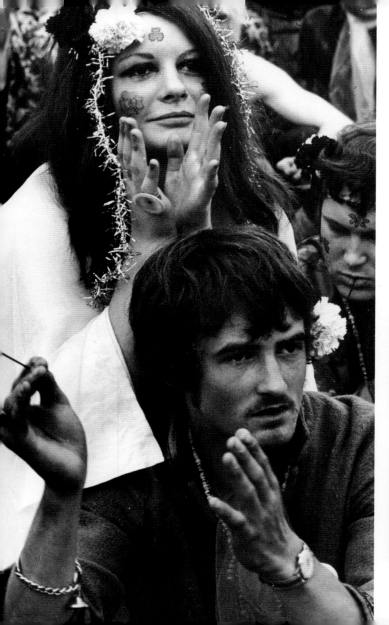

.Hippies.

LEFT: *The perfect hippy couple, both wearing flowers in their hair at the Love-In at Woburn Park, Bedfordshire, England in August 1967.*

BELOW: *Young hippies at the Isle of Wight Music Festival, August 1970.*

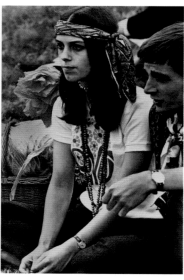

RIGHT: The mini goes micro. Model Biddy Lampard wearing a seriously short mini-dress in 1967, which was inspired by Courrèges. The daisy embellishment forecasts the 'flower power' vogue of the next few years, when hemlines began to change.

Skinheads & Rudeboys.

ABOVE: A group of boys wearing a mix of mod and rude boy style clothing in East London in 1980. While mod youth culture germinated in working class 1960s Britain, the Rude Boys hailed from the dance halls of Kingston, Jamaica and were influenced by ska music. The mingling of these two movements would result in a cross-pollination of clothing styles – parkas were associated with mods, pork pie hats with Rude Boys, but here the two are blended.

OPPOSITE: Skinheads emerged from mod culture as a breakaway group that was felt more representative of its working class origins. Originally united by a love of ska and reggae, the uniform of shaved heads (feathered haircuts for girls), bomber jackets, jeans and the all-important Doc Marten boots later came to be associated with violence and racism practised by a small minority.

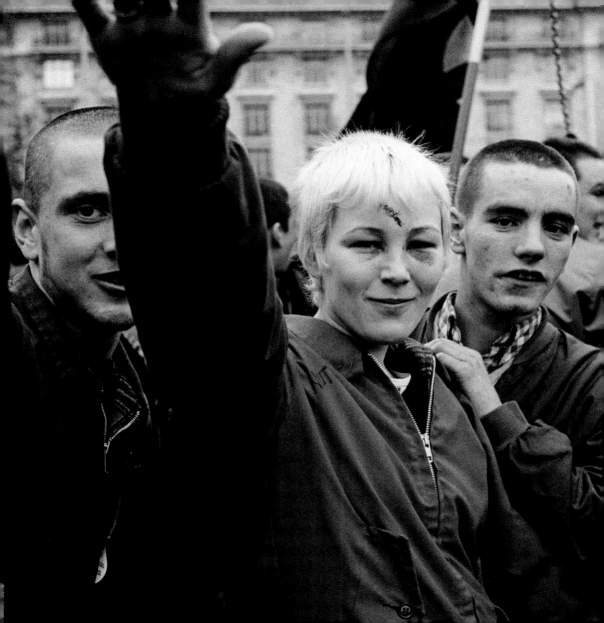

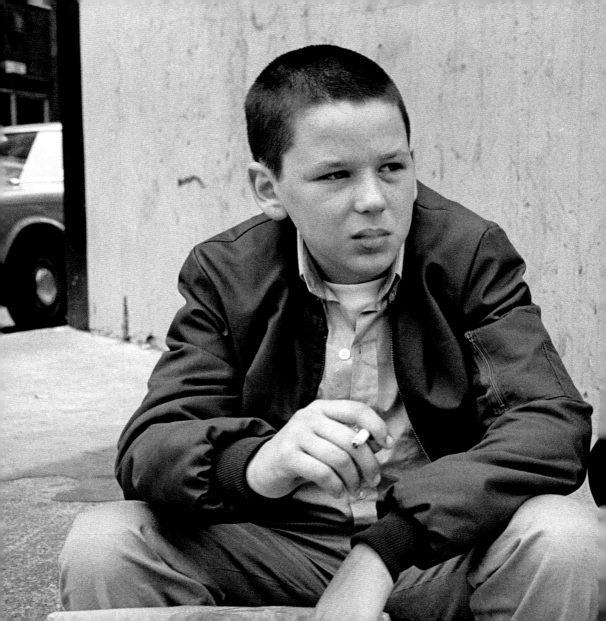

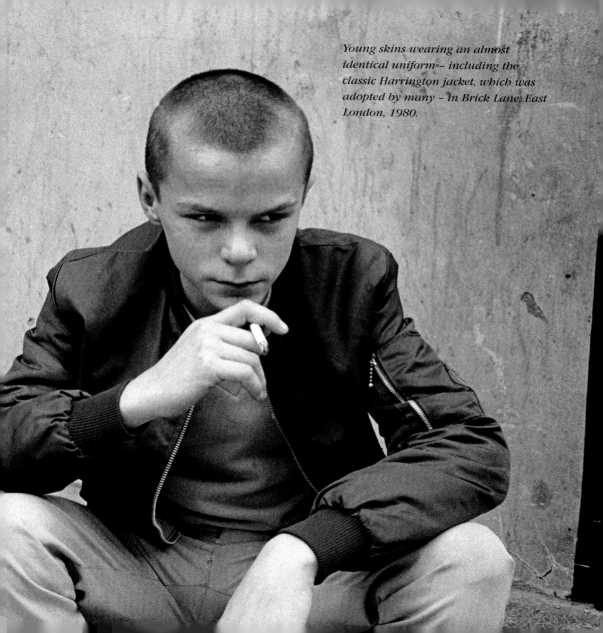

Young skins wearing an almost identical uniform – including the classic Harrington jacket, which was adopted by many – in Brick Lane, East London, 1980.

.70s Disco.

LEFT: *The three-piece white suit may be a much-parodied fancy dress staple today, but 'Saturday Night Fever', the 1977 film that witnessed the journey of Tony Romero (played by John Travolta) from urban cowboy to knight of the dance floor, was a true reflection of the heady, hedonistic days of disco. The costume designer, Patrizia von Brandenstein, sourced rather than made the clothes worn in the film for an authentic feel. From the tight crotched polyester flares and winged collars to the romantic 70s version of 30s and 40s dance dresses worn by the female lead, von Brandenstein created a look that disco-lovers around the world used as a reference point.*

OPPOSITE: *Disco fever, late 1970s.*

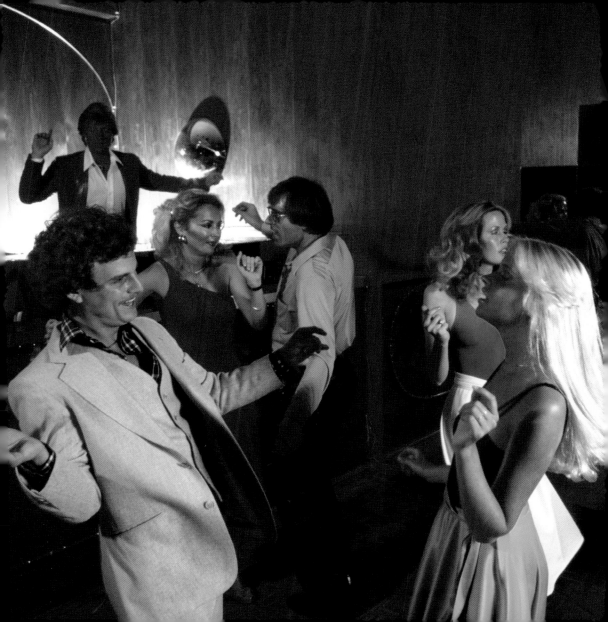

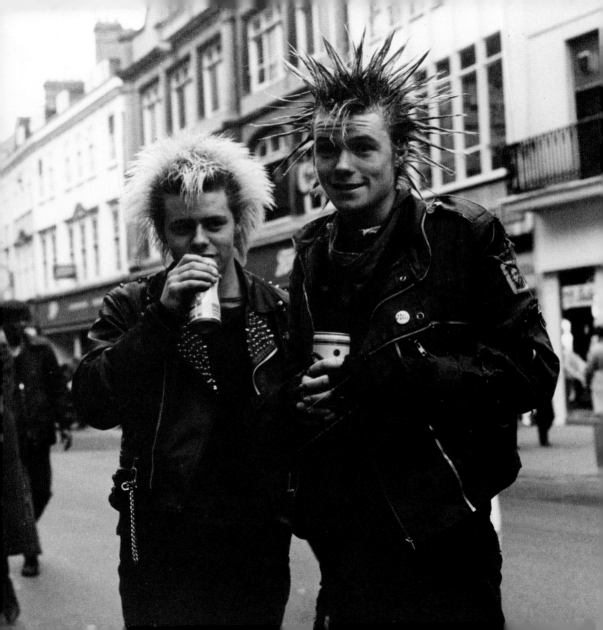

.PUNK.

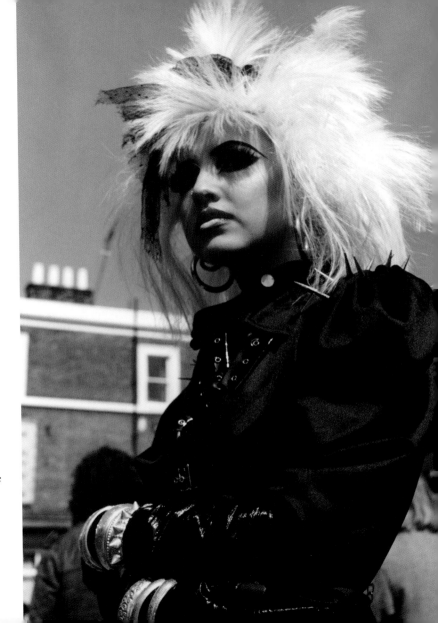

OPPOSITE: Two Punks in leather jackets, with spiked hair, drinking cans of beer in Cornmarket Street, Oxford, 1982.

RIGHT: A punk wearing a black satin dress with spiked shoulder pads, wild white wig, heavy make-up and gold and silver bangles, stands in a Camden street as shoppers hunt for bargains in the market behind, 1986. By the 1980s, many elements of punk style had been adopted by Goths, and the two looks intermingled.

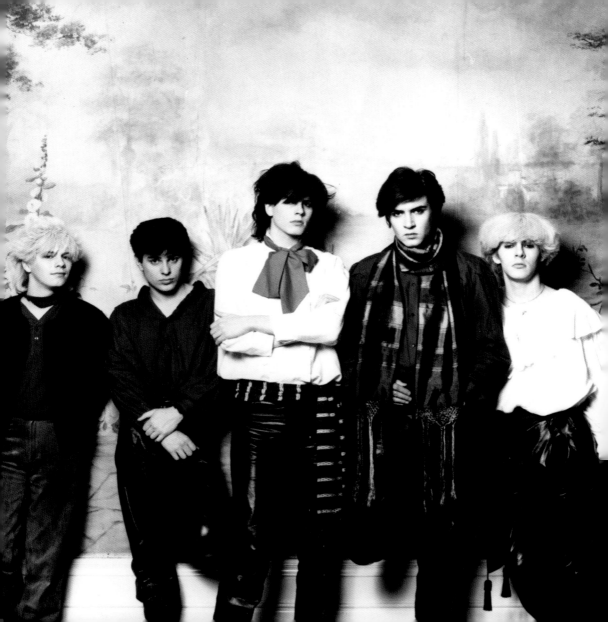

.80s Style & New Romantics.

OPPOSITE: *Birmingham band Duran Duran found global success in the early 1980s, and were a mainstream representative of the New Romantic style of the decade. The New Romantics originated in the Blitz Club in London taking as their inspiration music icons such as David Bowie and Roxy Music. Their style blended romantic elements of historical costume (floppy shirts, boots and piratical scarves), glam rock and old school Hollywood glamour with make up for men and women to create an individual, androgynous and flamboyant look. Duran Duran's early outfits were designed by Kahn and Bell, a Birmingham-based boutique and design label which pioneered the New Romantic look.*

RIGHT: *Limo Babes– late 1970s power dressing. Fashion illustration by Anne Zielinski-Old exemplifying a style that marks the transition between the glam and disco elements of the 1970s and the strident power dressing of the impending 1980s.*

OUT ON THE TOWN

So put your glad rags on and join me hon'
We're gonna have some fun when the clock strikes one.

We're gonna rock around the clock tonight
We're gonna rock, rock, rock till the broad daylight
We're gonna rock, gonna rock around the clock tonight.

It is more than sixty years since Max C. Friedman penned the song that would become a hit for Bill Haley and his Comets but people have been putting on their glad rags both before and since rock 'n' roll declared it an essential element of late night revelry.

Dressing up – 'getting ready' – is part and parcel of going out – a ritual of beautification and transformation from the mere mortals of everyday life into the glamorous inhabitants of a transient, nocturnal world. A new lipstick, a spritz of scent, the haze of hairspray and the rustle of a new frock might be, in some opinions, the best bit about a night on the town.

The dawn of the 20th century coincided with a boom in nightlife and evening entertainment in global cities such as London, Paris, and New York. For those with money to enjoy such things, the theatre, ballet, and opera were soon supplemented by fine restaurants, lavish dinner dances at luxurious hotels and, by the end of the first decade, the phenomenon of nightclubs – initially known as supper-clubs.

This new decadence called for corresponding finery. Undoubtedly the Victorians dressed sumptuously, but the Edwardian era signalled a move towards clothes that reflected a slowly loosening moral code, and styles were cultivated to reflect not only the wearer's wealth but also their desirability. Fashion at this time channelled an exquisite, fairy-like feminity, blending delicate fabrics such as crepe de chine, chiffon and tulle in soft hues of lilac, pink and pale blue with cascades of lace and delicate beading, revealing a heaving embonpoint for evening. On the eve of the First World War, the influence of the Diaghilev's Ballets Russes, with their dazzling costumes designed by Leon Bakst, alongside the eclectic originality of the French designer Paul Poiret injected an exotic Orientalism into fashion. This new style ushered in a looser silhouette and hems became increasingly tapered towards the ankle in the manner of a harem skirt. For those who wished to tango, the new dance craze in 1912, there was the option of a split skirt or harem pants for the more adventurous.

During the First World War, a surprisingly dynamic if financially constrained period for fashion, the theatre became the place where an audience could enjoy a fashion fix as actresses turned the stage into

a catwalk. Lavish costumes were seen as a justifiable extravagance when the theatre was such a morale-boosting tonic. The British designer Norman Hartnell's passion for fashion was first sparked by trips to West End shows as a teenager. He particularly fell in love with the enchanting French actress, Gaby Deslys who would wear costumes designed by well-known names in the fashion world; Maison Callot Soeurs or the society artist Drian. For 'Suzette' in which she starred in 1917, Hartnell recalled that, 'the play did not matter a bit, for the author had wisely based the main interest on Gaby's constant entrances in about fifteen staggering toilettes, designed by Reggie de Veulle. Her succession of gorgeous dresses was quite overshadowed, however, by the even more colossal headdresses that towered, twice her height, above her.'

The war had marked a major shift in women's roles and fashion had adapted accordingly, most markedly in skirt lengths which began to rise and continued to do so in the 1920s until mid-decade saw the flapper look reach its zenith. The soft outline of curvaceous bosoms and hips of the Edwardian age (achieved by viciously constrictive corseting) had evolved in the space of 25 years into an androgynous, flat-chested, slim silhouette. The waist and décolletage gave way to legs encased in flesh or beige coloured stockings ending in elegant shoes. And while this new boyish look might seem ideal for sporting girls, it also translated well into spangled, shimmying evening frocks in which revellers could dance to the sound of the new jazz bands unimpeded. A new generation of young designers rose up to meet this demand - Hartnell himself set up his salon in Bruton Street in 1926, he was joined by other young British designers such as Victor Stiebel, Edward Molyneux (already established in Paris) and Isobel. The link between the fashion and theatre worlds remained closely bound; in Paris, Jean Patou dressed the glamorous sister cabaret act, the Dolly Twins, while both Hartnell and Stiebel had both served an apprenticeship as designing costumes for Footlights productions at Cambridge. It was not unusual for established designers to continue to design for West End plays and musicals during the period.

These couture houses catered to an upper class and monied clientele, the type of customers who could afford to eat out in restaurants or spend long weekends at house parties. In reality, few people would have the requirement for the high-octane glamour found in the pages of Vogue or Harper's Bazaar so the fact that they lacked the means to buy it was an irrelevance. But fashion pages and celebrity endorsement, then, as now, had a part to play in influencing fashion and many women would have at least one 'good frock' for nights out whether it was homemade or bought off the peg from department stores or local boutiques.

In the cyclical nature of fashion, hemlines descended once again in the 1930s and the female hourglass figure began to re-emerge, this time in slinky bias cut gowns worn with full va-va-voom by screen sirens such as Marlene Dietrich and Jean Harlow. While the 1920s had been a homage to the legs, the 1930s revealed the curve of the back, and for the first time, the bottom, and film stars dressed by American

designers such as the MGM costume designer Adrian became the new fashion icons. Cinema continued to offer fashion escapism in the 1940s when the rationing of the war years meant that evening wear was beyond the reach of most. Instead, elaborate coiffures of rolls and curls injected some glamour into female appearance and dresses, when obtainable, were more likely to be economically cut with knee-length skirts and the masculine squared-off shoulders, an echo of utilitarian daywear.

The full skirts of the post-war new look injected a sumptuous, Victorian romance into evening wear which also became increasingly accessible through mid-range design houses (Susan Small, Frederick Starke and Dereta among them) and department stores who offered their own affordable versions of couture gowns in new fabrics like nylon. More formal entertaining at home was also becoming a trend among middle classes making 'dinner' or 'cocktail' dresses another desirable addition to a fashion-conscious middle class woman's wardrobe. But fashion's love affair with evening formality, as dictated from the Parisian ateliers of Dior and Balenciaga remained the dominating factor until the next decade witnessed a seismic shift in the concept of dressing for a night out.

In 1955, Mary Quant opened her London boutique, Bazaar in Chelsea's King's Road. At a time when, according to Quant, 'fashion wasn't designed for young people', her clothes and ideas were playful, hip and aimed squarely at a younger customer. Though beyond the purse of most, Quant's style, and particularly her era-defining 'mini' dress (a garment that can also be attributed to British designer John Bates, and the Parisian Paco Rabanne), cut a swathe through establishment fashion, and set a trend that was to define the so-called swinging sixties. It was an explosive time of youth culture where the post-war baby boomers, all reaching teenage years at the same time, created an unprecedented demand for clothes to suit a new mood. Music, art and fashion seamlessly blended and instead of stage actresses or film stars, rock musicians and waif-like models such as Twiggy or Peggy Moffitt became the new leaders of fashion. Never before had fashion felt so accessible. Department stores phased out their couture departments and instead laid out dedicated areas that sought to recreate the cool buzz of London boutiques such as Bus Stop or Granny Takes a Trip in Carnaby Street, then the epicentre of British fashion. Selfridges launched their youth brand, Miss Selfridge in 1967 – a brand that still remains a high street name today, while the Biba phenomenon, the brainchild of Barbara Hulanicki marked the ultimate in fast, fun fashion. Biba offered an entire concept dedicated to selling a dressing up box of ideas to a market who, at the prices charged, could afford to buy an outfit for a night out and then another after the next pay day. It was the ultimate retail experience and though the fashion was considered comparatively throwaway, Biba pieces today are highly collectable. Paris soon began to ride this new wave of design ideas and the ultra-modern space age style imagined by Pierre Cardin, Courrèges and Paco Rabanne was translated by mid-range designers for the mass market. The

distinction between day and evening wear also began to blur. Mini skirts and dresses in op-art prints, or slim Foale and Tuffin trouser suits were made for sashaying down King's Road as much as dancing at clubs and music gigs. The days of swishing glamorously into a hotel restaurant were long gone. Of course, if an occasion was formal enough to demand it then dinner suits and evening gowns still had their place, but clothes passed some sort of invisible, egalitarian boundary in the 1960s, accelerated by a British-led retail revolution. Soon, donning glad rags became a natural part of a Saturday night out on the town for everyone. And shopping for them was all part of the fun.

Advertisement for Julienne luxury shoes, with shops in Paris, Cannes and Biarritz from
Art, Goût, Beauté, July 1924

The French stage star, Gaby Deslys (1884–1920) pictured in 1911 wearing a typically sumptuous costume. Gaby's extravagant ensembles, including her flamboyant headdresses were an intrinsic part of her act, frequently designed by leading couturiers and set trends for evening attire. One male critic wrote of her outfits, '(they are) so many, so extraordinary, so overpowering, that it must need the verve and personality of a Gaby Deslys to prevent the wearer of them seeing to be no more than a dressmaker's dummy or mannequin.' Gaby's style was to influence the young Norman Hartnell, a designer renowned for his love of decoration and embellishment.

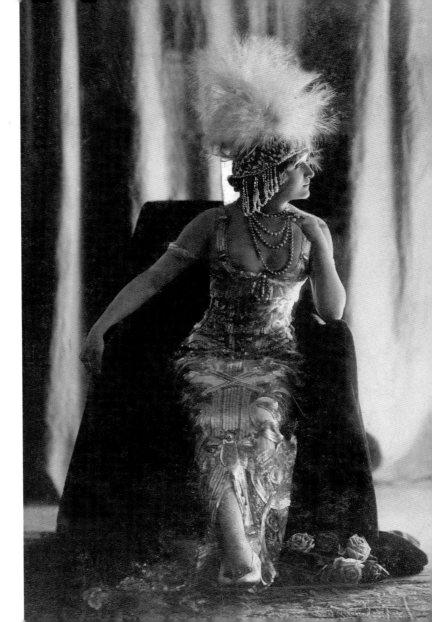

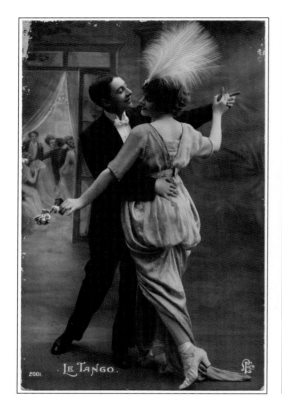

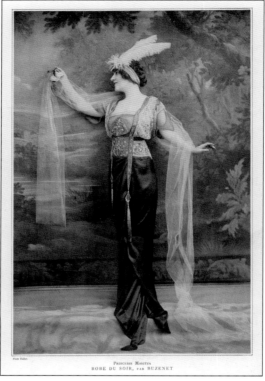

ABOVE LEFT: *The restrictive hobble skirt was not compatible with the tango craze that swept through America and Europe in 1912 and so dancers could opt for a skirt with a split to allow ease of movement, while the more daring might choose harem pants. The combination of the sensual dance with this fashionable outline was one of snaking elegance.*

ABOVE RIGHT: *An exquisite 1913 gown incorporating Chinese style tassels, a narrow draped satin skirt with train and an embroidered, square necked bodice with decorative cut under-sleeves - an example of the taste for exotic Orientalism, particularly in evening wear, just prior to the First World War.*

A LA COMÉDIE
Manteau de Théâtre, par Paquin

ABOVE LEFT: Exotic pink & black kimono style theatre coat by Jeanne Paquin (1869-1936) embellished with Chinese embroidery & trimmed with fur. The outfit, completed by a headdress ornamented with embroidery & beads, is heavily influenced by Orientalism, and reflects the popular silhouette of the pre WWI era with the sack shape coat tapering towards the narrow hem of the skirt. Paquin, who frequently collaborated with artists and designers such as Leon Bakst and Georges Barbier to create stage costumes, was one of seven leading Parisian couturiers to have their designs illustrated in the quality fashion magazine, Gazette du Bon Ton. *This illustration by Francisco Javier Gose is from the first volume in 1912.*

ABOVE RIGHT: Jeanne Paquin, (1869-1936) leading French fashion designer, pictured in 1914 at the peak of her powers. The Sphere magazine, which printed this photograph declared that she stood, "for everything that is beautiful and perfect and original in the world of dress," and as a, "brilliant inventor of most of the new modes."

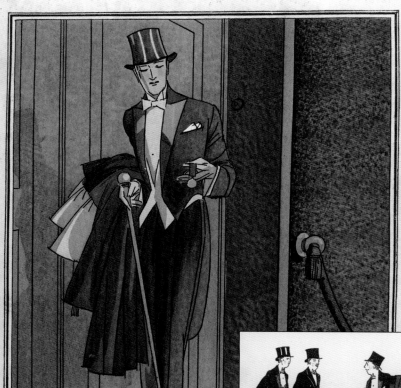

Monsieur

LEFT: Fashion
illustration by Benito
for the front cover of
Monsieur magazine,
November 1920.
Gentleman in full
'white tie' evening
dress, complete with
top hat, cane and
evening cloak.

BELOW: Gentlemen in
evening dress queue to
collect their overcoats
from the cloakroom.
Illustration by Bernard
Boutet de Monvel in
"Gazette du Bon Ton"
October 1913.

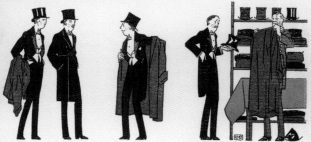

The discovery of Tutankhamun's tomb at Luxor by Howard Carter in 1922 triggered a craze for Egyptian inspired fashion and jewellery in the immediate aftermath. This black evening dress (right) by Madeleine Vionnet (drawn by Thayaht in Gazette du Bon Ton, 1923) , with its tubular long bodice, gored skirt and handkerchief hem shows the subtle influence of the archaeological discoveries, while the jewels by Cartier featured in The Illustrated London News (below) in January 1924 are near accurate replicas of ancient Egyptian pieces.

.THAYAH
23

ONNET

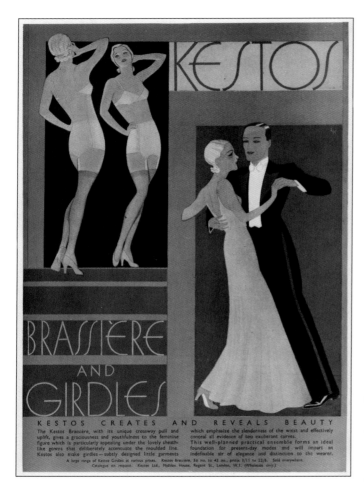

LEFT: A popular underwear brand during the inter-war years, Kestos designed numerous lingerie variations to aid the modern, fashionable woman. Here, the trend for bias cut backless evening dresses is catered to with a special low-strapped brassiere and smoothing girdle. Advertisement from Britannia and Eve *magazine, November 1932.*

OPPOSITE LEFT: An Oriental theme surrounds this evening frock featured in The Tatler *in July 1929. Comprising white chiffon, made of circular flounces graduated in size and sewn to a tight slip worn with green satin shoes, the cigarette case, brooch and bracelets are all made of enamel with Chinese designs. The illustration is by Gordon Conway (1894–1956), a female American graphic artist and designer, who had worked for* Vogue *and* Harper's Bazaar *in America and subsequently went on to design costumes for numerous stage shows. Her pictures epitomise the sleek, svelte, chic new woman of the 1920s.*

RIGHT: Mauve crepe evening dress and matching feather fan by Edward Molyneux, featured in Art, Goûte, Beauté, April 1924. British-born Molyneux (1891–1972) established his first salon in Paris in 1919, opening other branches in France before arriving in London in 1932. His creations were renowned for their simplicity of line and impeccable tailoring. A favourite of Princess Marina, Duchess of Kent, he designed her wedding dress in 1934.

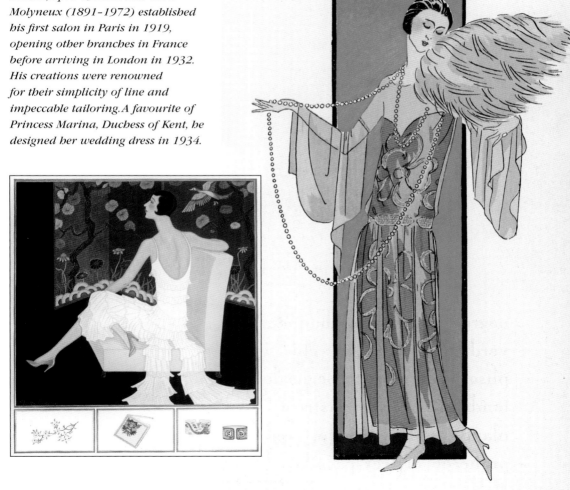

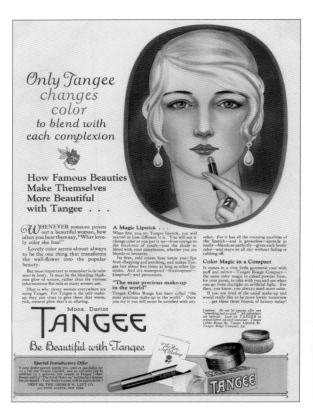

Cosmetics began to be more commonly accepted during the 1920s as more and more women added lipstick and rouge to the face creams and powders they had begun to use during the First World War. A smart compact for reapplications was an essential in any woman's handbag on an evening out. Tangee lip colour adapted to suit the wearer's complexion and can still be bought today.

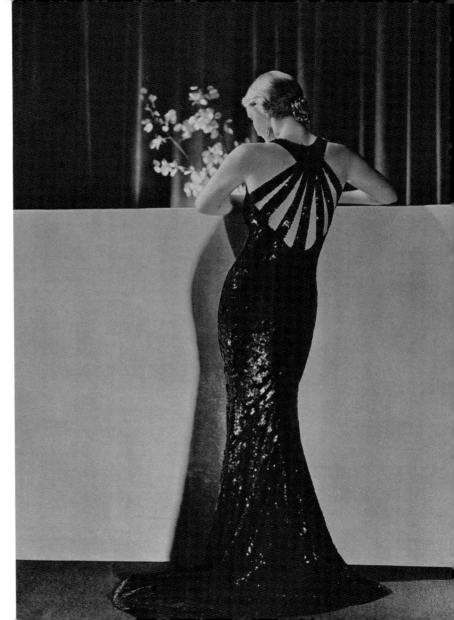

A 1934 evening dress by Patrick Perrott, designed for Liberty of London, composed of sequins made from the shavings of tortoiseshell combs with rayed straps at the back giving it an 'enviable distinction'. As skirts lengthened during the 1930s, the back became a new erotic focus in dressing.

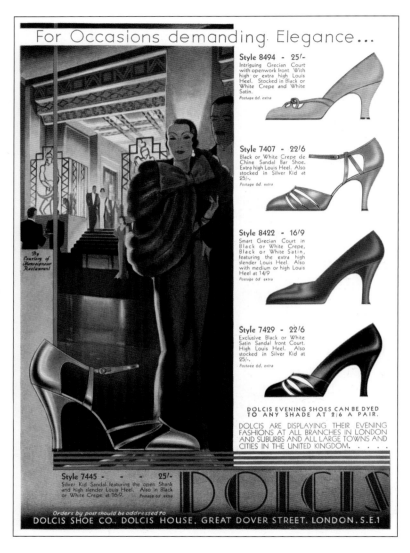

The shoe chain Dolcis, which began life on a street barrow in Woolwich in 1863, evolved into a quality brand designing beautiful shoes for a glamorous lifestyle throughout much of the 20th century. The high street chain lost its gloss in later years and eventually went into administration in 2007. Advertisement in The Tatler, *December 1933.*

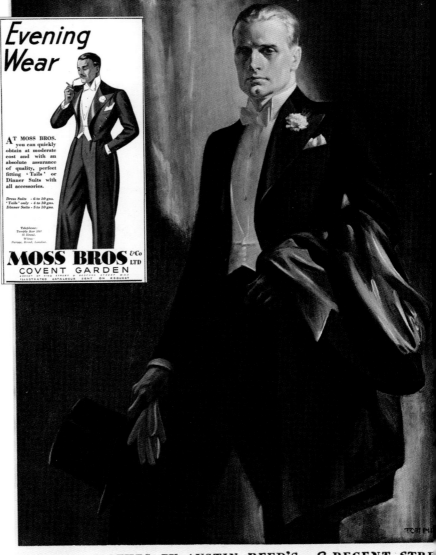

Advertisements from the early 1930s for men's evening wear. Moss Bros was established in 1851 and is still trading today, specialising in suit hire but Austin Reed, renowned for its quality tailoring for men and women, went into administration in 2016.

Evening Wear

AT MOSS BROS. you can quickly obtain at moderate cost and with an absolute assurance of quality, perfect fitting 'Tails' or Dinner Suits with all accessories.

Dress Suits - 6 to 10 gns.
'Tails' only - 4 to 10 gns.
Dinner Suits - 5 to 10 gns.

Telephone:
Temple Bar 1511
(6 lines).
Wires:
Parage, Rand, London.

MOSS BROS &Co LTD
COVENT GARDEN
CORNER OF KING STREET & BEDFORD STREET, W.C.2
ILLUSTRATED CATALOGUE SENT ON REQUEST

EVENING CLOTHES BY AUSTIN REED'S of REGENT STRE

Dress Coat 7 gns · Dinner Jacket 4½ & 6 gns · White Waistcoats 10/6 to 21/- · Trousers 45/-

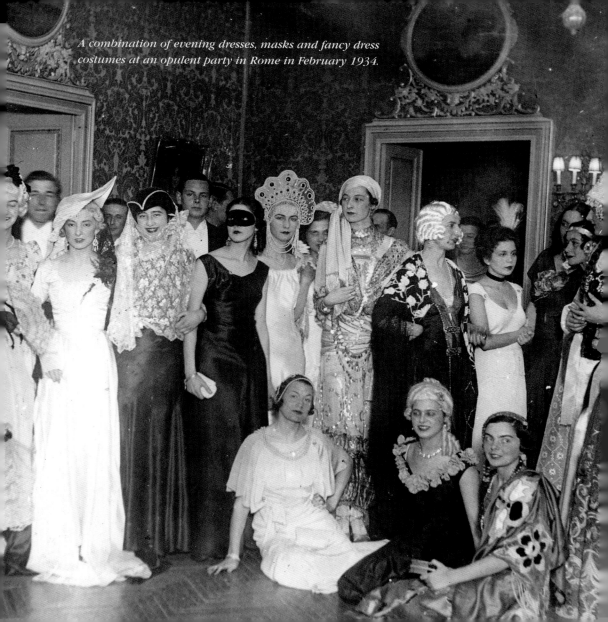

A combination of evening dresses, masks and fancy dress costumes at an opulent party in Rome in February 1934.

ABOVE: A Lanvin dress worn by a mannequin exhibit variations on the angel sleeve.

RIGHT: In the early 1930s, flounced 'angel sleeves' became popular after a similar style was worn by Joan Crawford in the 1932 film, 'Letty Lynton'. Crawford's dress was designed by Adrian (Adrian Adolph Greenberg – 1903–1959), MGM's chief costume designer. The style became a huge influence in women's evening wear such as this organdie, flounced gown (designer unknown)

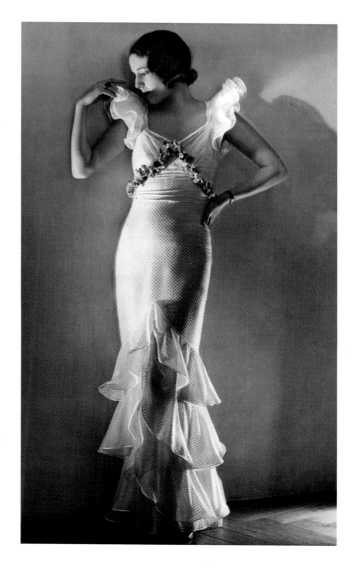

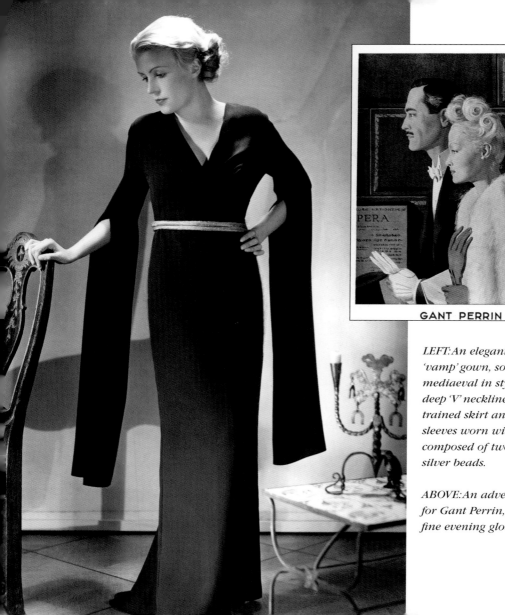

GANT PERRIN

LEFT: An elegant 1930s 'vamp' gown, somewhat mediaeval in style with a deep 'V' neckline, slender trained skirt and hanging sleeves worn with a belt composed of two rows of silver beads.

ABOVE: An advertisement for Gant Perrin, makers of fine evening gloves, c.1938.

Cigarette advertising in the 1930s and 40s promoted a lifestyle of glamour and leisure such as in this example for Wills' Gold Flake published in The Bystander *magazine on 6 September 1939, just a day after Britain had declared war on Germany. The woman's backless dress exhibits a more tailored fit than gowns from earlier in the decade and the waved, swept up hair is typical of the styles that would dominate during the war years.*

"*What's yours?*"
It's a WILLS's GOLD FLAKE
THE MAN'S CIGARETTE THAT WOMEN LIKE

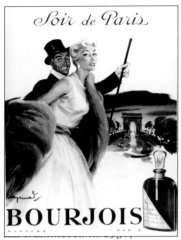

'Shocking' became the signature fragrance of the fashion designer Elsa Schiaparelli. Meant to be the olfactory equivalent of the famed 'shocking pink' shade she used in a number of her designs, the bottle was modelled on the figure of Mae West. This advertisement, from 1938 reflects Schiaparelli's interest and involvement in the Surrealist movement.

ABOVE AND PAGE 206: Bourjois' Soir de Paris – the perfect fragrance for a glamorous night on the town.

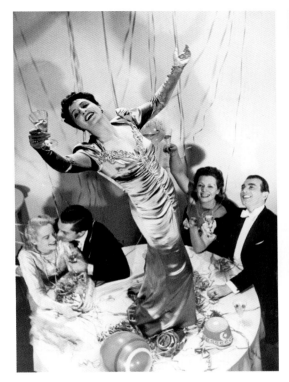

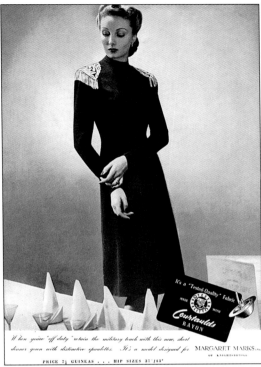

ABOVE: Cheers! The 1930s saw a revival of 1880s style and the dress worn by this central reveller, echoes the late Victorian tight, corseted bodice and narrow skirts, while even the hair is reminiscent of the curled fringe or 'bangs' fashionable at the time and worn by the Princess of Wales (the future Queen Alexandra).

ABOVE: Advertisement from November 1939 for a short gown made with Courtaulds Rayon, designed by Margaret Marks Ltd. Wartime inevitably led to military trends in dress as seen here with the distinctive epaulette detail.

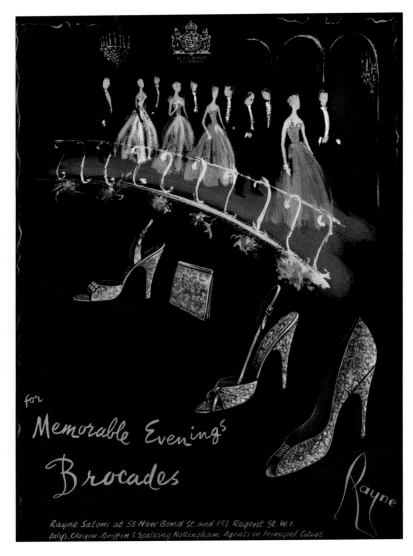

LEFT: A 1953 advertisement for Rayne shoes, in particular their range of brocade heels for 'memorable evenings'. Founded in 1889 to supply shoes to the theatrical trade, the firm of Rayne, which holds a royal warrant, is synonymous with quality and classic style.

ABOVE: Emerald green sleeveless evening gown with detail on bodice, designed by Hardy Amies, 1941.

ABOVE: Clothing might have been rationed and the supply of stockings limited, but elaborate, waved hairstyles more than compensated during the Second World War. This style, featured in 'The Art and Craft of Hairdressing,' was named the 'Cascade' and recommended as an elegant choice for evening.

RIGHT: After wartime shortages, nylon stockings became available once more in the years after the Second World War adding a polished finesse to evening outfits.

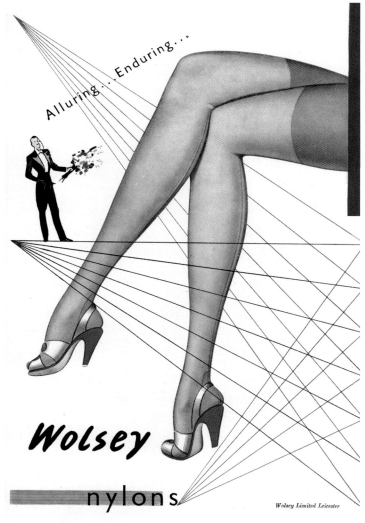

Alluring...Enduring...

Wolsey

nylons

Wolsey Limited Leicester

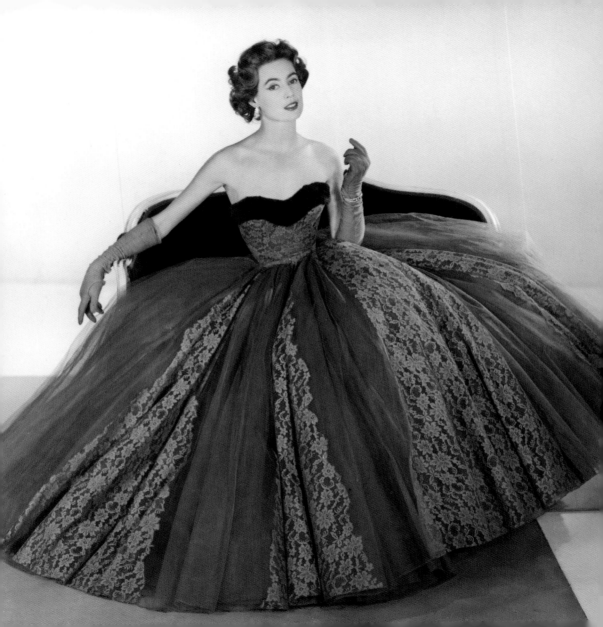

OPPOSITE: *The full majesty of 1950s evening wear. Model Jean Dawnay in 1953 wearing a sumptuous lace and organdie strapless evening dress with a billowing skirt by Victor Stiebel (1907–1976).*

RIGHT: *An evening dress designed by Norman Hartnell in full-skirted organza glittered with love knots. Sketched by Ruth Freeman in* Britannia and Eve *magazine, April 1954.*

OPPOSITE: A short sheath dress in black French silk jersey with a deep V back and décolleté and a swirling hem of black taffeta, designed by Neil 'Bunny' Roger for Fortnum and Mason in 1956. The fashion shoot was set in Roger's own elegant house and the scenario reflects the growing popularity of home entertaining during the 1950s, when cocktails and dinner parties required the hostess to wear something chic and sophisticated.

RIGHT: A Christian Dior evening dress of blue silk organza worn over a number of full net underskirts, embroidered with swags of silver bugle beads and set off by jewellery from Garrard.

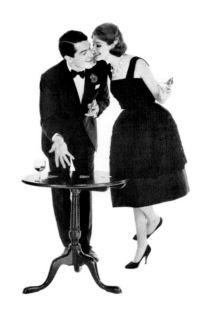

LEFT: A prim and pretty 1959 party dress by Maggy Rouff in white lace mounted on dull pink satin. Shorter dresses became a more typical choice for evening towards the end of the 1950s.

ABOVE: A black cocktail dress by Mattli in crisp, black organdie with a bell-shaped skirt swinging over a stiffened petticoat. The material is crisp organdie with Swiss embroidery. Swiss-born British design Jo Mattli was one of the key members of the Incorporated Society of London Fashion Designers. Vogue described his clothes as having, 'a charming, wearable quality.'

ABOVE LEFT: A Belleville and Cie evening gown worn by Jean Shrimpton in The Tatler, 1962. The skirt is described as a, 'froth of grey and white shadow striped organza bubbles over five layers of net petticoats'. The stripes and white cape over the bodice secured by a wide black patent belt give it a modern twist. Belinda Belville, who would later team up with David Sasson to form the label Belville Sassoon, was one of the go-to designers for debutantes and royalty designing for the Duchess of Kent and later, Diana, Princess of Wales

ABOVE RIGHT: Front cover of The Tatler for May 1962 celebrating London Fashion Week and featuring three models (Jean Shrimpton at the back) wearing colourful ball gowns. They were specially designed for the magazine by three prominent members of the Fashion House Group of London – Frederick Starke made the ball gown in the foreground in gold Sekers brocade, Susan Small designed the gold satin strapless dress in the middle and the orange corded silk and regal purple at the back came from Jean Allen.

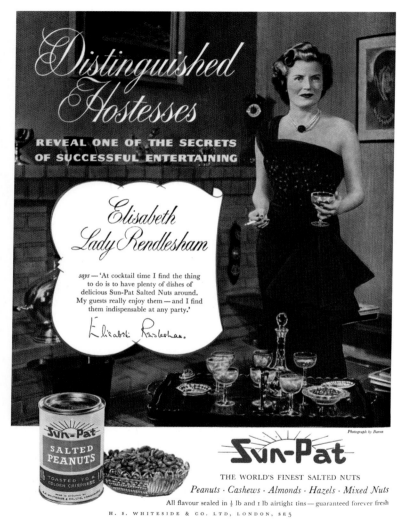

Distinguished
Hostesses

REVEAL ONE OF THE SECRETS
OF SUCCESSFUL ENTERTAINING

Elisabeth
Lady Rendlesham

says — 'At cocktail time I find the thing
to do is to have plenty of dishes of
delicious Sun-Pat Salted Nuts around.
My guests really enjoy them — and I find
them indispensable at any party.'

Elisabeth Rendlesham

Photograph by Baron

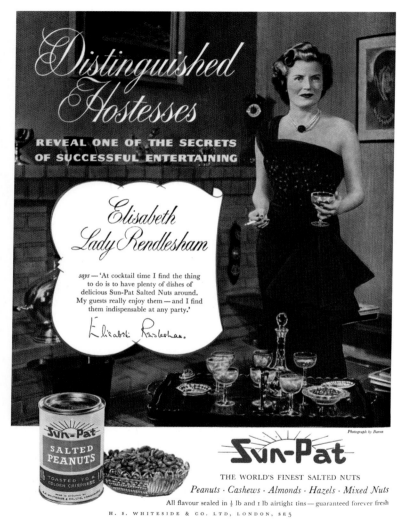

Sun-Pat

THE WORLD'S FINEST SALTED NUTS

Peanuts · Cashews · Almonds · Hazels · Mixed Nuts

All flavour sealed in ½ lb and 1 lb airtight tins — guaranteed forever fresh

H. S. WHITESIDE & CO. LTD, LONDON, SE5

*LEFT: Dressed in an elegant
red velvet cocktail dress,
Lady Rendlesham divulges
the secret of the very best
parties in 1954 – Sun-Pat
salted peanuts.*

*OPPOSITE PAGE: Bingo
hall, Sheffield, 1963. Going
out does not always
require dressing up. Note
the woman in the middle
who is still wearing hair
curlers and an apron
underneath her coat.*

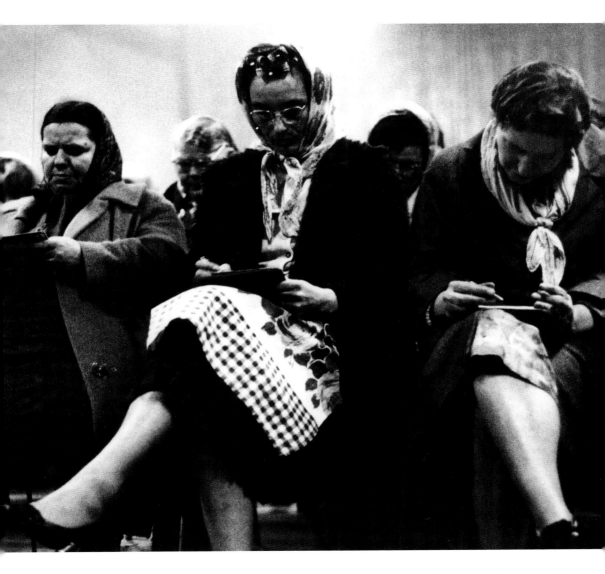

OPPOSITE: Model Danae Best (with her son Alexander) pictured in London Life *magazine in 1966 wearing a purple moire trouser suit from Biba. Biba offered eclectic, glamorous and affordable clothes to a younger generation who had become increasingly fashion conscious. Retailing food as well as clothes and accessories at the height of its success, it offered shoppers an entire lifestyle concept at a time when London was at the epicentre of a youthful revolution.*

ABOVE: An Yves St Laurent full length evening shift in violet jersey with rose pink, silver embroidered sleeves and polo collar. The curled vertiginous hair is by Bruno at AldoBruno. The shape and unusual contrast of fabrics make this 1964 dress a modern take on traditional evening wear.

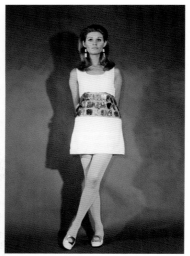

LEFT: Young women and their dates queue for entry into a dance hall in Norwich in the 1960s. A world away from the couture looks featured in glossy magazines, the look is tight jeans, cardigans and beehive hair for women and sharp suits & quiffs for men.

ABOVE: Mini-dress: bodice and skirt are joined by a band of flat metal discs riveted to transparent plastic – a futuristic style reminiscent of Paco Rabanne's metal dress of 1967.

OPPOSITE: Dance hall dirndls. Two girls in hoop skirts dance a jive in front of assembled parents in the early 1960s.

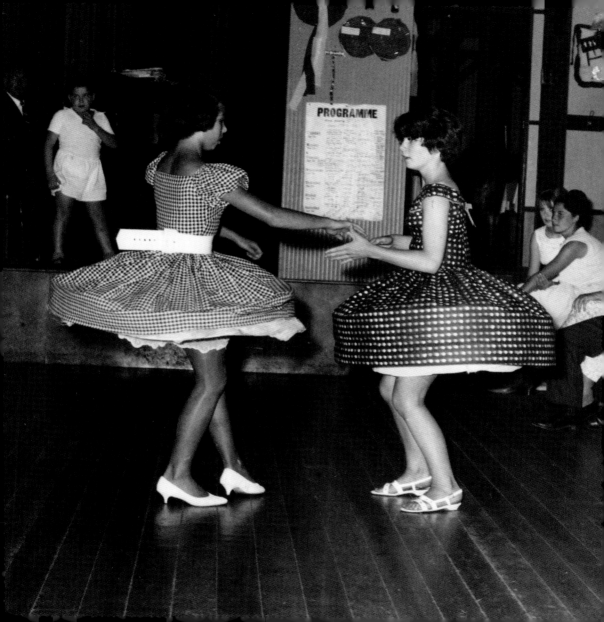

PROGRAMME

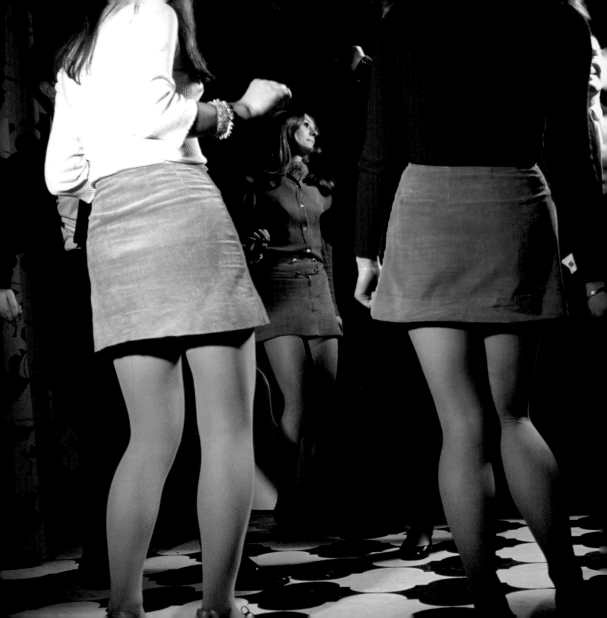

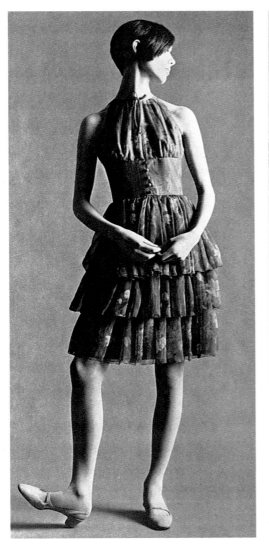

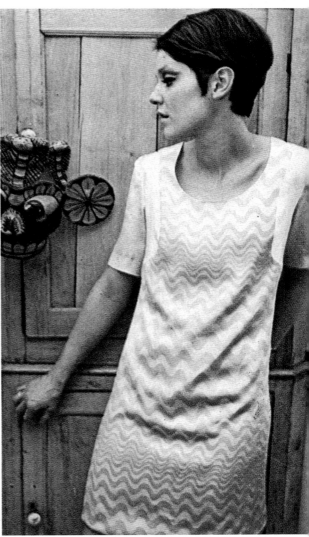

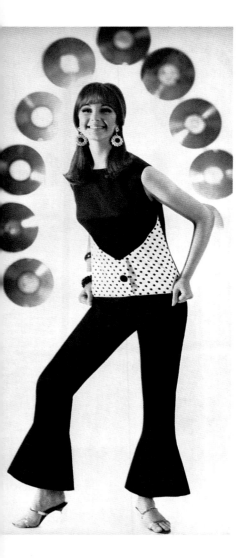

PAGE 242: *Just a decade on from the sumptuous skirts of New Look style evening gowns, nights out in the 1960s was dominated by the mini-skirt.*

PAGE 243 LEFT: *A party dress from 1965 of soft chiffon in an exotic print by Jane & Jane (designed by Jean Muir until she launched her own eponymous label in 1967). Available from Woollands of Knightsbridge.*

PAGE 243 RIGHT: *Alice Pollock (born 1942), the British fashion designer and retailer who founded the boutique Quorum, where she stocked the work of fellow designers Ossie Clark and Celia Birtwell. Pictured here wearing a dress in two shades of green by Ossie Clark with fabric designed by Celia Birtwell for Quorum, a simple shift that could take the wearer from day to evening. The old rules of dressing were fast disappearing.*

LEFT: *For the 'young individualist' – a disco trouser suit in pitch black rayon Tricel comprising a shell top with polka dots and sassy trumpet trews, available from the 'Younger Set Evening Dresses' department of Harrods in 1965. During the sixties, traditional stores recognised the burgeoning youth market and opened dedicated departments.*

OPPOSITE: *Girls on a night out in Darlington, Co. Durham in North East England in the 1970s wearing identical pinafore style dresses and make up. Beauty trends saw plucked, pencil thin eyebrows and pale shimmering eye shadow popularised in the early 1970s as a kind of beauty homage to 1930s film stars such as Jean Harlow and Greta Garbo. In reality, the effect did not always flatter!*

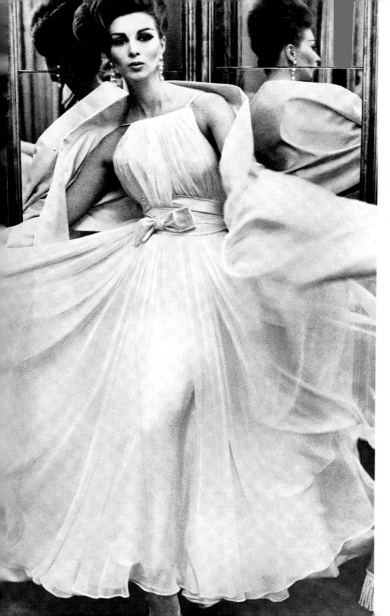

LEFT: The return of the ball gown 'a la Grecque'; a pearly white chiffon dress with flounced skirt and shoestring strapped bodice swathed at the waist and accentuated by a bow of pink satin, worn with chandalier earrings in pearl and diamond. By Balmain, 1962.

ABOVE: Ballgown couture by Harrods drawn by fashion artist, Anne Zielinski-Old in 1982. The romantic off-the-shoulder evening dress echoes the crinoline revival work of designers such as David and Elizabeth Emanuel as worn by Diana, Princess of Wales.

The costumes worn in the long-running, prime time 1980s American soap Dynasty, *featured sequins and shoulder pads galore. Designed by Nolan Miller (1933–2012), the clothes epitomised the affluent glamour and glitzy power-dressing of the era.*

SPECIAL OCCASIONS

On 21 February 1933, traffic ground to a halt in the roads around Brompton Oratory in Knightsbridge as crowds gathered to witness one of that year's most eagerly anticipated events – the wedding of Miss Margaret Whigham to American golfer Charles Sweeney. The fascination with the new Mrs Sweeny had taken hold three years earlier when she emerged in her first Season as debutante of the year, celebrated as the epitome of grace, good looks and style. Of her appearance at Ascot in 1930, The Tatler oozed compliments writing, 'Miss Margaret Whigham must, I think, be awarded the prize for this year's dazzle of debutantes. Her black and yellow chiffon dress only helped to confirm a pretty general opinion…'

The designer Norman Hartnell was equally smitten, writing in his memoirs – 'her perfection of appearance recalls the pink and white camellias, and her hesitant stutter adds one more charm to this beautiful person who showed the women of her age how to use cosmetics, how to dress, how to be a success, and how to behave whilst becoming one.'

It was Hartnell who was called upon to provide a wedding gown worthy of such a style maven and he did not disappoint. Margaret's princess dress of figure-hugging ivory satin was described in The Times as heavily embroidered with a jasmine flower design picked out in pearls and crystals. The train splayed out behind the bride a full five yards creating a pale river of satin either side of which a crowd of onlookers and press men strained to get a closer look at the it girl of her day. The overall effect declared *The Tatler,* 'fully justified her reputation for loveliness.'

More than eighty years later, Hartnell's creation was once more the subject of fervent public scrutiny when it was chosen as one of the exhibits at a blockbuster show of wedding dresses at the V&A museum in 2014. Standing alone in a case large enough to allow the train to fully fan out, it remains a breathtakingly exquisite example of 1930s couture, a dress evocative of an elegant era, and a mouth-watering marriage of show stopping chic. At the time Hartnell had designed the dress, he had hit his stride as one of Britain's top-flight designers, and his love of theatre and occasion would ensure that many more wedding dress commissions would cement his reputation as the go-to man when the occasion demanded something spectacular. He would, after all, be remembered as the creator of the future Queen Elizabeth II's wedding dress in 1947, and, in 1953, her magnificent Coronation gown.

Hartnell was also a pair of safe hands for any young lady embarking on her first Season as a debutante.

OPPOSITE: A high fashion wedding dress from 1958 by Carina Martin in lace tinted with the merest pink, with a skirt short enough in front to show a stocking and slippered foot. Worn with an organza rose headdress and satin Dior shoes.

While not all might be able to pull off the inherent chic of Miss Margaret Whigham, most young women of the upper classes who would embark on this intensive, three-month social whirl of balls, dinner parties and sporting fixtures, would hope to do so while being well dressed. It was an undertaking that did not come cheaply. A debutante's trousseau for her first Season might cost around the equivalent of £12,000 today. The highlight of a debutante's first Season would be her presentation at Court when she went to Buckingham Palace to make her curtsey in front of the King. Courts were abolished in 1958, outmoded and no longer relevant in a modern, more meritocratic society, but in Hartnell's day, designing court gowns was a lucrative element of his, and many other dressmakers', annual business. Interviewed in *The Queen* magazine in 1932 he advised on tulle for a teenage debutante's court gown being, 'suggestive of youth and unsophistication.' In the same issue, the magazine compiled what was apparently a modest list of clothes a debutante should amass to be prepared for her first season. It included six pairs of shoes, ten pairs of gloves, four new sets of underwear, an evening cloak, a coat to 'go over tennis frocks' and all important 'afternoon frocks for Ascot etc. with hats to match.'

Debutante balls and court presentations may be relegated to the past, but Ascot remains a key fixture of Britain's summer sporting season and has provided a spectacle of style throughout the decades right up to the present day. It is a chance for the most fashionable to put on a show in their finest attire (especially the hats) and for the press to record it for eager readers. Royal Ascot basks in the presence of the monarch, but in 1910, following the death of King Edward VII, society was plunged into mourning and the papers of the day ran stories on the novelty of seeing the Grandstand and royal enclosure transformed into a sea of black and mauve.

Dressing for a special occasion is not of course the preserve of the wealthy and privileged. For everyone, dressing up and looking one's best is a way of marking and honouring the memorable moments of life, from cradle to grave. Baptisms, confirmations or first communions, birthdays and weddings have all required specific clothes not just for the main protagonists, but for the supporting cast too. This chapter includes bridesmaid and wedding guest fashions as well as mother of the bride outfits. In addition to the illustration of the Queen's coronation dress, there is an example of a gown designed by Mattili, and worn by a member of the congregation, Carly Thorneycroft. And in amongst the glamour and influential high-end couture, there are examples of times when dressing up had to be curtailed – during the Second World War for instance, many weddings were necessarily simple, the bride often wearing a day dress or skirt suit, or sometimes proudly wearing uniform herself.

Today's fashion's magazines are bulging with suggestions for clothes to wear during the Christmas party season, and things were no different in the 1930s or 40s. Children's party clothes are remembered too, not

just the traditional flounced, beribboned party dress but fancy dress or carnival costumes, a reminder that countless outfits for special occasions over the years have been the result of a sewing machine and a kindly and skilled relation or neighbour.

For the 1950s American teenager, her prom dress would be the most exciting purchase of her life to that point, an outfit that would take her on a rite of passage signifying the end of her time as a high school student. The prom phenomenon, associated particularly with the 1950s and those sweetheart prom dresses with their net petticoats, has endured and has now spread beyond the States. Many UK and Australian schools have dispensed with an end-of-term dance or ball in favour of a 'prom'. And the fashions have escalated accordingly.

And this is the appeal of special occasion dressing. For better or for worse, it awakens a sense of adventure in the wearer, and allows for a little (or a lot of) flamboyance. Seventies wedding dresses incorporated exaggerated historical elements, from high-necked bodices to Elizabethan trumpet sleeves. The romantic trend of the mid–1930s, when hems tumbled back down to the ankles and floaty chiffon dresses were worn with floppy hats and parasols, seems perfectly at home in grounds of Royal Ascot or at a high society garden party. The first half of the 20th century saw thousands of little boys and girls dressed as miniature Renaissance maidens or in Gainsborough–era satin breeches at weddings, victims of the bride's desire to recreate a picturesque pastiche of a previous era. Yet there is no arguing that the overall effect was utterly charming. Some of the cleverest and savviest of special occasion dressers manage to combine wit with style. Take the wonderful aviation themed hat worn with aplomb by Miss Constance Babington Smith at a Royal Aeronautical Society garden party in 1938 – a choice of headwear that undoubtedly rises to the occasion.

And is there anything to rival the sinuous beauty of Margaret Whigham's wedding dress? Mary Ashley in her 1927 wedding to Captain Alec Cunningham-Reid certainly comes close. Knee-length and flirty, her dress is ravishingly fashionable while the fringe beading give it a magical shimmy. Blending high fashion with a sense of occasion can be a delicate balancing act but The Observer noted that the ensemble was given dignity by the 'long train of silver tissue edged with three rows of crystal fringe' and the 'oyster white tulle veil'. Like the Whigham-Sweeney wedding five years later, thousands swarmed outside St. Margaret's in Westminster to get a view of the bride who was the sister of Lady Louis Mountbatten.

Whichever of these brides win in the style stakes, neither of them won in love. Mary divorced her dashing husband in 1940 – and he successfully sued her for half her annual income. Margaret divorced Charles Sweeney in 1947 though the pair remained on amicable terms. She did, however, suffer a spectacular fall from grace in 1964 when the scandalous divorce case between herself and her second husband, the 9th

Duke of Argyll, revealed that she had indulged in a string of adulterous affairs. One wonders what Hartnell thought of it all.

One thing is clear, the dress he created in 1933, is, like many wedding gowns, proof that clothes worn to mark special occasions frequently outlast the people and the events they were made for. Margaret's wedding dress, when it was recently displayed in one of the world's finest museums, is a dignified and elegant reminder of a girl who once had the world at her feet.

OPPOSITE: *Five Eton College schoolboys in smart suits and top hats, sitting on a wall on 4 June, one of the fixtures of the Season for smart society. Traditionally, it is the date when King George III's birthday is celebrated at the school with speeches, cricket games and a boat procession. The boys are wearing polished top hats in this Edwardian era photograph. The headwear was abolished at the school in the 1960s.*

RIGHT: *Four children in fancy dress, 1930s.*

OPPOSITE: Fashion shoot from 1965 showing elegant formality for ladies who lunch, in this case, at the exclusive Mayfair restaurant, the Caprice. On the left, model wears a slip dress in navy linen by Norman Hartnell's Petit Salon with a navy-edged white panama Breton hat by Jean Barthet. On the right, a Chanel-styled suit from Paris in turquoise ribbed wool, lined and bloused in turquoise georgette from Fortnum and Mason and a matching felt hat by Otto Lucas.

ABOVE LEFT: The prom was synonymous with the American teenage experience and was a defining moment for every high school girl, who would spend time and seek advice from friends before deciding on her dress. The sweetheart style prom dress, often strapless with a crinoline style skirt was the classic prom look and would be worn with a corsage – given by the girl's date for the evening – pinned to the waist.

ABOVE RIGHT: A young bridesmaid holding a basket of flowers and wearing a flounced white dress and hair ribbon at a wedding in Buckinghamshire, late 1950s.

ABOVE: A garden party dress with a high waist, gathered corsage, sash belt & heavily embroidered skirt with a plain yoke. Worn with a capeline hat with a velvet hatband. Featured in Femina *magazine in 1912, this period of style would inspire Cecil Beaton when he created the costumes for the musical, 'My Fair Lady.'*

ABOVE: Garden parties were an excuse to dress up and in this case, on an aviation theme. This is Miss Constance Babington Smith (1912–2000) at the 1938 Royal Aeronautical Society Garden Party held at Fairey's Great West Aerodrome, Hayes, Middlesex wearing a hat quite fabulously topped with a miniature aeroplane.

A short yellow satin party or dancing dress, suitable for a debutante, with delicate embroidery and self-encrusted flowers in pale yellow chiffon by Rahvis. The skirt is turn back (puff ball) and comes with a chiffon evening coat. Rahvis, run by sisters Raemonde and Dora Rahvis was one of London's best known couture houses and specialised particularly in romantic occasion wear for high society.

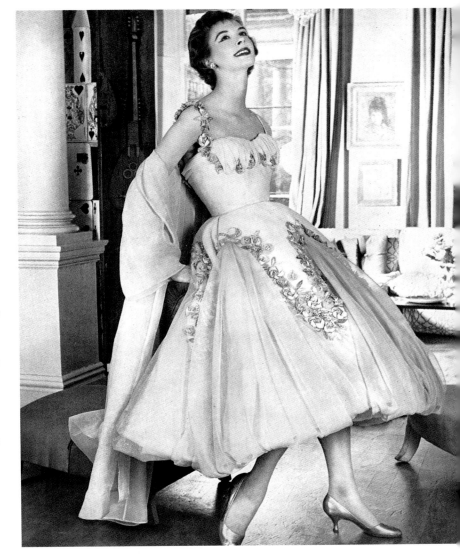

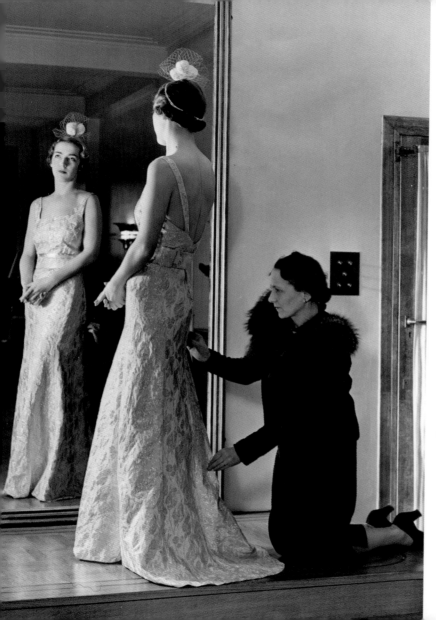

LEFT: *A dress to be worn by a guest at the Coronation of King George VI in 1937 being fitted at the salon of Lucile. Royal Coronations were a chance for leading dressmakers to provide gowns for a prestigious clientele. Fashion magazines would feature sketches and descriptions of outfits worn after the event.*

OPPOSITE: *The Carnival Queen and her two attendants in their finery during a 1955 carnival procession through Walton-on-the-Naze, Essex.*

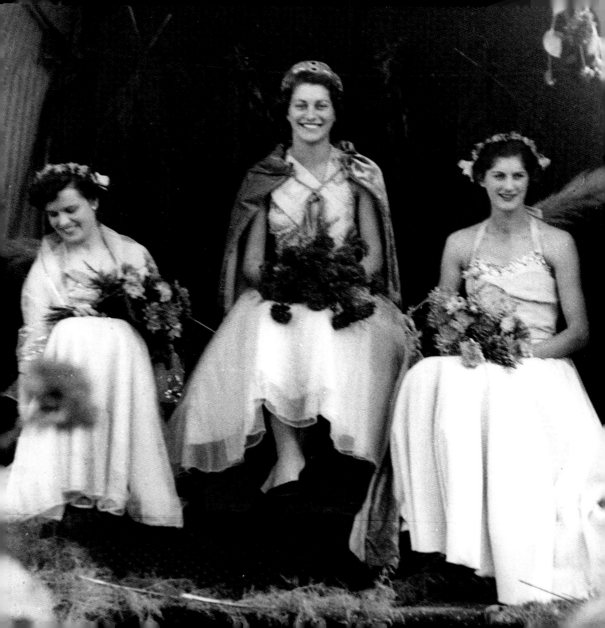

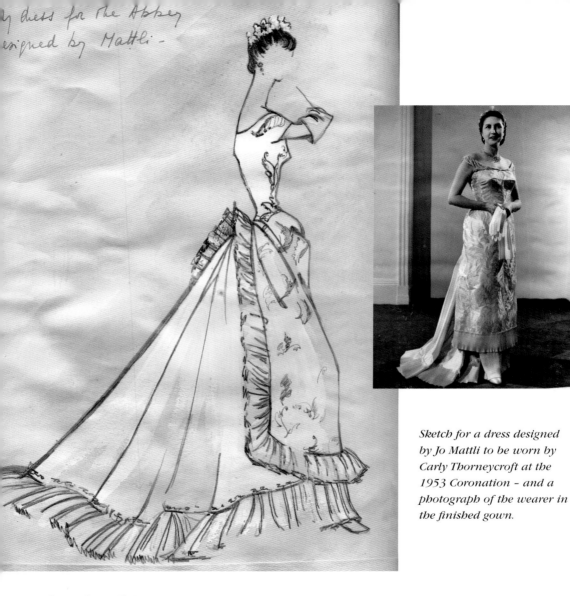

y dress for the Abbey
esigned by Mattli -

*Sketch for a dress designed
by Jo Mattli to be worn by
Carly Thorneycroft at the
1953 Coronation – and a
photograph of the wearer in
the finished gown.*

Perhaps the ultimate special occasion dress, the Coronation gown of Queen Elizabeth II was created by couturier, Norman Hartnell and featured exquisitely intricate embroidery, a hallmark of Hartnell's work, depicting the various floral symbols of the British Isles and Commonwealth countries. The drawing also shows the Queen wearing the George IV diadem and behind her is the Imperial State Crown.

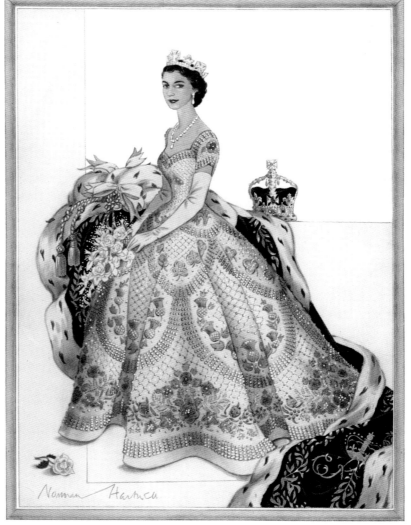

Design for the dress worn by Her Majesty Queen Elizabeth II at her Coronation.

DICKINS & JONES

Mourning in all its Branches

'BRANDON'
Full length Walking Coat, suitable for Mourning, in fine quality black serge, finished with silk braiding, facings and cuffs of black satin, sleeves and to waist lined silk.

Price = 65/6

DICKINS & JONES, LTD.,
REGENT STREET, LONDON, W.

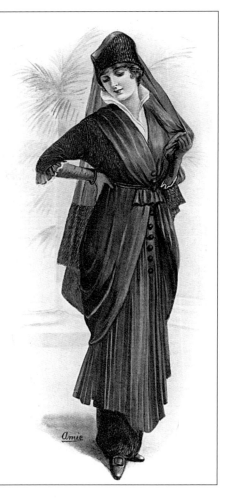

GOOCH'S

THE MODERN STORE OF KNIGHTSBRIDGE.

Christmas Party Wear for the Boys and Girls

FOR over three-quarters of a century, Gooch's have made a great speciality of Boys' and Girls' Outfitting. Here are a few examples of what the Children will be wanting for the Parties this Christmas ... bring them to Gooch's.

Father Christmas
is in his wonderful Enchanted Castle in the Great Toy Fair, on the Third Floor at Gooch's

Dinner Suits
Expert craftsmanship, combined with fine quality materials, produce in this fashionably cut suit that quiet dignity associated with good dress clothes. Ready to wear, in sizes to fit 11 to 19 years. First sizes, 90/- to **125/-** Rising 4/- each size.

The "Dudley"
This smart Party Suit in Black Velveteen with White Waistcoat or Brown with Champagne Waistcoat is designed specially for that difficult intermediate age when a boy has ceased to wear fancy suits. To fit 4 to 8 years. Price **50/-** Rising 2/- each size

Boys' Patent Dress Oxford Shoes cut from selected skins of the highest quality. Perfect fitting and most comfortable in wear. Sizes 11 to 1 Price per pair **15/9**

Dancing Operas or Sandals. Beautifully made, with pliant leather soles. Stocked in Black Glacé Kid. ½ sizes 7 to 10 Price per pair **7/11** ½ sizes 11 to 1, 18/11

Party Frock
Of Artificial Taffeta. The skirt is composed of rows of frills, and the bodice is tight-fitting. Stocked in pretty light colours or can be made to order in almost any shade. Price per in. **75/-** Rising 2/6 each size.

Evening Frock
Dainty Evening Frock, in art. Bolero is trimmed satin. The full ankle length skirt is composed of alternate rows of net and satin. Sizes to fit 13 to 17 years of age. Stocked in many pretty light shades. All sizes. Price, each **£5:9:6**

GOOCH'S of KNIGHTSBRIDGE, LONDON, S.W.3

'Phone: KENSINGTON 5100

OPPOSITE LEFT: *Advertisement by Dickins and Jones of Regent Street for a full length walking coat, suitable for mourning. The advertisement appeared in* Black and White, *a commemorative issue of the* Illustrated London News *to mark the death of Edward VII in 1910. During the Victorian and Edwardian era, mourning protocol was observed with general mourning lasting three months; the first six weeks in black, the latter half relieved by other shades such as purple or grey.*

OPPOSITE RIGHT: *A becoming widow's dress of dull black crepe de chine. The jupe is of black crepe, with an accordion-pleated tunic of crepe de chine. The corsage is cleverly arranged with pannier basque, with a snow-white lawn Medici collar and vest. The scheme completed with a hat-bonnet of crape and graceful flowing veil. The mounting casualties of the First World War meant that many young women spent time in mourning, though only a small number would have been able to afford an ensemble as elaborate as this one, featured in* The Tatler *magazine in November 1914.*

ABOVE: *Advertisement for Gooch's of Knightsbridge from 1930 featuring some Christmas party wear outfits for girls and boys, from a miniature dinner suit on the left, to a party frock of artificial taffeta.*

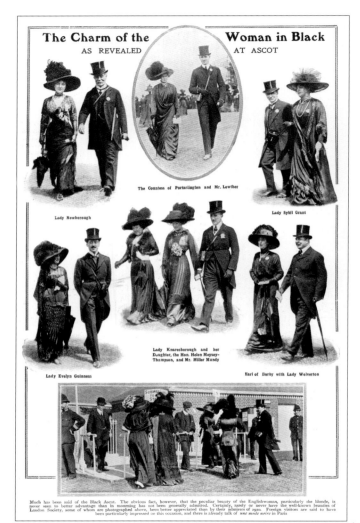

LEFT: Fashionable racegoers wear black in 1910 in mourning for the death of King Edward VII.

ABOVE: The 1953 Coronation saw the nation dress up in celebration. At street parties around the country, many children donned fancy dress such as this little girl, who has won first prize at a London street party.

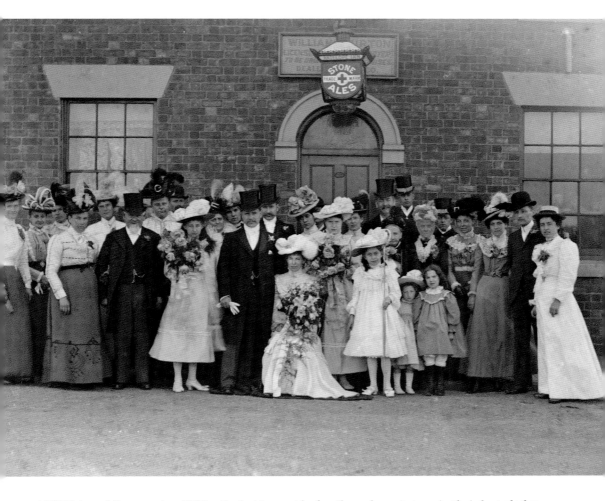

ABOVE: A wedding group c. 1900 – the happy couple, family and guests pose in their best clothes outside the pub where the wedding party is held. The bride is in white but wears a hat instead of a veil, and carries a huge bouquet.

ABOVE LEFT: First Communion, 1960s.

ABOVE RIGHT: A little girl dressed all in white for her (Roman Catholic) confirmation, 1930s.

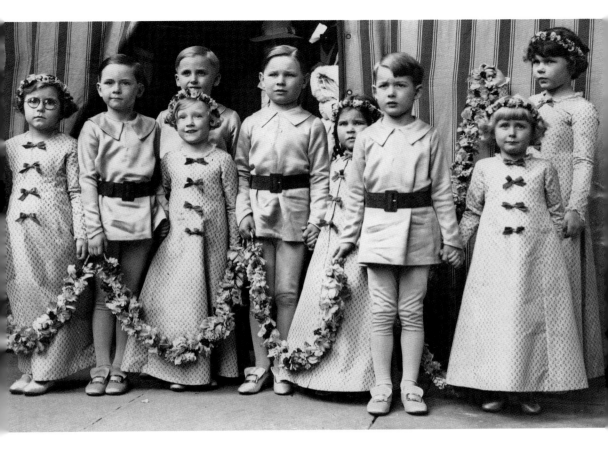

ABOVE: The trend during the inter-war years was for numerous bridesmaids and page boys, and outfits on a period theme, such as here where the page boys wear belted medieval style tunics, tights and buckled shoes.

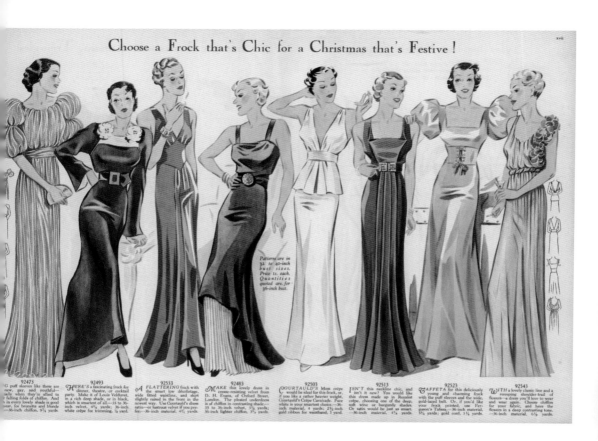

Choose a Frock that's Chic for a Christmas that's Festive!

ABOVE: *Eight chic Christmas party frocks for 1935. One has a distinct Classical Grecian influence while broad belts, corsages and puffed sleeves are also in evidence*

OPPOSITE: *The taking of afternoon tea, and welcoming guests into the home, gave rise to the phenomenon of the tea gown, devised to provide ladies of leisure with a delicate, loosely constructed and attractive garment for women during the Edwardian era.*

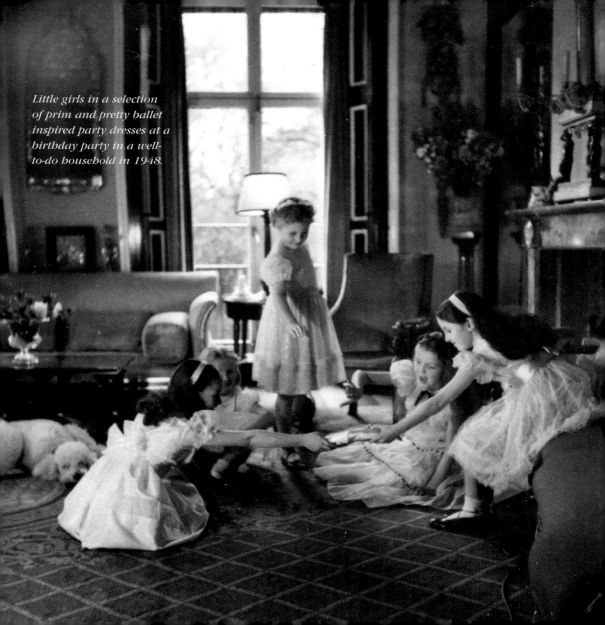

Little girls in a selection of prim and pretty ballet inspired party dresses at a birthday party in a well-to-do household in 1948.

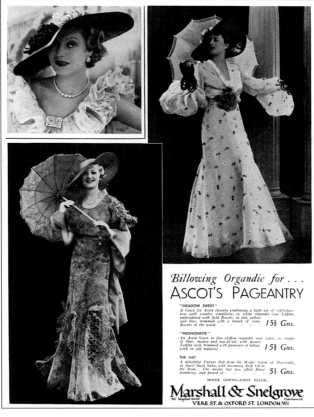

ABOVE LEFT: *Cover of* Eve *Magazine, 1 June 1927, featuring an Ascot gown and hat from Zyrot et Cie of Hanover Square, London.*

ABOVE RIGHT: *Advertisement for Marshall & Snelgrove of London, suggesting 'billowing organdie' for Ascot in 1937. The long dresses, picture hats and parasols of the early 1930s were a particularly picturesque choice for the event.*

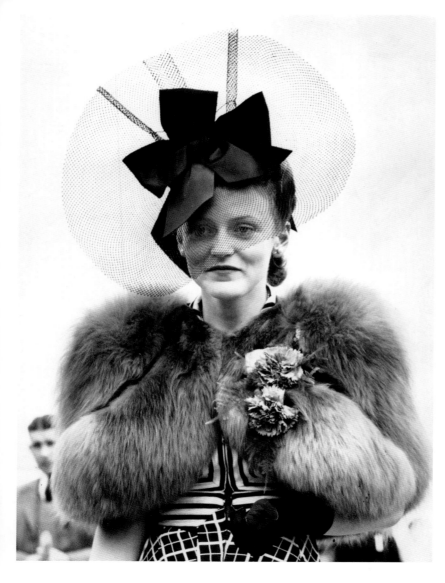

Ascot fashions. Mrs. Crompton Wood wearing a hat with a round veil and large bow at Royal Ascot in 1939. Each year Ladies Day is held on the Thursday of the Royal Meeting, which is also the day of one of Britain's most prestigious events, the Gold Cup. The event, a highlight of the social and sporting Season, has always been an opportunity for an attention grabbing display of peacock finery.

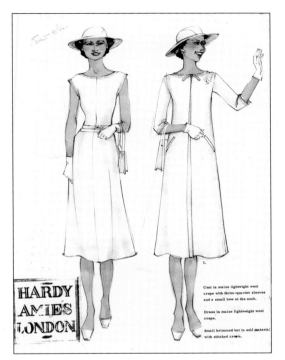

ABOVE: Outfit designed by Hardy Amies for Queen Elizabeth II to wear for a visit to Ascot in the 1970s comprising a maize lightweight wool crepe dress with fitted bodice and long easy fitting skirt. The matching coat has 3/4 sleeves and a small bow tie fastener at the neck while a matching brimmed hat with stitched crown completes the ensemble.

ABOVE: Demi-toilettes de Printemps. Soft blue and beige charmeuse make up the dress on the left, which has a distinctive note, a cleverly arranged panel of black satin. Lemon colored georgette and green ribbons are worn by the figure on the right, with a wide sash of striped taffeta. Ideal ensembles for smart events during the season.

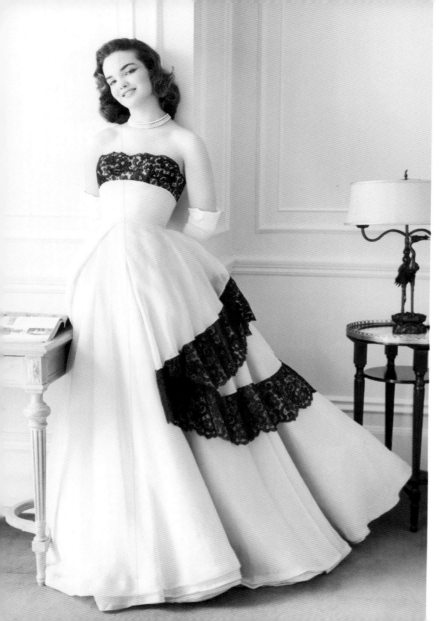

Portrait of Henrietta Tiarks, debutante of 1957, later Marchioness of Tavistock, now Dowager Duchess of Bedford wearing a Victor Stiebel gown trimmed with black lace a year after her coming out. Daughter of the actress Joan Barry and a renowned beauty, Tiarks spent some time modelling before her marriage in 1960.

An elegant, streamlined court gown for presentation at their Majesties' court in 1938 by Isobel worn with the Prince of Wales three feathers which ladies were required to fix to their hair (though they were being phased out around this time). The design label Isobel, founded by Isobel Spevak Harris was situated in Grosvenor Street, the centre of high glamour British fashion at the time. Her window displays were unique in showing just one costume at a time against a tasteful background of grey.

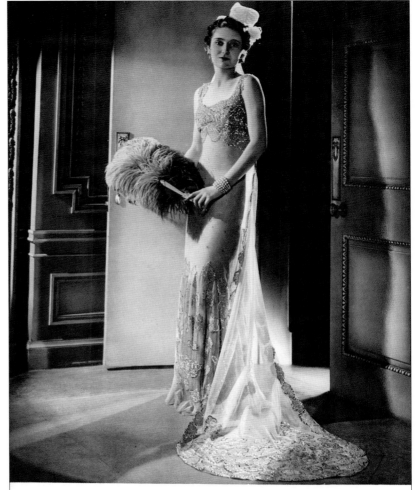

FOR THEIR MAJESTIES' COURTS

Isobel

70, GROSVENOR ST., W.1
AND AT HARROGATE
(Only Addresses)

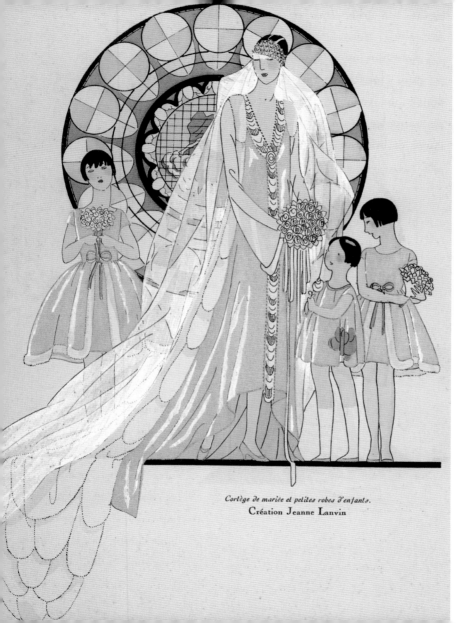

Cortège de mariée et petites robes d'enfants.
Création Jeanne Lanvin

*Exquisite
illustration from
Art Goût Beauté
in 1926 showing a
bride and her small
attendants wearing
elegant pearl grey
by Jeanne Lanvin.*

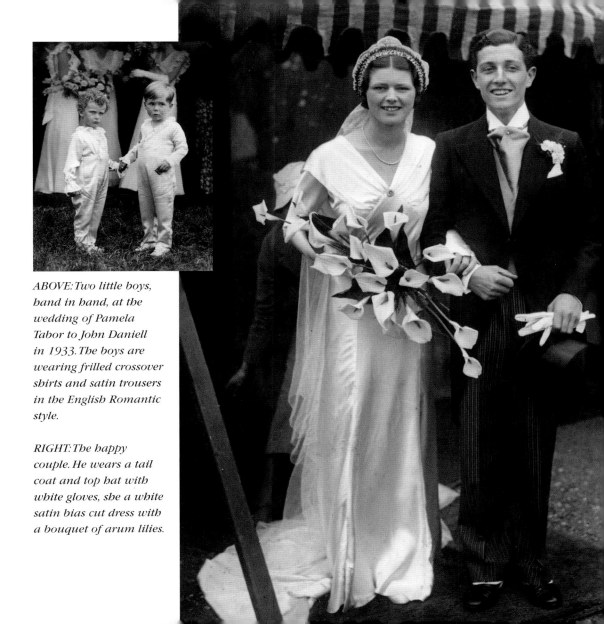

ABOVE: Two little boys, hand in hand, at the wedding of Pamela Tabor to John Daniell in 1933. The boys are wearing frilled crossover shirts and satin trousers in the English Romantic style.

RIGHT: The happy couple. He wears a tail coat and top hat with white gloves, she a white satin bias cut dress with a bouquet of arum lilies.

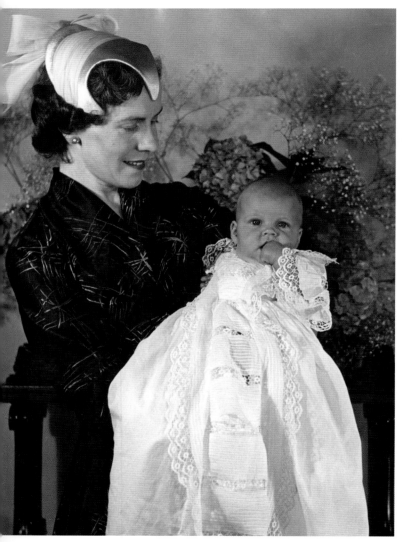

P. STEINMANN & CO.
Estd. 1865.
Lace Specialists — Trousseaux — Layettes

New Shape Collar in deep beige and Net, made by hand **18/9**

Exquisite Christening Robe in Fine Tambour Lace, rich cream shade, lined good Jap Silk.
6½ Gns. Cap to match **25/6**
Specialists in the Layette, Cots, Baskets, Shawls, Frocks, etc., at strictly moderate prices.

Smart set in beige net and Valenciennes, made by hand. Length of collar 32 inches . . . Set **22/9**
Laces for Lingerie in endless variety. Books of actual patterns sent.

185-6, Piccadilly (Between Piccadilly Circus and Bond St.)**, London, W. 1**
(*First Floor Showrooms*)

LEFT: *Babies have traditionally been christened in long, delicate white dresses regardless of their gender, such as in this photograph from the 1950s. The pieces are often heirlooms, passed down through the generations.*

ABOVE: *Advertisement for P. Steinmann of Piccadilly, London, dating from 1940 suggesting an 'exquisite Christening robe in fine tambour lace, rich cream shade, lined with good jap silk.'*

ABOVE: Front cover of French fashion magazine, Modes et Travaux *with a bridal dress for 1936 with long sleeves and the bias cut so popular at the time.*

RIGHT: Elegant bride and her attendants in Rome, 1934. The dress is almost identical in style and detail to the one featured on the front cover of Modes et Travaux.

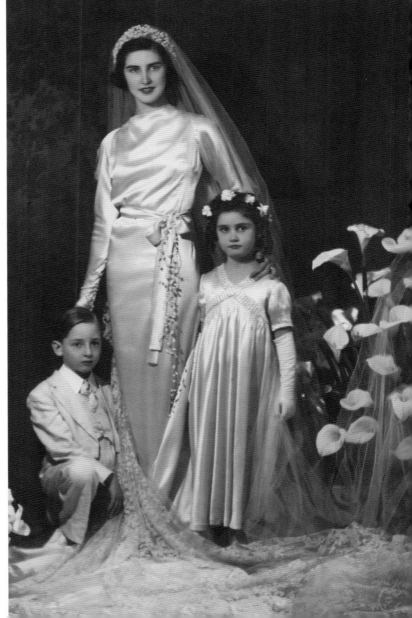

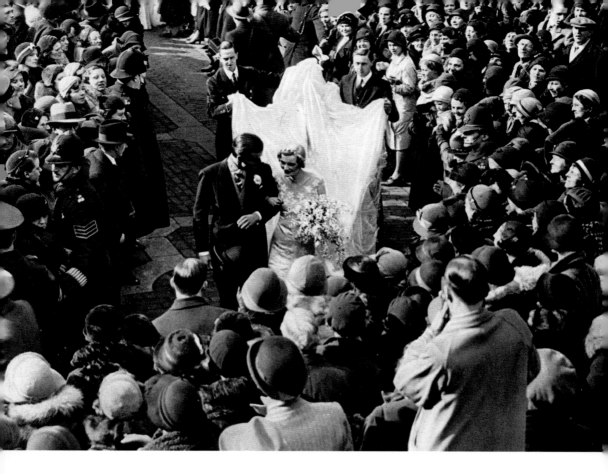

The wedding of the year in 1933 – that of society beauty and media darling, Miss Margaret Whigham, later Duchess of Argyll, to Mr Charles Sweeny, Oxford University golfer, at Brompton Oratory. The bride's dress with exquisite pearl star embroidery was designed by Norman Hartnell and its five-yard train stopped the traffic in Knightsbridge where thousands of people turned out to catch a glimpse of the wedding. The dress was a centre piece and star attraction at the wedding dress exhibition held at the Victoria and Albert Museum in London in 2014.

The Duchess of Gloucester (1901–2004), formerly Lady Alice Montagu-Douglas-Scott, pictured on her wedding day after marrying Prince Henry, Duke of Gloucester, third son of King George V and Queen Mary. The deep cream dress, unusual in that it radiated a very soft blush pink hue, was designed by Norman Hartnell and was the commission that would trigger his long and successful association with the royal family.

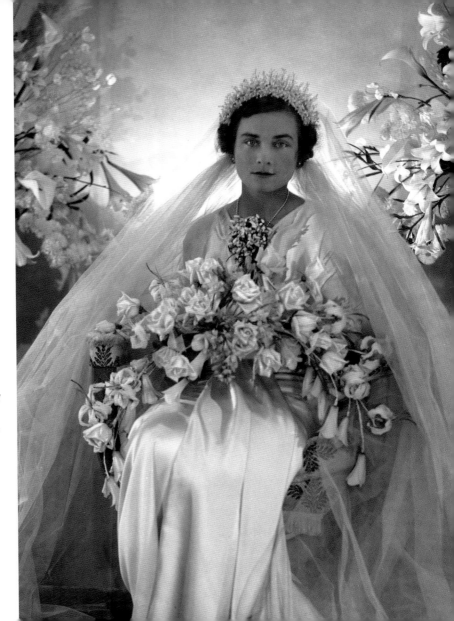

ABOVE: For a spring wedding in 1928, the bride wears a ¾ length shrimp-pink enriched lace satin dress with panels to the sides, worn with a matching long net train. The orange blossom skull cap headdress has a long veil fastened to the cap. The bridesmaid is in a sleeveless ¾ length dress made of taffeta and lace – around the neck is a long light weight sheer dress scarf. The small bridemaid's dress is in blue taffeta and lace, with a skirt is covered in frills and pantaloons finished with lace. The page boy suit is in linen muslin. Illustration by Marla Tyrell in The Tatler.

OPPOSITE LEFT: Front cover of The Tatler *featuring a photograph of the wedding of First World War flying ace, Captain Alec Cunningham-Reid (1895–1977) and the Hon. Ruth Mary Clarisse Ashley (1906-1986), daughter of multi-millionaire, Lt-Col Wilfred Ashley (1st Baron Mount Temple) and sister of Edwina, Countess Mountbatten. They were described as 'England's wealthiest girl and handsomest man'. When the couple divorced in 1940, Alec sued his ex-wife for half her fortune. Mary's silver lamé knee length wedding dress is the height of fashion for 1927 with layers of fringing giving a shimmering effect.* The Sketch *magazine, in its coverage of the wedding called it an unusual and beautiful 'silver waterfall' dress.*

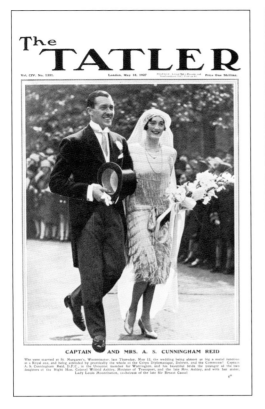

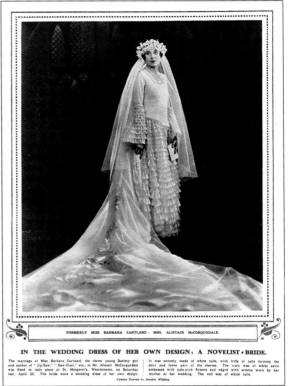

ABOVE RIGHT: Dame Mary Barbara Hamilton Cartland (1901–2000), married name Mrs Barbara McCorquodale, British novelist. Pictured in the wedding gown she designed herself for her marriage to Alistair McCorquodale in April 1927. The dress was made entirely of white tulle, with layers of frills forming the lower skirt and the lower part of the sleeves. The train of white satin embossed with pale pink flowers and edged with ermine was worn by her mother at her wedding. The veil was of white tulle.

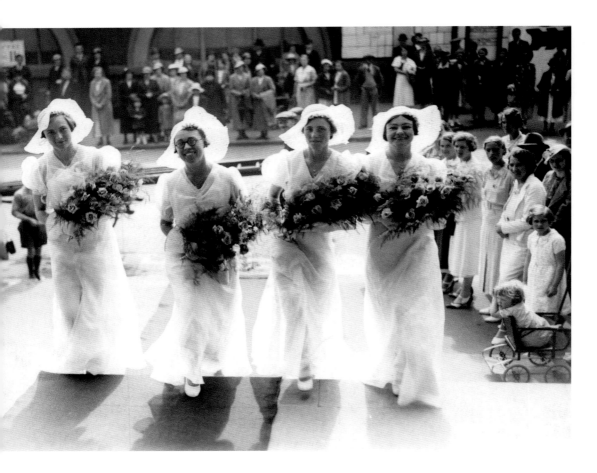

Wonderful photograph of four bridesmaids arriving at a society wedding in the mid-1930s dressed in long flowing gowns and wide-brimmed hats, as they carry huge bouquets of flowers.

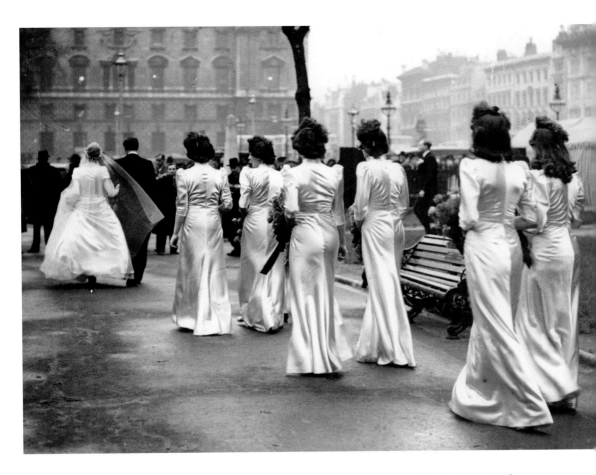

A back view of the eight bridesmaids at the marriage of Henry Cecil, son of Lady Amherst of Hackney, and Robays Burnett, daughter of Sir James and Lady Burnett of Leys at St. Margaret's Church, Westminster in December 1938. In figure-hugging satin, the overall effect of the attendants is quite captivating on such a dull, grey day.

COUPON WEDDING!

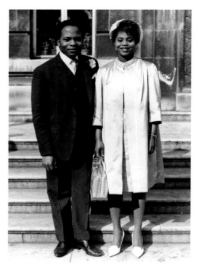

LEFT: *Coupon Wedding – Clothes rationing during the Second World War meant that many brides either wore uniform, or a smart day suit to get married. This postcard by Laurie Taylor implies that low fabric supplies could lead to a rather daring wedding gown!*

ABOVE: *A black British couple standing proudly together on the steps of a Registry Office, 1960s.*

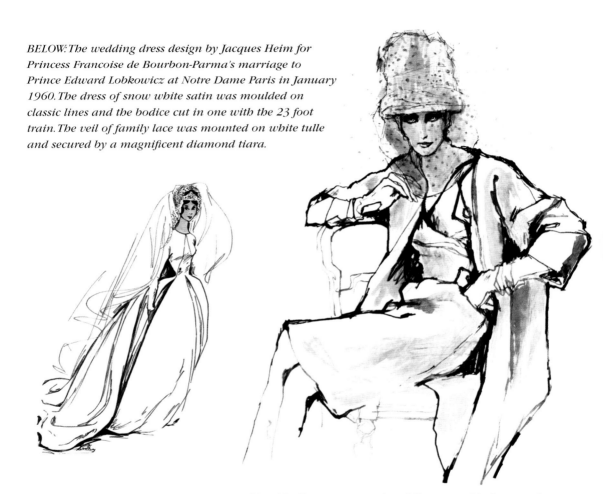

BELOW: The wedding dress design by Jacques Heim for Princess Francoise de Bourbon-Parma's marriage to Prince Edward Lobkowicz at Notre Dame Paris in January 1960. The dress of snow white satin was moulded on classic lines and the bodice cut in one with the 23 foot train. The veil of family lace was mounted on white tulle and secured by a magnificent diamond tiara.

RIGHT: A dress and coat in delicate emerald wild silk as a suggested wedding ensemble for a mother of the bride, with a low, swathed neckline and bow at the waist of the dress and dramatic full coat, all by Julian Rose. The spotted net toque hat is by Simone Mirman. Drawing by Barbara Hulanicki for The Tatler, 1962.

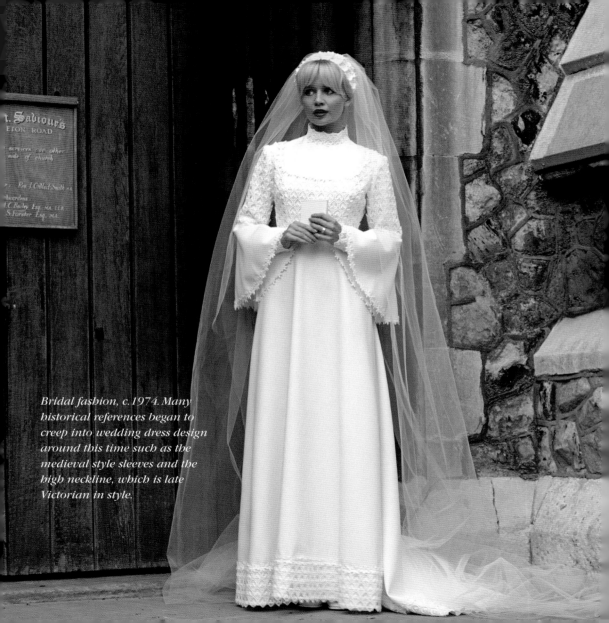

Bridal fashion, c.1974. Many historical references began to creep into wedding dress design around this time such as the medieval style sleeves and the high neckline, which is late Victorian in style.

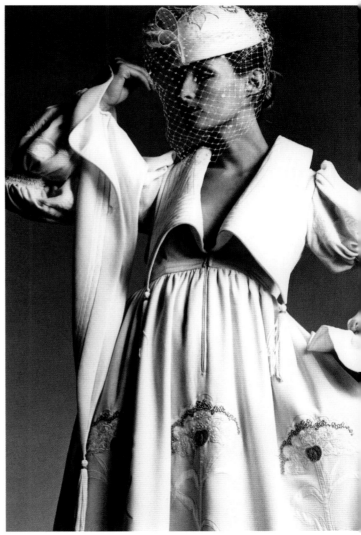

ABOVE: A Camelot-style wedding dress and veil of nun-like simplicity in translucent white organdie with a wide border of guipure lace trimming the cuffs, hem veil and train. By Belinda Belville, 1965.

RIGHT: Flamboyant wedding dress design by John Bates, with an exaggerated rever collar, art nouveau style embroidered flowers on the skirt and ruched sleeves and long, medieval style cuffs. Worn with a matching veiled hat. Bates was famous for his mini skirts in the 1960s, but this 1970s dress shows instead the maximalist aesthetic of the subsequent decade. Photograph by Peter Akehurst, c.1975.

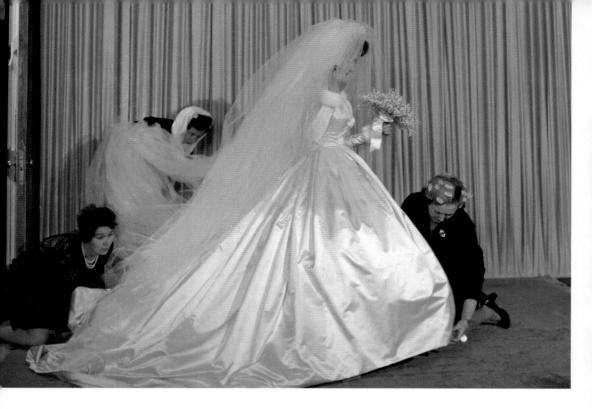

ABOVE: Lady Pamela Mountbatten, younger daughter of Earl and Countess Mountbatten (and niece of Mary Ashley who is featured on a previous page in her wedding dress), pictured in her superb, fur-trimmed gown designed by Worth, for her marriage to interior designer, David Hicks at Romsey Abbey, Hampshire in January 1960.

OPPOSITE: A wedding group outside St. Mary's Catholic Church in Grangetown, Middlesborough, North East England captured by the photographer Robin Dale in 1977. The bride is dressed in a buttercup yellow maxi dress with matching hat and her new husband wears a lurid purple shirt and bow tie. His platform-heeled shoes are echoed by the young man in the foreground, and one particular guest at the end has eschewed shoes altogether in favour of her slippers instead!

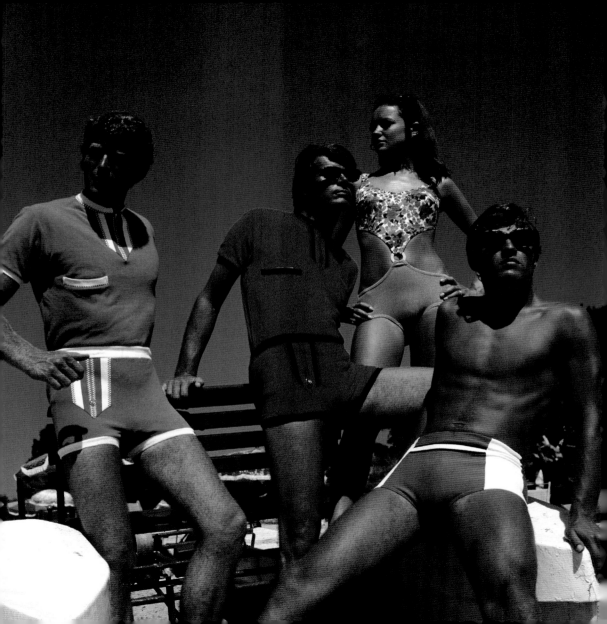

Sport & Leisure

In 1907, on Revere beach, Massachusetts, the world famous Australian swimmer Annette Kellerman was arrested and charged with indecency, for daring to appear in broad daylight wearing a one piece swimsuit. The costume, of her own design, offered women a practical alternative to the bulky smock and bloomers combination worn at the time and laid the foundations for the modern day unitard one piece we take for granted today. Kellerman was a global superstar, appearing in endless exhibition shows, writing numerous books and making over twenty films. Despite the conservative opposition to her swimsuit, Kellerman began to market it to the public, with great success. Thousands of women around the world wanted to emulate the swimmer whose figure had been hailed as that of, 'the perfect woman'. Bodily perfection could not possibly be achieved while idly splashing about, impeded by cumbersome swimwear and so Kellerman's prototype laid the foundations for swimwear fashion, which continued to develop in line with public demands.

As swimming costumes took on a more sporty tone, clothes for lounging about on holiday became a new trend in the inter-war years. These were typified by playsuits and particularly beach pyjamas, a combination of wide-legged trousers (mimicking those of sailors) worn together with halter neck tops, bolero waistcoats or jersey blouses often incorporating nautical or art deco details. Unlike a number of sports, swimming was a pastime accessible to nearly all, especially as day trips to the seaside increased in popularity. By the 1930s, with lidos in more urban areas opening to provide a place of recreation and healthy activity for urban dwellers, a swimming costume would have formed part of most peoples' wardrobes, though quality might vary.

Many parents and grandparents today regale their offspring with tales of wearing hand knitted bathing costumes as children, leading to some quite spectacular sagging after a single dousing in the sea, not to mention the itching that plagued the wearer as they began to dry off. But the advent of manmade fabrics designed to retain shape and dry quickly would transform the swimming costume into a garment of sleek practicality. And once this had been achieved, swimwear could become more fashion led. The 1930s saw backless costumes designed for the growing band of sun worshippers, the bikini was introduced in the 1940s and the 1950s returned to boned and shaped costumes in a range of fancy prints and fabrics, in pursuit of the hourglass silhouette. Though not intended for any type of competitive swimming, 'modern' swimwear, as manufactured by firms such as Jantzen or Lastex fulfilled a dual function in allowing the

OPPOSITE: 1970s beach outfits and swimwear, leaving little to the imagination!

wearer to swim, and to look rather good while doing so.

The late 19th and early 20th century saw massive advances in female participation in sport. The cycling craze of the 1890s witnessed both men and women taking to two wheels, and while it was an activity that could be practised in the blouse and long skirts most women of that time wore, the advent of bloomers appealed to serious cycling aficionados. Lawn tennis gained many converts too, though women of the Edwardian era would still play in what appeared to be a costume more suited to a garden party. White was favoured as it was less likely to show perspiration and corsets were worn even though the movement and exertion regularly caused the bone and steel to dig into players and draw blood. Many doctors believed the corset was advantageous during sport to ensure all internal organs were kept in place and the support warded against back pain and other such ills. Dorothea Lambert Chambers, seven-time singles champion at Wimbledon in the decade leading up to the First World War, won her matches wearing a business-like but nevertheless constricting combination of white blouse with tie and shin-length skirt. In her 1910 book, 'Lawn Tennis for Ladies,' her chapter on tennis clothing advises the wearing of, '…a plain gored skirt—not pleated; I think these most unsuitable on court—about four or five inches from the ground. It should just clear your ankles and have plenty of fullness round the hem. Always be careful that the hem is quite level all round; nothing is more untidy than a skirt that dips down at the back or sides—dropping at the back is a little trick a cotton skirt cultivates when it comes home from the laundry. A plain shirt without "frills or furbelows" – if any trimming at all, tucks are the neatest – a collar, tie, and waistband, go to make an outfit as comfortable and suitable as you could possibly desire'.

She also prescribes thin-soled white 'gymnasium shoes', choosing white cotton over heavier, coloured flannel or 'stuff' due to its infinitely washable properties and avoiding the wearing of hats. A decade later, the girl who beat Mrs Lambert Chambers in a gruelling 3-set match to take the Wimbledon title in 1919, would revolutionise tennis fashion. Suzanne Lenglen presciently brought the youth and vivacity of the 1920s to the tennis court, sporting a succession of lightweight; chemise style dresses with pleated skirts, loose, straight cardigans and short-sleeved blouses or V-necked vests (still considered a risqué neckline). Lenglen's outfits were designed by Jean Patou, the French couturier who pioneered sportswear as fashion and championed the 'garconne' look, opening a dedicated sportswear department in his couture store in 1925 and subsequently opening further branches in fashionable resorts such as Deauville and Biarritz. Lenglen's clothes were embroidered with Patou's signature, a visible declaration of the creative and commercial bond between designer and sports person and one that remains an essential relationship in the sportswear industry today. Patou was to continue as the go-to designer for a leisured lifestyle; in 1927, dialling in to the new trend for tanning with the launch of the first suntan oil, Huile de Chaldee in 1927

and a fragrance called, quite simply, 'Sport' the following year. Lenglen meanwhile, was hailed as a fashion revolutionary. London department store, Selfridges drafted her in to design a range of tennis clothes for them in 1933. Elizabeth Ryan, a contemporary of Lenglen and holder of 19 doubles titles at Wimbledon, said of her, "All women players should go on their knees in thankfulness to Suzanne for delivering them from the tyranny of corsets." Ryan had witnessed the drying rack in the women's dressing rooms at Wimbledon where blood stained corsets were hung.

Tennis, perhaps because of the high profile of women players, continued to be a showcase for the development of sporting style. When the Spanish player Lili D'Alvarez wore a divided skirt designed by Elsa Schiaparelli, at Wimbledon in 1932, the garment caused a sensation. The same occurred again in 1937 when the American Alice Marble wore shorts. In today's age of 'performance' sportswear, that such a benign garment should be the cause of consternation seems difficult to comprehend. It is worth noting that many men, including Fred Perry and Rene Lacoste, both of whom would go on to design their own sportswear lines, were still playing tennis in long trousers at this time.

One sport where men did match women in sartorial terms was golf. The sport's leisurely pace allowed some flexing of the expected uniform, often with quite outlandish results. Plus fours, gaudy knitted jumpers and patterned socks were all part of the golfers' wardrobe during its most flamboyant period, the 1930s. It was a look that was adopted with relish by one particularly enthusiastic golfer and trendsetter, the Prince of Wales. The women's game thrived during the first half of the 20th century, and clothing followed suit. A plethora of novelty jumpers, worn with pleated knee length skirts, berets and brogues, meant that women looked as stylish as men on the golf course did. Women golfers of the inter-war years looked considerably more chic than their predecessors who instead had made do with sensible ankle length serge skirts, though Tam O'Shanter hats gave a jaunty air during the Edwardian era.

While swimming and cycling might be sports enjoyed by much of the population, there were other pastimes that, until recently, were enjoyed only by those who could afford them. Motoring, in its early days, was very much considered a sport, being a dirty, daring and potentially dangerous pursuit. However, motoring could only be enjoyed by those with the means to own a car, and Edwardian car owners could invariably invest well in their motoring attire. Hence quality brands such as Dunhill or Burberry designed duster coats, goggles and hats specifically for drivers and their passengers. Such shops would also offer the correct attire for a shooting weekend or a skiing holiday, both of which remained the preserve of the wealthy for a large proportion of the 20th century. The advent of mass market travel in the 1960s and 1970s would create a corresponding need for affordable ski fashion, neatly provided by the department store C&A, whose Rodeo brand in the 1980s was hugely successful.

The notion of wearing different outfits for different sports is not a new one. But the idea of 'sportswear' as a general term had a very different meaning back in the 1920s and 30s, at least to those wealthy enough to compartmentalise their clothing according to activity and situation. Back then it was used to describe clothes that were more informal; mainly knitwear and tweedy separates – the kind of look pioneered by Cocoa Chanel, and intended as low maintenance, easy pieces, not for playing sport in, but for maintaining a relaxed elegance whatever the leisurely situation. It was a style that was pared back and chic, but a far cry from what we would consider informal today. The intervening years saw the phenomenon of non-sporting 'sportswear' die out to be replaced by cheaper 'leisurewear' (though the resurgence of the 'sports luxe' look in recent years is proof that successful trends never quite go away). By the 1970s and 80s, tracksuits and shell suits became a uniform ironically associated with those often most unlikely to pick up a racquet or golf club. Sports brands launched by Fred Perry and Rene Lacoste have become staple classics for everyday wear chosen for their logo, style and heritage, rather than their sporting performance enhancing properties. Where once a sporting wardrobe might be a sign of wealth and status, today, sports clothes today range from the costly to the affordable and are widely available to all, as likely to be worn as street wear as at the gym. And there isn't a knitted swimsuit in sight.

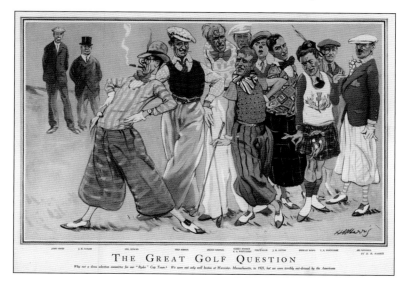

Cartoon by H. H. Harris in The Bystander, 1929 caricaturing golfers of the day, and their choice of sportswear. Players featured include James Braid, Fred Robson and George Duncan.

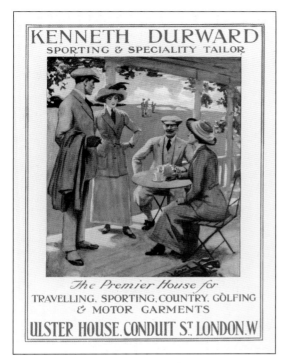

FOR THE MOORS

ABOVE: Sports clothes for smart society. An advertisement in 'London's Social Calendar' for Kenneth Durward (Tailor) of Conduit Street. For gentleman golfers there are plus fours, flat caps, monocles, single-breasted suits, spats and turn-ups to the trousers. Ladies wear tailor made costumes with short flaring skirts & belted jackets.

ABOVE: After the summer Season of sporting events in London and the South East had drawn to a close, smart society traditionally migrated to the moors and highlands of the north for shooting in August. This suggestion for a slimline country tweed suit by Gordon Conway, was published in Britannia and Eve *magazine in 1930 and is perfect for striding stylishly over moorland on the Glorious Twelfth.*

The 'right' clothing for Flying people

WITH the removal of flying restrictions comes the need for suitable clothing. For pilots or passengers, for "joy-flights" or business journeys, the ideal clothing is "Adastra" the makers of which have produced the air-clothing for the R.A.F.

"Adastra" designs are based upon practical experience in providing clothes for wear in all weathers and under actual flying conditions. Comfort and ease combined with immunity from wind or rain and attractive appearance stamp "Adastra" as the right clothing for all flying people.

To be worn by
Handley-Page Pilots
for
Transatlantic Flight

Obtainable at HARRODS', SELFRIDGE'S, DICKINS & JONES, SWAN and EDGAR'S, DERRY and TOMS, and most other well-known outfitters.

Adastra

Clothing for Airmen & Airwomen

P.C.B2.

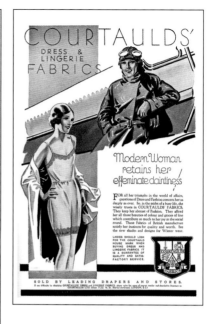

LEFT AND ABOVE: In the years after the First World War, the growing popularity of aviation as a pastime infiltrated advertising. Adastra had manufactured clothing for the R.A.F. during the war and this later advert, for Courtaulds Dress and Lingerie Fabrics, 1931, suggests that modern woman can retain her feminine daintiness by wearing their underwear, even as an intrepid aviatrix.

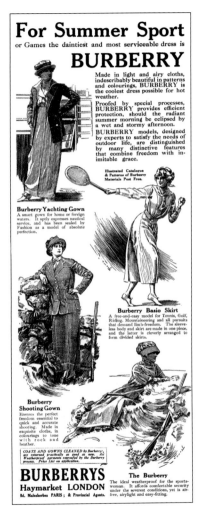

For Summer Sport

or Games the daintiest and most serviceable dress is

BURBERRY

Made in light and airy cloths, indescribably beautiful in patterns and colourings, BURBERRY is the coolest dress possible for hot weather.

Proofed by special processes, BURBERRY provides efficient protection, should the radiant summer morning be eclipsed by a wet and stormy afternoon.

BURBERRY models, designed by experts to satisfy the needs of outdoor life, are distinguished by many distinctive features that combine freedom with inimitable grace.

Illustrated Catalogue & Patterns of Burberry Materials Post Free.

Burberry Yachting Gown
A smart gown for home or foreign waters. It aptly expresses nautical service, and has been sealed by Fashion as a model of absolute perfection.

Burberry Basio Skirt
A free-and-easy model for Tennis, Golf, Riding, Mountaineering and all pursuits that demand limb-freedom. The sleeveless body and skirt are made in one piece, and the latter is cleverly arranged to form divided skirts.

Burberry Shooting Gown
Ensures the perfect freedom essential to quick and accurate shooting. Made in exquisite cloths, in colourings to tone with rock and heather.

COATS AND GOWNS CLEANED by Burberry's, are returned practically as good as new. All Weatherproof garments reproofed by the Burberry process. Price List on application.

The Burberry
The ideal weatherproof for the sportswoman. It affords comfortable security under the severest conditions, yet is air-free, airylight and easy-fitting.

BURBERRYS
Haymarket LONDON
8d. Malssherbes PARIS ; & Provincial Agents.

LEFT: Advertisement for Burberrys of London, placed in The Sketch *magazine's 5 August 1914 issue, showing four outfits suitable for the pursuits of the season from a yachting gown for Cowes to a shooting gown and weatherproof Burberry for grouse shooting on the moors, not forgetting a basic skirt ideal for playing tennis.*

RIGHT: An outfit for a lady motorist of 1919 comprising a leather jumper of a dark penguin grey shade broken by touches of crimson velvet worn with a grey suede double breasted coat, all completed with a becoming Dutch leather bonnet. Dunhill also had other motoring accessories available including gloves and could make bespoke car mascots for customers.

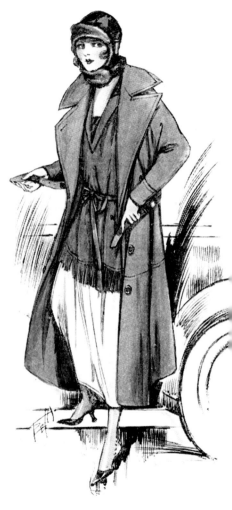

LEFT: *Advertising poster, c. 1930, for Sportex men's clothing showing two dapper gents dressed immaculately in plus fours and jackets ready for a round of golf.*

ABOVE: *The flamboyance of men's golfing fashions was ripe for lampooning, such as in this 1919 cartoon by the master of social satire, H. M. Bateman.*

The Prince Wears Red and Black Checks and a Tuck-in Pullover

A CROTAL red and black check plus four suit is being worn by the Prince of Wales at golf matches here and at Le Touquet. The jacket has two slits at the back (a style he started in plus four suits a year or more ago), while the type of check is the shepherd's plaid. His cap in the right photograph does not quite match, for the check here is of the hounds' tooth variety.

The fact that many people have condemned the tuck-in pullover as " cheap " is gainsayed by the fact that the Prince is still wearing this style, while his stockings are in a light fawn with a light over-checking.

In the seat-stick picture he is wearing, too, a twin-tab collared shirt, the fine lines on the collar and cuffs being vertical and on the front horizontal—a reversal of the usual patterning.

Colonel Myddleton, his partner in the other photograph, is wearing an interesting proofed golf jacket with two vertical pockets just beneath the lapels, for his pipe, tobacco pouch and other odds and ends.

ABOVE: Article featured in the magazine, Man and his Clothes *in 1930 commenting with interest on the ensemble worn by Edward, Prince of Wales (later King Edward VIII, Duke of Windsor) to play golf. His plus four suit was in a crotal red and black check for matches he played at Le Touquet, his pullover was tucked in (a style many people had condemned as 'cheap' apparently) and his stockings were in light fawn with over checking. His partner is Colonel Myddleton who was wearing an interesting proof golf jacket with two vertical pockets just beneath the lapels, for his pipe, tobacco pouch and 'other odds and ends'.*

LEFT: The Prince of Wales (later King Edward VIII and Duke of Windsor), dressed in an outfit of plus fours and beret which his father would most certainly not have approved of, playing golf on the Chiberta golf links at Biarritz while on holiday in 1932.

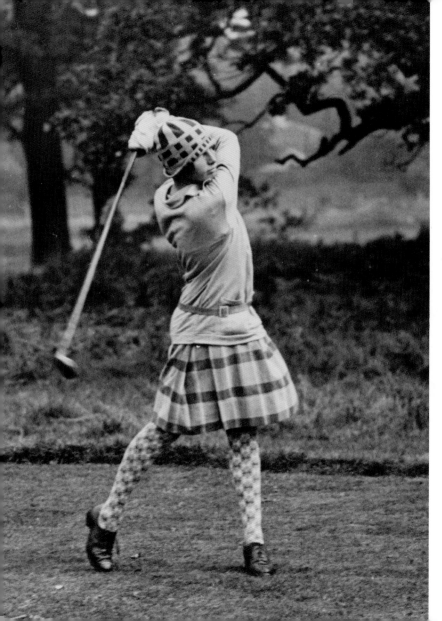

LEFT: Leading female golfer, Diana Fishwick in action at Stoke Poges in 1927 where she won a girls' championship. Her fabulous multi-checked outfit more than rivals the flamboyant male golf fashions of the time. At the age of 19 she defeated 6-time US Ladies Amateur Champion Glenna Collett, at the 1930 British Ladies Amateur Championship at Formby Golf Club in Merseyside.

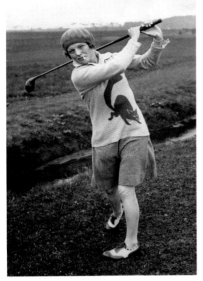

ABOVE: Miss M. Hamilton (USA) during the Women's Open Golf Championships at the golf course of the Royal Ancient Golf Club in St. Andrew around 1930. She is wearing a beret and an intarsia jumper featuring a cat. Novelty and patterned jumpers were all the rage in golf circles.

RIGHT: 'The Golf Girl' drawn by Wilmot Lunt, 1908. Women wore sturdy tailor made suits for playing golf in the Edwardian era, often topped by a jaunty tam o'shanter.

WILMOT LVNT
1908

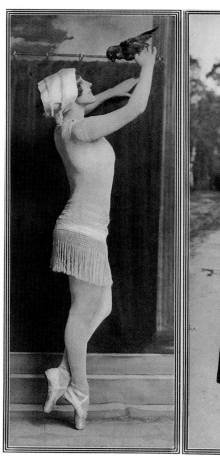

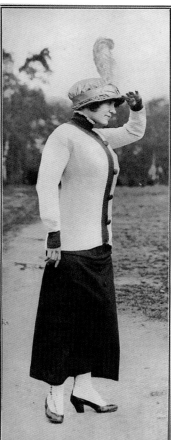

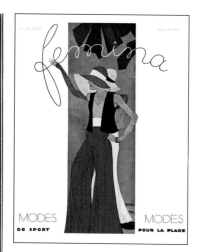

ABOVE: Annette Marie Sarah Kellerman (1886-1975), Australian swimmer, film star, and writer. One of the first women to wear a one piece bathing costume, causing a minor scandal at the time. Pictured at the time she was appearing in The Wood Nymphs at the Alhambra, on and off stage, her stage costume showing off her celebrated slim and athletic figure.

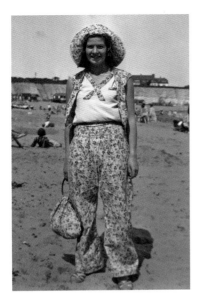

ABOVE: Beach pyjamas worn on holiday in the early 1930s. These relaxed, coordinated outfits were characterised by wide-legged trousers. This woman's entire outfit, including sun hat and beach bag are made up in matching floral fabric.

RIGHT: Special holiday or summer leisure wear in 1956 showing quite different proportions to the 1930s with brief 'Italian' shorts worn with an easy shirt, both in a matching patterned cotton.

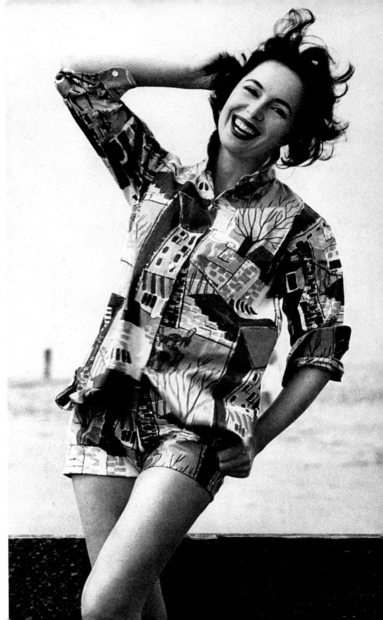

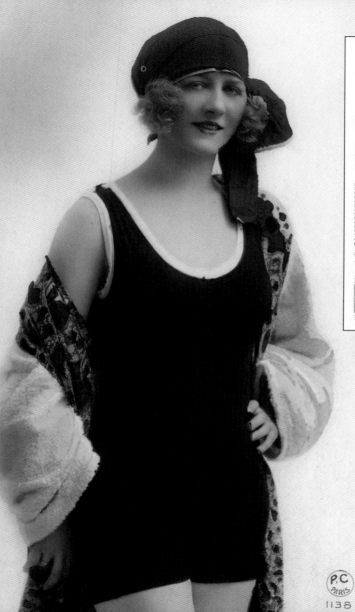

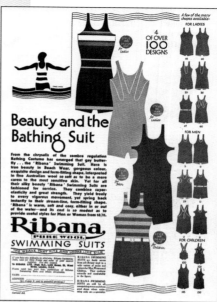

LEFT: Picture postcard, c.1920.

ABOVE: Advertisement for Ribana pure wool, 1931 bathing suits for women, men and children made finely woven from soft Botany wool in a wide variety of styles and colours to, 'conform naturally and comfortably to the figure'.

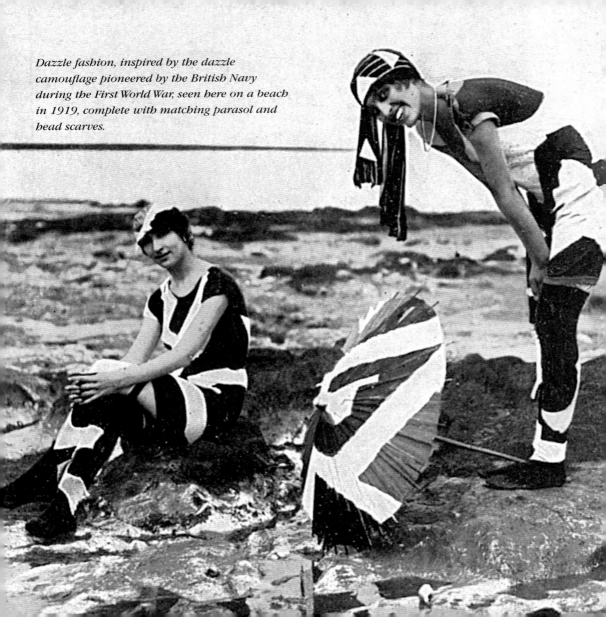

Dazzle fashion, inspired by the dazzle camouflage pioneered by the British Navy during the First World War, seen here on a beach in 1919, complete with matching parasol and head scarves.

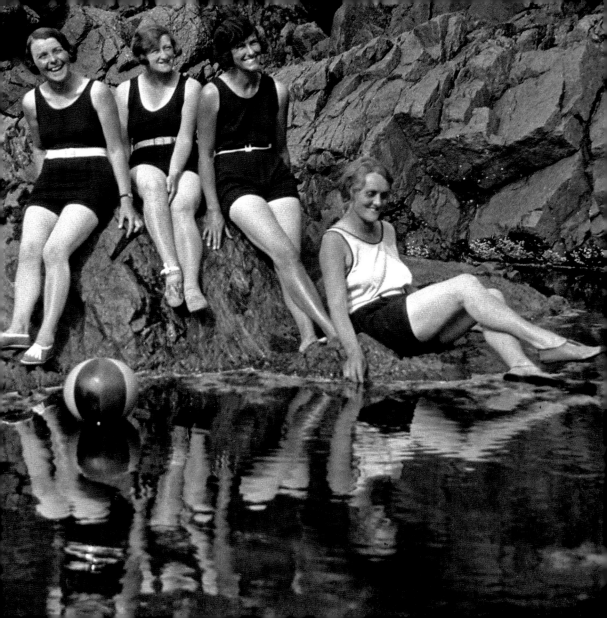

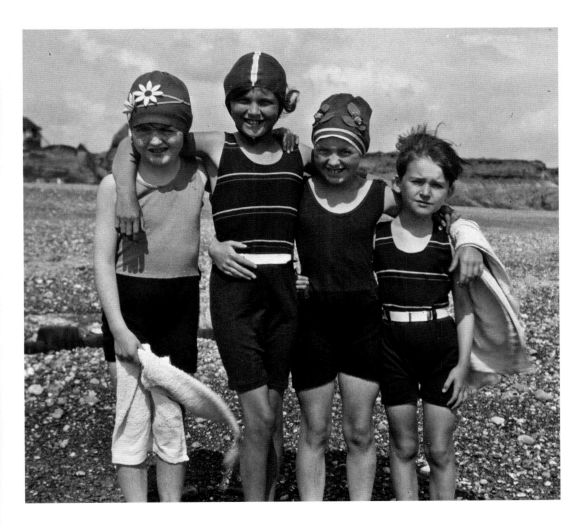

OPPOSITE: *Female baech fashion, 1920s.*
ABOVE: *Children on an unidentified beach in England, c. 1930.*

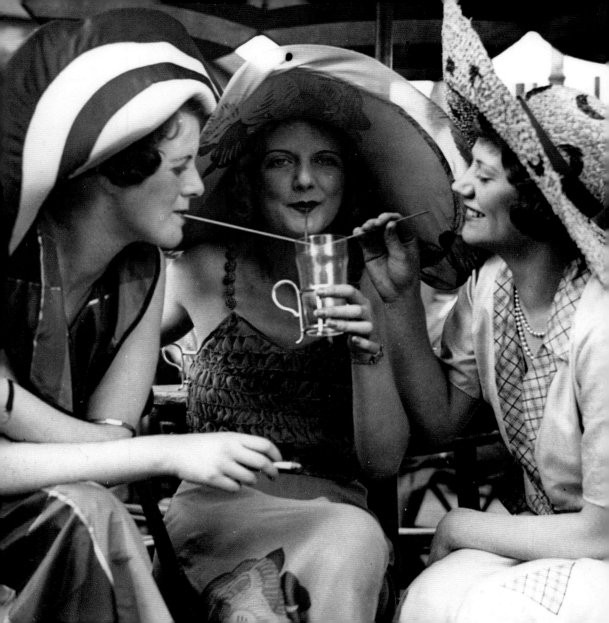

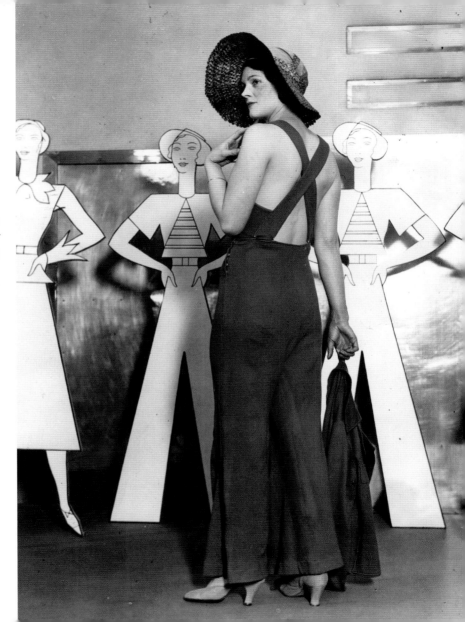

OPPOSITE: Three women pose with a cocktail on the roof of a store in Oxford Street. (probably Selfridges) wearing the latest beach fashions in June 1931.

RIGHT: A back-revealing sunsuit modelled at Jaeger in London, 1935.

OPPOSITE AND RIGHT: Advertisement for the famous Jantzen swimwear brand, featuring an artist about to paint a model wearing one of their perfectly fitted red swimming costumes, 1935. Jantzen began life as the Portland Knitting Company in 1910 and five years later designed their first commercial bathing costume.

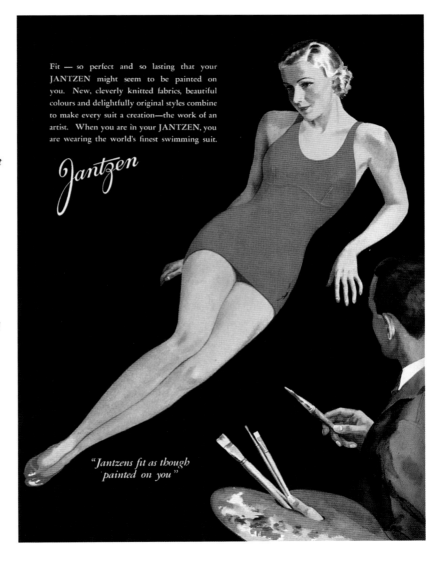

Fit — so perfect and so lasting that your JANTZEN might seem to be painted on you. New, cleverly knitted fabrics, beautiful colours and delightfully original styles combine to make every suit a creation—the work of an artist. When you are in your JANTZEN, you are wearing the world's finest swimming suit.

Jantzen

"Jantzens fit as though painted on you"

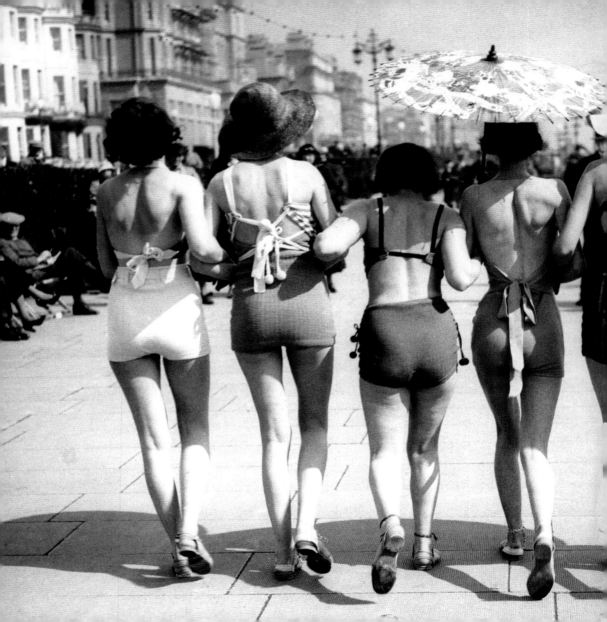

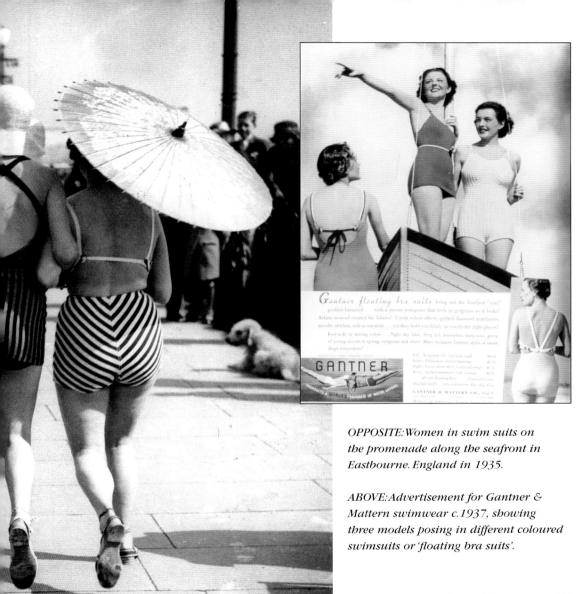

OPPOSITE: Women in swim suits on the promenade along the seafront in Eastbourne. England in 1935.

ABOVE: Advertisement for Gantner & Mattern swimwear c.1937, showing three models posing in different coloured swimsuits or 'floating bra suits'.

ABOVE: Elizabeth Arden suncare products, 1948.

ABOVE: Edwardian bathing beauty Miss M. Odell, c. 1910 wears a 'V'-neck, one-piece bathing costume with 'go-faster' stripes down the sides, similar to the pioneering swimsuit invented by Annette Kellerman

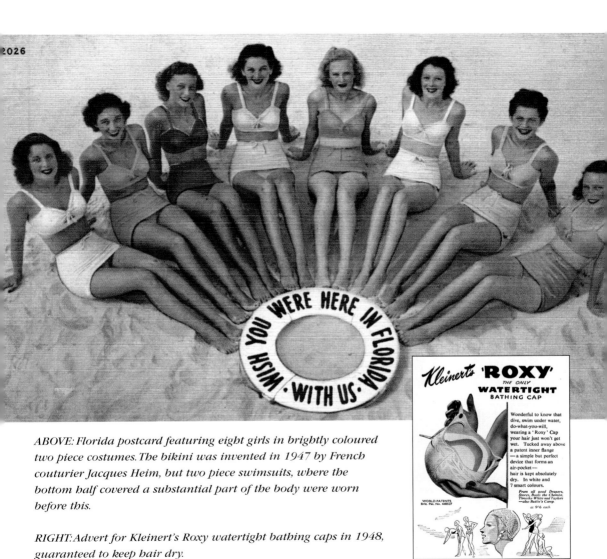

WISH YOU WERE HERE IN FLORIDA · WITH US ·

Kleinert's 'ROXY'
THE ONLY
WATERTIGHT
BATHING CAP

Wonderful to know that dive, swim under water, do-what-you-will, wearing a 'Roxy' Cap your hair just won't get wet. Tucked away above a patent inner flange — a simple but perfect device that forms an air-pocket — hair is kept absolutely dry. In white and 7 smart colours.

From all good Drapers, Stores, Boots the Chemist, Timothy White and Taylors —Also Butlin's Camp.

at 9'6 each

WORLD PATENTS
Brit. Pat. No. 440127

ABOVE: *Florida postcard featuring eight girls in brightly coloured two piece costumes. The bikini was invented in 1947 by French couturier Jacques Heim, but two piece swimsuits, where the bottom half covered a substantial part of the body were worn before this.*

RIGHT: *Advert for Kleinert's Roxy watertight bathing caps in 1948, guaranteed to keep hair dry.*

the news is
the short-skirted swim suit,
in three parts,
each wonderful,
each nicely influential
figuratively speaking.
Skirt and waist-length bra
are toffeta with latan,
white striped with
brown or navy.
Lastex faille trunks
match stripes 25.00.

nothing does as much for a girl as a Jantz

LEFT: By the 1950s, the fashionable silhouette was being replicated in swimwear. This Jantzen costume features a short flirty skirt and a boned, strapless bodice.

ABOVE: Jolly advertisement for Silhouette swimwear featuring a number of smiling and carefree women on a beach wearing some brightly printed swimwear, boasting Silhouette's 'keep shape' bra and figure control technology, 1962.

1960 beach barings

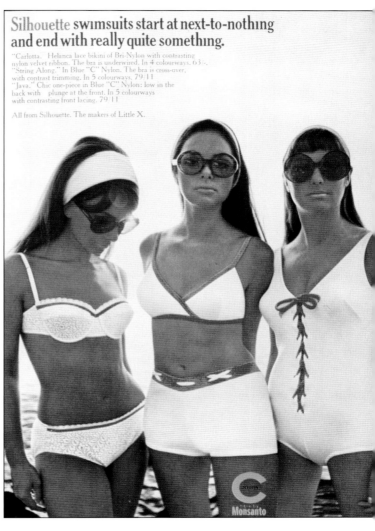

Silhouette **swimsuits start at next-to-nothing and end with really quite something.**

"Carlotta." Helanca lace bikini of Bri-Nylon with contrasting nylon velvet ribbon. The bra is underwired. In 4 colourways. 63/-.
"String Along." In Blue "C" Nylon. The bra is cross-over, with contrast trimming. In 5 colourways. 79/11
"Java." Chic one-piece in Blue "C" Nylon: low in the back with plunge at the front. In 5 colourways with contrasting front lacing. 79/11

All from Silhouette. The makers of Little X.

ABOVE: Advertisement for a two-piece swimsuit, made of wool knitted with Lastex, by Brigance for Sinclair, 1960.

RIGHT: Late 1960s advertisement for Silhouette swimwear made from Monsanto Nylon, showing three models in various styles: Carlotta, String Along, and Java.

Free Pattern of **HOME CHAT**

2ᵈ Every Monday

Mabs **NEW IRON-OUT-FLAT** *Frock*

Vol. CXXVIII. No. 1670.
MARCH 26th, 1927.

LEFT: Thrify tennis fashion in 1927 according to Home Chat *magazine which provides a free pattern for a new iron-out-flat frock.*

ABOVE: A fashionable young lady dressed for the tennis court in a creation by Molyneux, 1924.

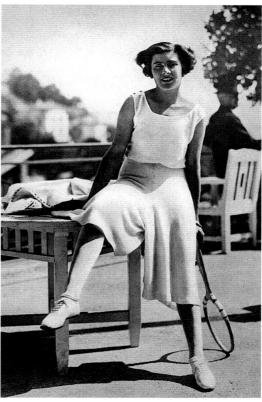

ABOVE LEFT: Elsa Schiparelli's practical but stylish jupe pantalon tennis dress in light white woollen weave with a waist belt of orange coloured tussore, and divided skirt.

ABOVE RIGHT: Lili Alvarez, Spanish tennis player, pictured modelling her famous culottes, *or 'divided skirt' which divided opinion when she wore them at Wimbledon in 1931. Designed by Elsa Schiaparelli, they were a sensation and despite their designer origins, the garment was part of an overall evolution towards performance based sportswear.*

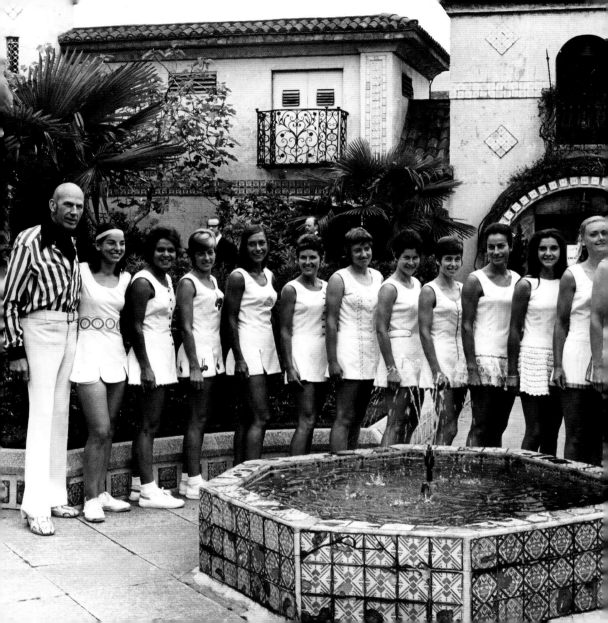

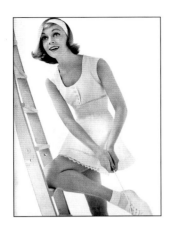

OPPOSITE: 6 ' 7" tall Cuthbert Collingwood "Ted" Tinling (1910–1990) - English tennis player and fashion designer - pictured in the 1970s with thirteen of the top women tennis players in the world wearing his designs, including Virginia Wade (fifth from the right) and Evonne Goolagong (third from left).

ABOVE: A high-waisted white pique dress from 1958 decorated with drawn tread work and worn with a broderie anglaise underslip by Teddy Tinling, England's leading designer of functional but fashion conscious tennis clothes.

RIGHT: Harrods advertisement for men's tennis clothing, 1936 with flannels, tennis shirts, tailored shorts and blazers among the variety of garments available.

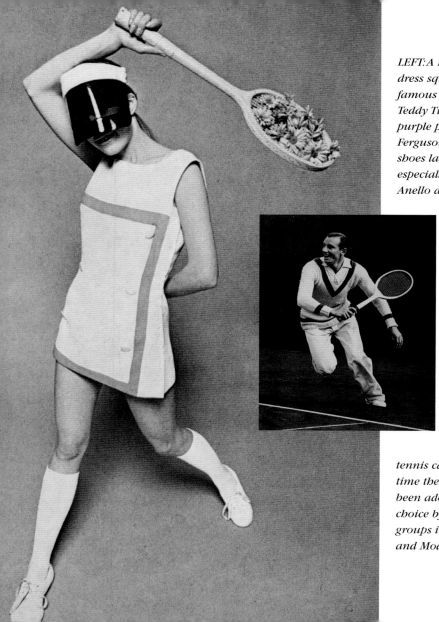

LEFT: A Dacron and cotton dress squared off in blue by famous tennis dress designer, Teddy Tinling, worn with a purple plastic visor by Joan Ferguson and white leather shoes laced in pink made especially for Teddy Tinling by Anello and Davide.

INSERT: Fred Perry (1909–1995) British tennis player and winner of three consecutive Wimbledon championships in 1934, 1935 and 1936 playing in long trousers in 1935. Perry launched his Fred Perry cotton pique sports shirt in 1952, long after his tennis career was over. Over time the Fred Perry shirt has been adopted as a garment of choice by a number of youth groups including skinheads and Mods.

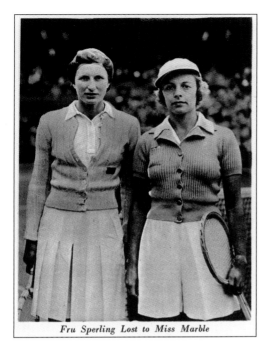

Fru Sperling Lost to Miss Marble

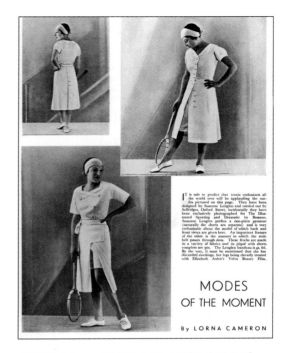

IT is safe to predict that tennis enthusiasts all the world over will be applauding the outfits pictured on this page. They have been designed by Suzanne Lenglen and carried out by Selfridges, Oxford Street, incidentally they have been exclusively photographed for The Illustrated Sporting and Dramatic by Romano. Suzanne Lenglen prefers a one-piece garment (naturally the shorts are separate) and is very enthusiastic about the model of which back and front views are given here. An important feature of the other is the manner in which the stole belt passes through this. These frocks are made in a variety of fabrics and in piqué with shorts complete are 30s. The Lenglen bandeau is 4s. 6d. By the way, it must be mentioned that she has discarded stockings, her legs being cleverly treated with Elizabeth Arden's Velva Beauty Film.

MODES
OF THE MOMENT

By LORNA CAMERON

ABOVE: Alice Marble (1913–1990), American tennis player, who was the first woman to win both the US Open and Wimbledon singles titles in the same year, as well as the ladies' doubles and mixed doubles. She also pioneered the wearing of shorts for tennis and in 1950, spoke out supporting the black tennis player, Althea Gibson, encouraging the public to accept black and homosexual tennis players into the game. Pictured here wearing shorts in 1939 with Fru Sperling who she beat in the semi-finals before beating Briton Kay Stammers in the final to clinch the championship.

ABOVE: A page depicting the outfits designed and modelled by Suzanne Lenglen for Selfridges, shown exclusively in the Illustrated Sporting and Dramatic News. Lenglen prefers a one-piece garment (naturally the shorts are separate) and is very enthusiastic about the model of which back and front views are shown here. Available in a variety of fabrics the outfits cost 30 shillings. The Lenglen bandeau was 4s. 6d and the daring player had dispensed with stockings, preferring instead to use Velva Beauty Film by Elizabeth Arden!

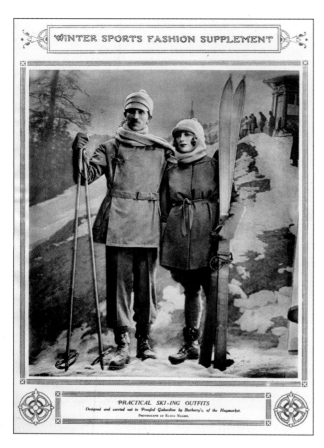

PRACTICAL SKI-ING OUTFITS

Designed and carried out in Proofed Gabardine by Burberry's, of the Haymarket.

PHOTOGRAPH BY ELSIE NEAME.

ABOVE: Outfits for the 1922 skiing season from Burberry in their proofed gabardine.

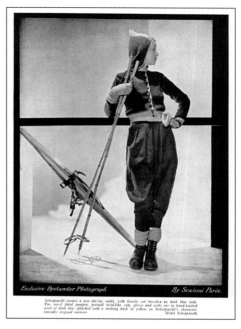

Exclusive Bystander Photograph *By Scaioni Paris.*

Schiaparelli creates a new ski-ing outfit, with loosely cut breeches in dark blue toile. The novel fitted jumper, pointed hood-like cap, gloves and socks are in hand-knitted wool of dark blue splashed with a striking dash of yellow in Schiaparelli's characteristically original manner

Model Schiaparelli

ABOVE: A skiing outfit by Elsa Schiaparelli featuring loosely cut breeches in dark blue toile and a novel fitted jumper, pointed hood-like cap, gloves and sock all in hand knitted wool of dark blue splashed with a striking dash of yellow in Schiaparelli's 'characteristically original manner.' Schiaparelli made extensive use of knitwear in her collections and the pixie style pointed hat appeared in her skiwear collections in subsequent years.

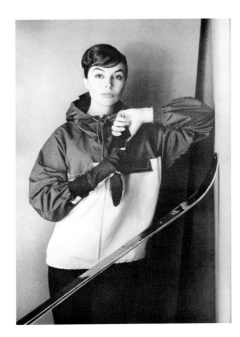

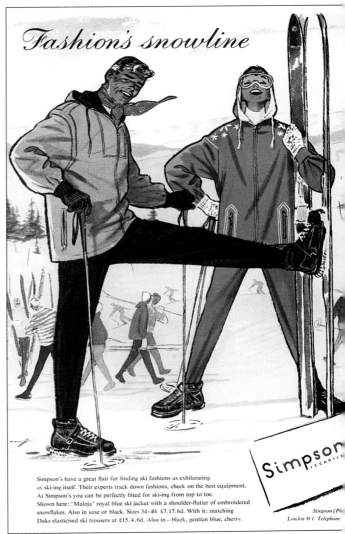

ABOVE: A model poses with skis in a proofed poplin jacket by Gordon Lowe from Debenhams in November 1956.

RIGHT: Advertisement for ski fashions from Simpson of Piccadilly in 1956 featuring a woman wearing a royal blue ski jacket with a shoulder flutter of embroidered snowflakes, worn with matching Daks elasticised ski trousers. The advertising copy claims, 'At Simpson's you can be perfectly fitted for skiing from top to toe.'

Simpson's have a great flair for finding ski fashions as exhilarating as ski-ing itself. Their experts track down fashions, check on the best equipment. At Simpson's you can be perfectly fitted for ski-ing from top to toe.
Shown here: 'Maloja' royal blue ski jacket with a shoulder-flutter of embroidered snowflakes. Also in saxe or black. Sizes 34-40. £7.17.6d. With it: matching Daks elasticised ski trousers at £15.4.6d. Also in — black, gentian blue, cherry.

Simpson (Pic London W1 Telephone

LEFT: The growing popularity of skiing holidays led to the concept of 'apres ski' wear for evening socialising such as these outfits from 1953 drawn by Sigrid and published in The Tatler. On the left is a grey and yellow checked wool taffeta blouse by Jaeger worn with their huge, button through circular felt skirt. Also from Jaeger are the narrow black gabardine slacks with deep cuffs, a yellow jersey Poncho with cowl neck and the 'enchantingly, brightly trimmed' seal skin apres-ski bootees.

Sigrid

ABOVE: Skating suit from Harrods, featured in The Bystander *magazine in 1929.*

RIGHT: A contrasting ski outfit from Jaeger. The tough looking, loose fitting wool sweater, with its ribbed knit and roll collar, and the tailored ski pants of black barathea produce an ensemble that, 'whilst undeniably gay, is also strictly workmanlike'. The sweater costs four guineas and the ski-pants 11 guineas in 1954.

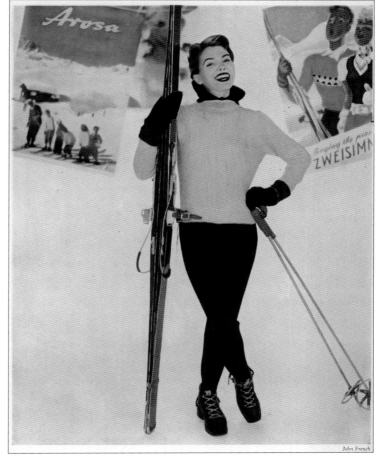

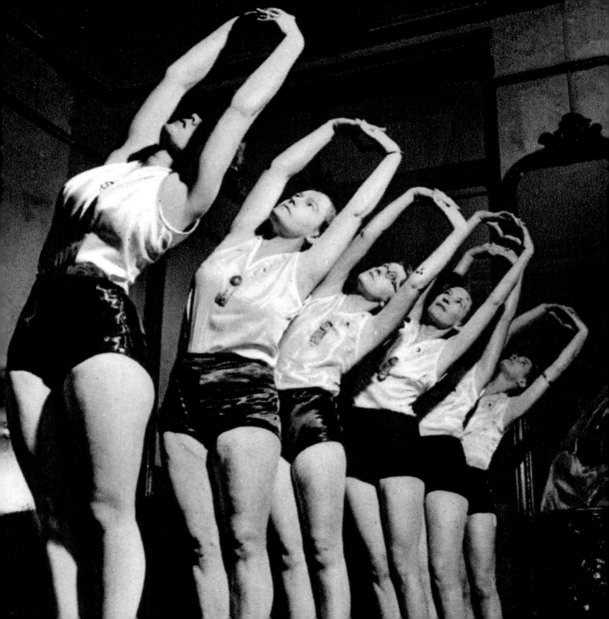

OPPOSITE: Health and beauty – a morning exercise class at Harrington Road, London for the Women's League of Health and Beauty, at the London Academy of Music and Dramatic Art in 1938. Here, young women demonstrate the side waist bend: a waist slimming sequence. Exercise classes in the early 20th century was characterised by a mass synchronicity of movement, the overall effect enhanced by the wearing of identical uniforms of shorts and short-sleeved tops.

RIGHT: Examples of World Cup inspired fashion for ladies. An assortment of colourful football shirts modelled by the female staff of London Life *magazine in 1966.*

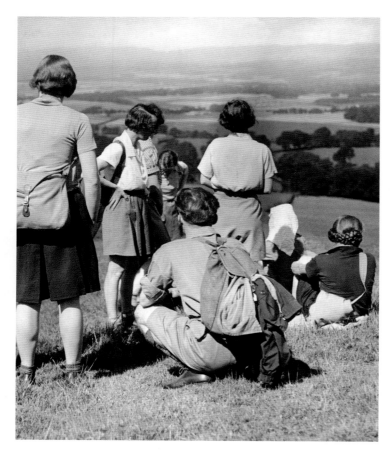

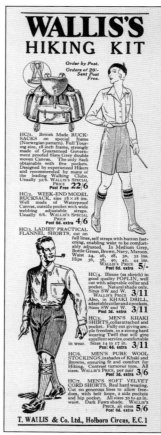

ABOVE AND RIGHT: Rambling and hiking enjoyed a surge of popularity during the 1920s and 30s, part of a wider interest in health and exercise. As people came to benefit from paid holidays from the workplace, a hiking holiday was viewed as a wholesome and healthy way to relax. Magazines advertised the right equipment for keen hikers from boots and rucksacks to sturdy shorts and stockings.

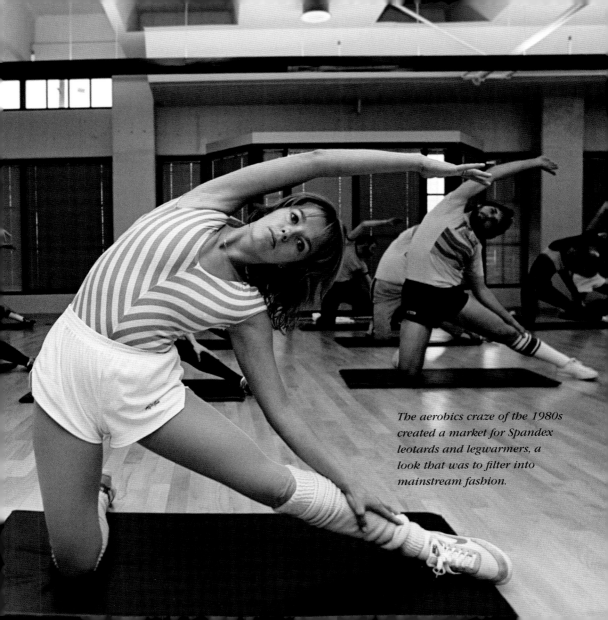

The aerobics craze of the 1980s created a market for Spandex leotards and legwarmers, a look that was to filter into mainstream fashion.

If its Sports Wear—*ready to put on—it should be*

MEAKERS

OPPOSITE: *On the piste in the 1970s wearing ski fashions in bright primary colours. European high street chains, such as C&A began to offer affordable skiwear as skiing holidays became increasingly popular.*

ABOVE: *Knitting pattern for a particularly garish cardigan, an exclusive design by sports store Lillywhites of Piccadilly, worn by members of the British Women's Olympic team at Innsbruck in 1976.*

ABOVE: *Advertisement for sportswear from Meakers, promoting clothes for the dapper gent to wear to the Henley Regatta. In the 1930s, Meakers had 150 branches around the UK.*

PICTURE CREDITS

All images are researched and supplied by Mary Evans Picture Library, Blackheath, London. Individual contributors available through the library are listed below.